ROOMS IN
CONTEMPORARY FLORALS FOR THE HOME
BLOOM

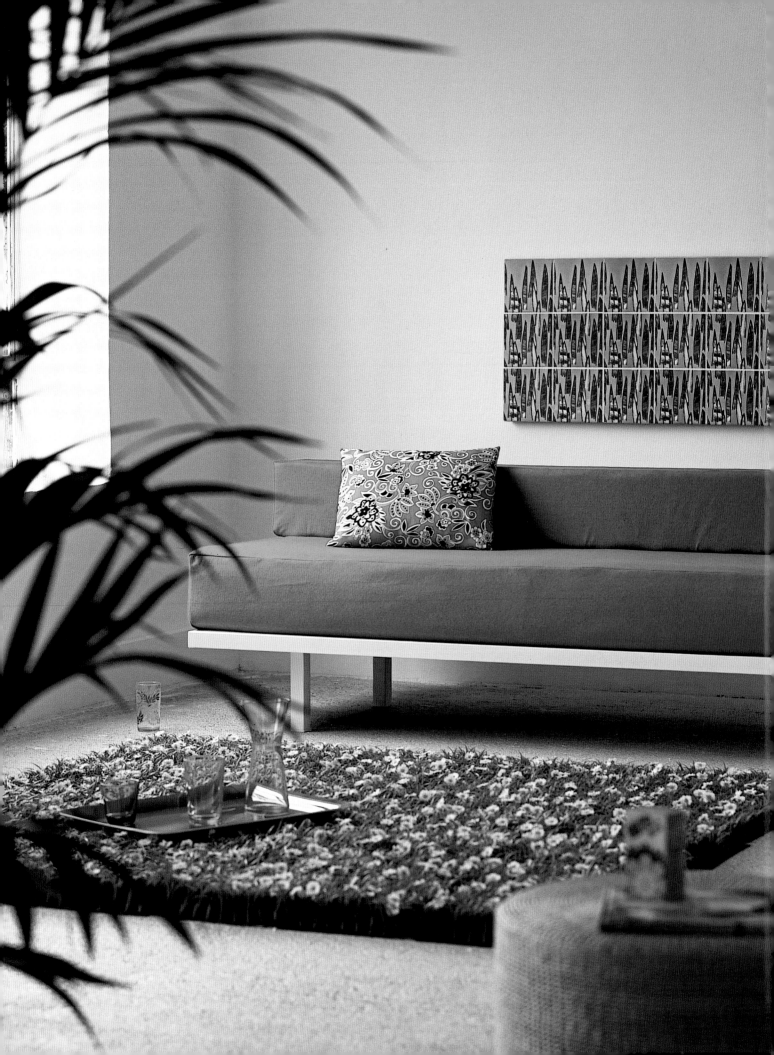

ROOMS IN BLOOM

CONTEMPORARY FLORALS FOR THE HOME

ALICE WHATELY

WATSON-GUPTILL PUBLICATIONS/NEW YORK

For Rollo and Francis, with love

First published in the United States in 2005
by Watson-Guptill Publications,
a division of VNU Business Media, Inc.
770 Broadway, New York, N. Y. 10003
www.wgpub.com

Text copyright © Conran Octopus 2005
Book design and layout copyright © Conran
Octopus 2005

Library of Congress Control Number:
2004117785
ISBN: 0-8230-6843-9

Publishing Director: Lorraine Dickey
Art Director: Chi Lam
Executive Editor: Zia Mattocks
Designer: Victoria Burley
Editor: Sian Parkhouse
Picture Research Manager: Liz Boyd
Picture Researcher: Vivien Hamley
Production Manager: Angela Couchman

Manufactured in China

1 2 3 4 5 6 7 / 07 06 05 04 03

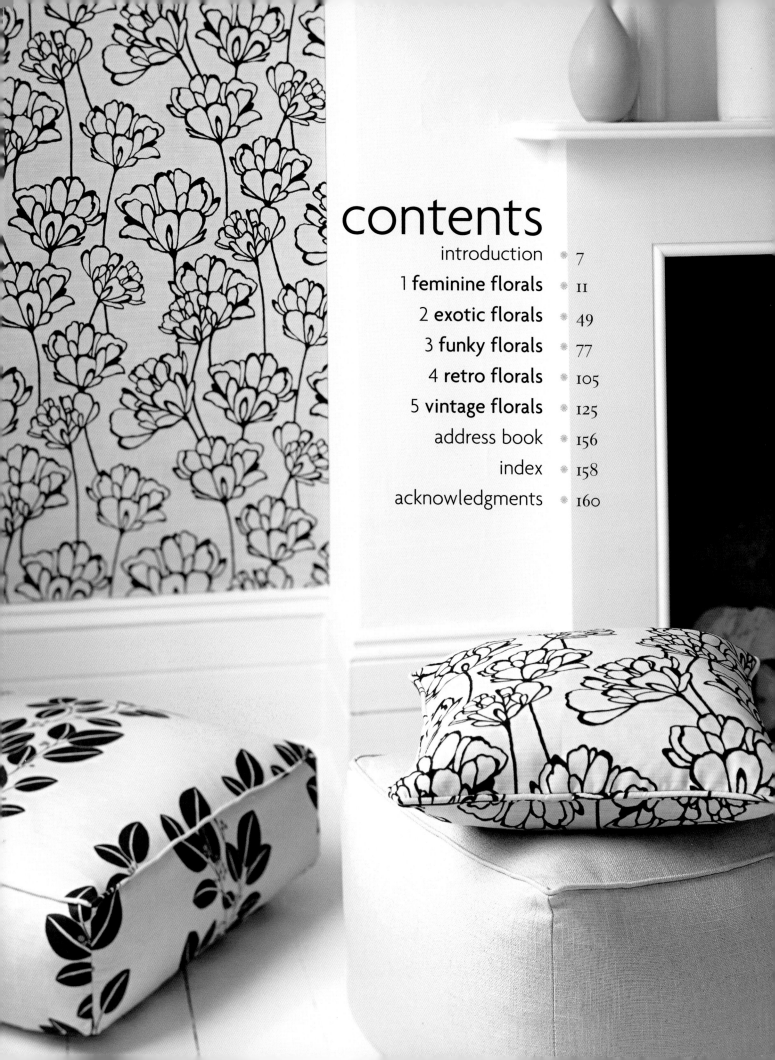

contents

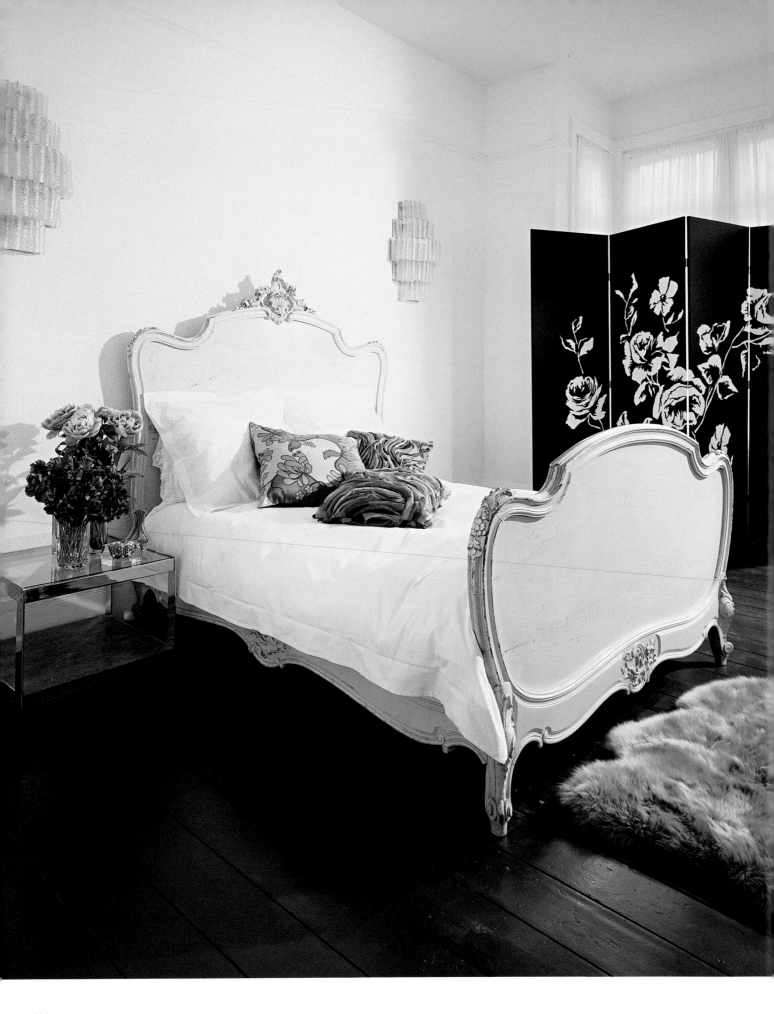

introduction

Floral decoration has been a popular choice in western interiors since the seventeenth century, when chintz was first imported to Britain from the East Indies. Featuring botanical motifs in dazzling hues, the revolutionary new fabric was an instant hit, its shiny, dust-repellent finish making it a natural choice for a range of soft furnishings.

The preeminence of chintz during the 1700s prompted English and French textile manufacturers to develop their own versions of this fabric. Featuring a riot of cottage-garden blooms—including roses, daisies, sweet peas, carnations, and tulips—this new-look chintz was later exported to America, where it was received with gusto.

These days, our desire to introduce a botanical theme to our interiors goes hand in hand with the enduring fashion for minimalism. As a result, floral decoration provides a tasteful complement to simply painted walls, wooden floors, and streamlined furnishings, helping to create design schemes that are as appealing as they are contemporary.

The resurgence of floral decor has resulted in a variety of different furnishing styles—the most significant of which are examined in this book. Designed to suit a range of interiors, *Rooms in Bloom* begins with a look at "Feminine Florals," in which romantic rooms are created through the introduction of pastel colors, overblown motifs, and floaty drapes. The faded furnishings that characterize a relaxed, pared-back style are also included here, in a bid to celebrate the timeworn appeal of flaky painted furniture, sun-bleached fabrics, and floral slipcovers.

By contrast, decorating with "Exotic Florals" imbues interiors with a sense of global sophistication. Motifs, including stylized

OPPOSITE Decorative floral touches, together with an ornately carved bed, breathe life into this essentially minimalist boudoir, creating a sense of feminine sophistication.

Indian roses and Chinese lotus blossoms, are depicted in jewel-bright shades, while the fashion for glamorous Asian-style furnishings witnesses the incorporation of Chinese wallpaper, ambient lighting, and exquisitely embroidered silks. Choosing to decorate your home with a variety of different global elements is also popular with contemporary homeowners, resulting in a relaxed, eclectic feel.

The "Funky Floral" look is characterized by graphic plants and stylized flowers that are as flashy as they are funky. Offering a radical departure from traditional designs, key elements include digitized wallpaper, modern artworks, vivid colors, and cheerful bead curtains. The look also encompasses fabrics and furnishings by contemporary fashion designers such as Jasper Conran, Matthew Williamson, and Donna Karan.

Currently enjoying a renaissance, "Retro Florals" provide an appealing complement to the sleek lines of contemporary interiors. Botanical designs from the sixties and seventies enliven stripped wooden floors and neutral-colored walls, while the demand for flashback furnishings has resulted in a growing number of outlets selling vintage collectibles. In addition, a number of companies are now reissuing classic furniture designs, while midcentury fabrics by Marimekko are also enjoying a revival.

Perfect for traditionalists, the faded charm of "Vintage Florals" recalls the cozy innocence of bygone days. Featuring furnishings and fabrics that have been sourced from antique fairs and junk shops, its mix-and-match approach results in design schemes that are as original as they are inspired. Old-fashioned fabrics such as patchwork, lace, and velvet are essential to the success of this look, while modern rustic-style furnishings help to compound the sense of nostalgia.

OPPOSITE Mixing floral wallpaper with modern furnishings creates a wonderfully eclectic feel, while the striped drapes compound the mix-and-match approach.

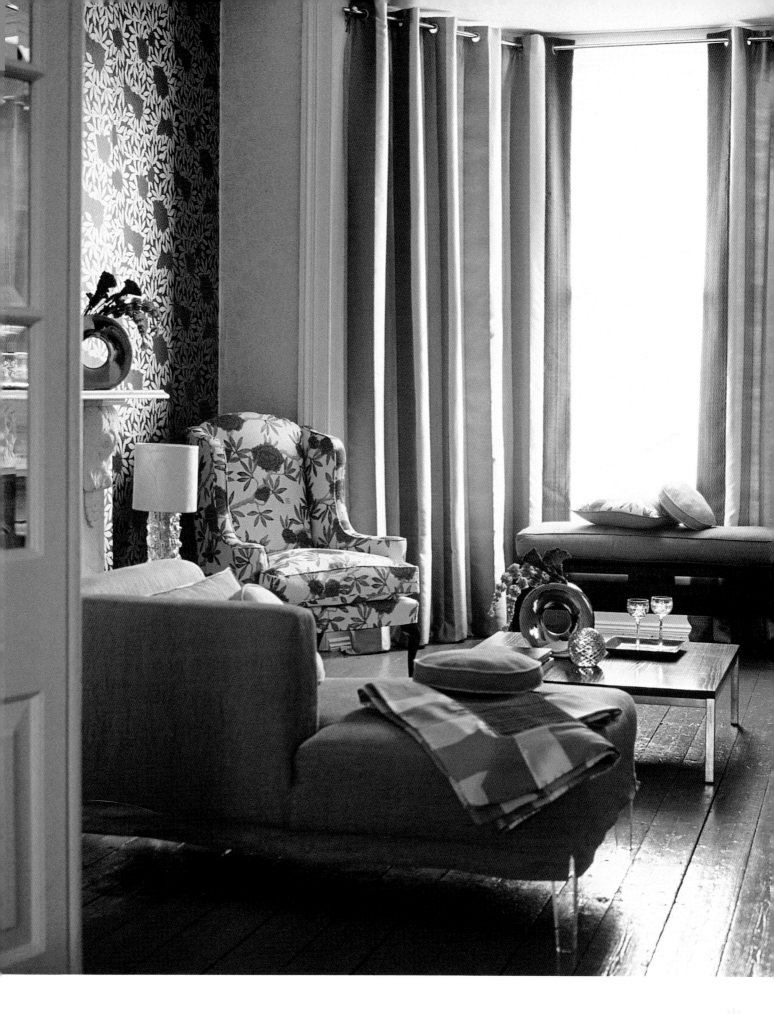

feminine florals

Flowers and floral designs are among the world's best-loved patterns, but such popularity has, on occasion, been their downfall. Certainly, florals did themselves few favors in the 1980s when they were combined with sumptuous swags and fussy frills, but now that the froufrou flounces of yesteryear have been rigorously edited, it's a very different story.

The new-look floral presents a marked departure from the previous glut of ponderous patterns and lumpen textures. Light and bright, rather than rambling and overblown, the focus is on color, contrast, and simplicity, which, combined together with simply painted walls and pared-back furniture, allow the intrinsic charm of petal prints to shine through.

Today's feminine florals are as effective in traditional interiors as they are in more contemporary ones—with the key looks including **NEW ROMANTIC** and **SIMPLE CHIC**. Although these decorating schemes work well in any room in the house, they are best suited to **BEDROOMS**, **BATHROOMS**, **LIVING ROOMS**, and **EATING AREAS**.

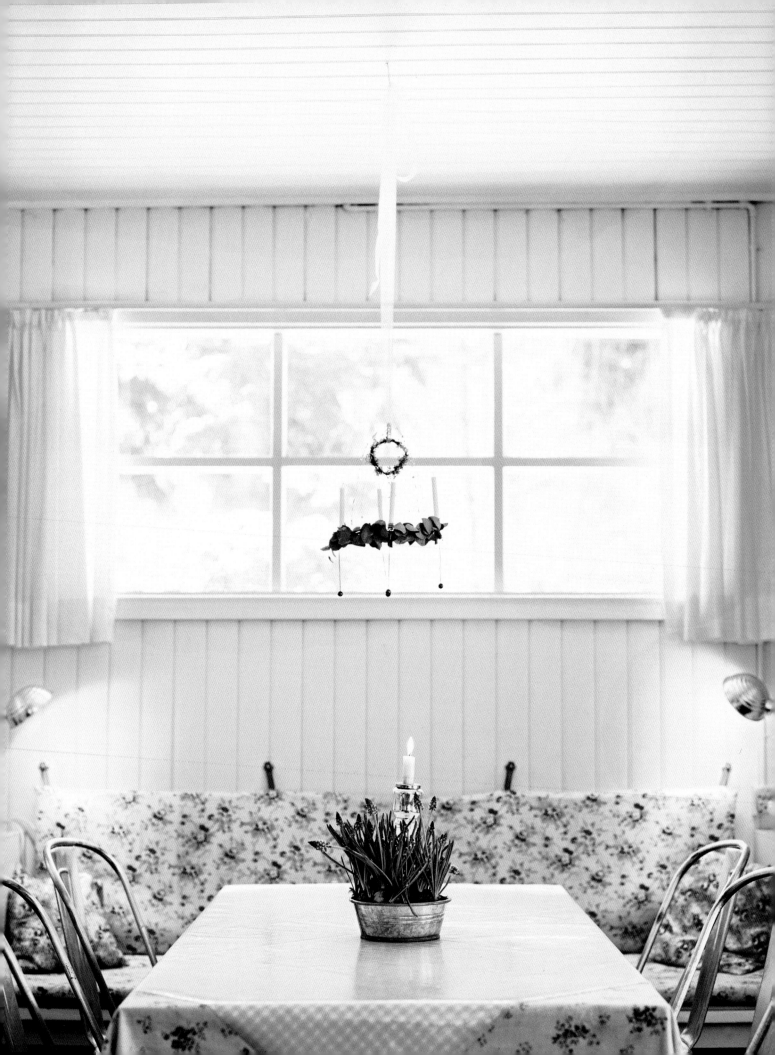

petal palette

In order to prime your home for a floral decorative scheme, it's important first to simplify your surroundings. While you may have chosen to eschew minimalism in favor of a more florid approach, this doesn't mean that clean white spaces need to go out the window. Instead, it's possible to combine elements of the two looks so that you create a home that is cool and contemporary rather than cluttered and claustrophobic.

The theory of space clearing combines the physical process of removing any unnecessary clutter with the aesthetic one of simplifying your surroundings. Keeping a light touch with your background will allow your blooms to breathe—vital in creating an attractive floral scheme. Remember: clarity is key to success.

Choosing a pale color palette is instrumental in this process. For example, if you opt for white or off-white walls, you will create a blank canvas with beautifully classic foundations. In addition, neutral wall treatments complement a vast choice of colors, tones, and textures, as well as provide a stylish backdrop for different furniture styles and floral treatments. Better still, walls that are painted in pale shades reflect natural light, automatically making your space seem bigger and brighter. But avoid too-stark whites and opt for the softer shades of string, bone, ivory, and calico for a better effect.

Keeping your flooring simple is another way of allowing floral designs to take center stage. Does your carpet cover space-enhancing floorboards or antique parquet blocks? Stripped wood boards, sisal, or sandblasted cement all help to clear the decks for botanical wallpapers, upholstery, and stenciled motifs—as well as provide a perfect foil for pretty Aubusson rugs.

The sensitive harnessing of light is also important. The best illumination for a bowery of feminine florals is daylight, a natural phenomenon you should exploit to the fullest.

COLORS FROM THE GARDEN

Colors from the garden are a prime inspiration in the floral home:

❋ Rose red
Shades of scarlet, crimson, magenta, and cerise are perennially popular, thanks to the enduring appeal of roses. Combine with cream, pink, and green for an English country-house feel, or with white for a contemporary effect.

❋ Sunflower yellow
Yellow is hugely effective in energizing a room deprived of natural light. Team with cream or white to maximize the sun-soaked feel, or with green and white for revitalization.

❋ Delphinium blue
Said to trigger up to 11 tranquilizing hormones, blue is perfect for blissed-out bedrooms. Mix with violet and lilac to create the ultimate chill-out zone.

❋ Peony pink
Pink represents the fragility of love and romance. Combine with red to create an electrifying effect, or with pastel shades for a more peaceful note.

❋ Parma violet
Excellent for creating a sense of nurturing, violet soothes body, mind, and spirit. Mix with white, cream, or pink to compound the feminine feeling, or with blues for a more laid-back vibe.

❋ Carnation white
Crisp and clean, white is the ideal backdrop for sprightly schemes. Use to make small, light-deprived rooms feel more spacious, or to enhance purity in bathrooms.

❋ Creamy magnolia
Soft and sensual, magnolia is perfect for sensual decorating schemes, and often used to complement busy patterns and bright colors.

OPPOSITE An all-white decor provides a pristine setting for floral furnishings such as this elegantly upholstered sofa.

new romantic

Introducing feminine florals into your interior is one of the best ways to create a dreamy sense of romanticism. Fabrics such as floating rose-printed drapes or silk sheets embroidered with tiny buds give a sweetly seductive look, while pastel colors such as pink, lilac, and powder blue compound the sense of feminine allure. Fixtures and fittings in the shapes of floral candelabras and decorative mirrors are also key in romantic room sets, together with lush linens and softly curved furniture. In terms of decorative details, opt for a few carefully chosen mementos, including floral watercolors, scented candles, and delicate blooms in single-stem vases.

LEFT These two cotton fabrics are ideal for decorative details such as cushion covers, chair seats, or tablecloths; the rosebud print is a particularly good choice for new romantic boudoirs. **OPPOSITE** This ultrafeminine living room retains a light, airy feel with white-painted floorboards and cotton drapes in different-scale floral prints dressing the floor-to-ceiling windows. The pink sofa with scatter cushions in shades of lilac, pink, and purple add blocks of color and prevent the room from looking overdone.

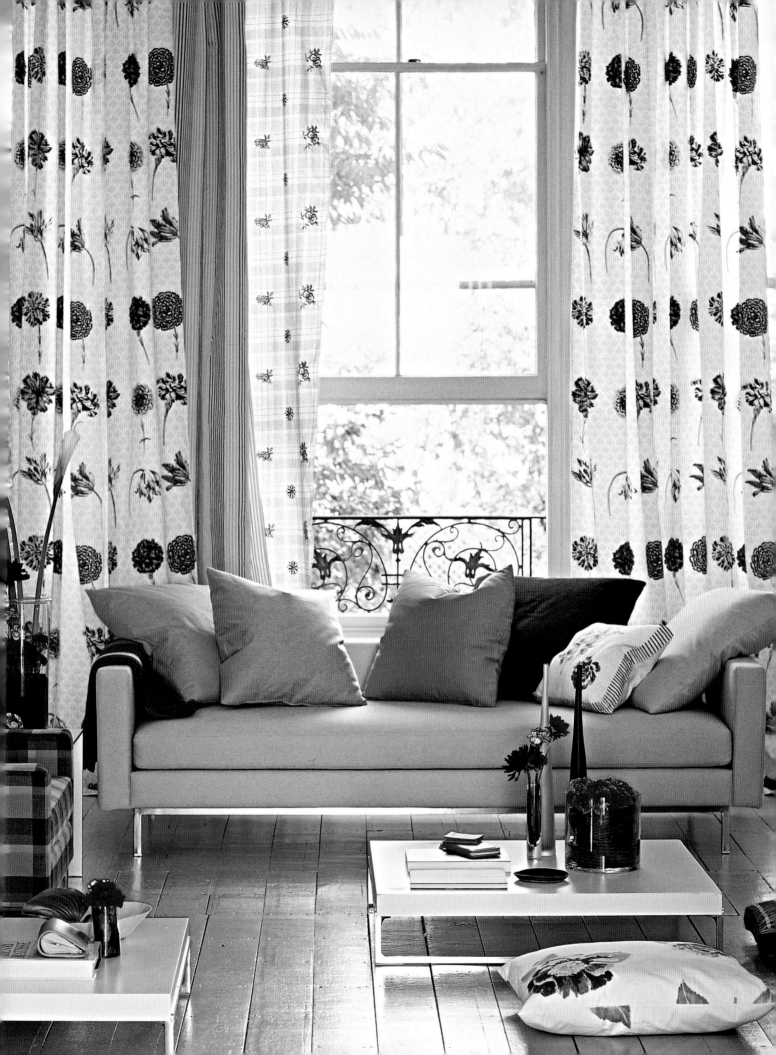

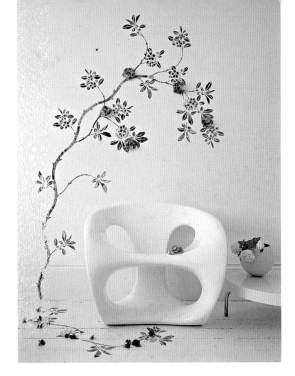

contemporary cutouts

One of the quickest and easiest ways to introduce florals into the home is through the application of stenciled motifs. A far cry from the old-fashioned designs that decorated walls during the 1980s, the new-look stencils are cleaner, crisper, and much more dramatic.

There are numerous advantages to stenciling—the most obvious being that it requires no greater skill than a steady hand to convey the impression of a pretty pattern that's been professionally applied. There's also a fabulous range of precut stencils available—with botanical designs ranging from Japanese cherry blossom to wisteria, roses, and daisies.

For a simple but striking look, use a graphic design against a neutral backdrop; alternatively, create maximum impact by covering an entire wall with an intricate design in a pale color, emphasizing various motifs at intervals with a stronger shade of color. Contemporary cutouts are best suited to rooms that are big enough to cater to modern motifs, many of which have been designed to unfold in one long fluid continuum across walls, floors, and doors. Stencils can also be used to improve a room's proportions, or to draw attention cleverly to quirky features such as an attractive chimneypiece or an intricate cornice.

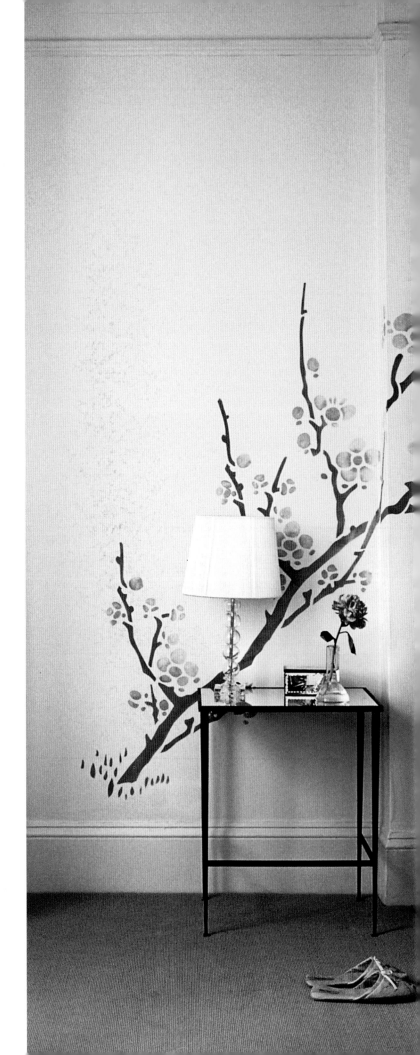

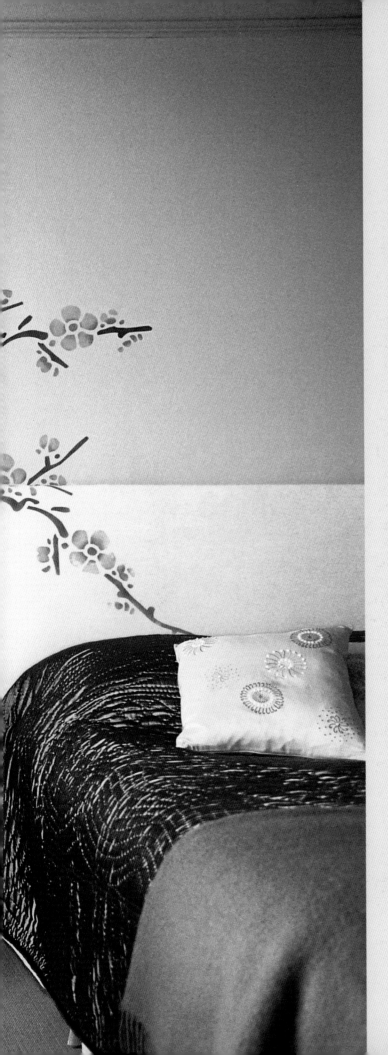

STENCIL LIKE A PRO

❋ **Use the right equipment**
Stenciling brushes are round with short, stiff bristles. Use them in rapid up-and-down movements to dab paint onto your stencil. This helps prevent paint from seeping under the edges. A sponge or small paint roller will also do the trick.

❋ **Work from the outside in**
Start on the edges of the stencil, working into the center, rather than from the center outward. Again, this helps prevent paint from leaking under the edges, as you are less likely to bump the brush against an outline accidentally.

❋ **Try not to go overboard**
Don't overload your brush with paint, as this can also cause it to leak under the edges of the stencil. Load the brush lightly, so that the ends of the bristles are covered evenly; wipe off any excess on a piece of paper or cloth first, before applying it to the stencil.

❋ **Repeat performance**
You'll get far better results by applying two thin coats rather than one thick one. Wait for the first application to dry before applying the second. Patience is a virtue.

❋ **Stick with it**
Keep your stencil in place by taping it at the top and bottom. Use low-tack tape as it is easy to remove and shouldn't pull off any paint from the surface.

❋ **Different color combinations**
To use more than one color in a stencil, use low-tack tape to mask off areas of the stencil you don't want in a particular color.

❋ **Do a trial run**
If you are using various stencils together, try out your design on a piece of paper first. It is much easier to find out that something is not working at this stage and then correct it than when you are painting the real thing.

❋ **Keep it clean**
If you're doing a repeat design, wash your stencil regularly in warm water to ensure that the edges remain free of paint. If there is some paint on an edge, you won't get a crisp edge on your painted motif. As paper stencils don't lend themselves to washing, acetate stencils are better for repeat designs. With a paper or card stencil, wipe off excess paint, then leave to dry before using it again.

❋ **Sensible storage**
A stencil must be kept completely flat to be reusable. To prevent it from buckling, place it between two pieces of cardboard and store it between the pages of a large heavy book.

FAR LEFT Offering a radical departure from the restrained and often strictly ordered designs of the 1980s, today's more organic stencils unfold across walls and floors in an apparently random display of pattern and color.
LEFT Continuing this stencil design across different media—from the wall, around a corner, and onto the headboard—is as clever as it is quirky.

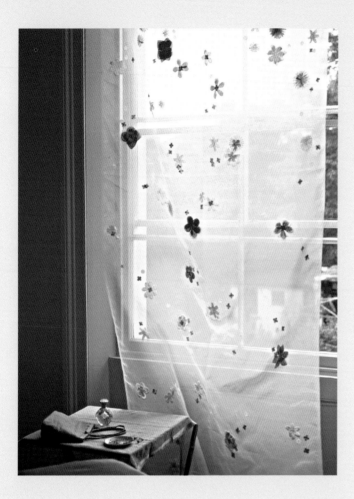

PRETTY PANELS

The sensitive harnessing of natural light is also key. As floral boudoirs focus on the creation of an airy ambience, it makes sense to dress your windows with floating drapes that diffuse the light so everything is bathed in a translucent haze. Lengths of semitransparent fabrics are ideal, and will stir seductively in the slightest breeze.

HOW TO MAKE FLORAL DRAPES

❋ **Materials**

Voile or organza; silk flowers in varying sizes; and a curtain rod

❋ **Method**

Cut the voile to the length and width of your window, allowing extra fabric at the top for inserting a rod, and ¾ in (2 cm) extra at the bottom for a double hem. Press under a ½-in (1-cm) hem allowance on either side of the curtain and stitch. Fold under a ¾-in (2-cm) hem at the bottom of the curtain. Turn under again to hide the raw edge. Press and stitch to create a hem. Make a channel at the top for a curtain pole. Scatter the largest flowers over the panel and attach with stitches of white thread. Repeat with smaller flowers.

ABOVE Decorating a voile panel with a random pattern of silk flowers is a great way to enliven a basic window treatment.

OPPOSITE A pretty glass light adds an original decorative element.

mood lighting

As every romantic knows, thoughtful illumination is vital for creating an atmosphere conducive to seduction. After all, who could possibly relax in a dingy, badly lit space, or feel flirtatious in the glare of a harsh neon strip? The alternative is to opt for artificial lighting that creates indirect pools of warmth in some areas, while leaving others seductively shadowy. Specific task lights can create an intimate glow, while the subtle illumination of uplighters is preferable to harsh overhead styles.

If aesthetics rather than ambience is your primary concern, you'll find a wealth of choices available. First up is the antique chandelier, a firm favorite in the style stakes, thanks to its graceful combination of wrought iron curlicues and frosted drops of clear or colored glass. Chandeliers range in style from extremely ornate to relatively simple—and while a larger model makes a wonderful centerpiece in a room, smaller, less obvious examples, in the form of wall and table lamps, also add romance.

Wrought iron candelabras—with their fake candles nestled among intertwining flowers and leaves—are similarly appealing, while other romantic illuminations include strings of floral fairy lights trailing across mirrors and mantelpieces, table lamps sporting sweet floral shades, and modern light installations such as Tord Boontje's Garland design, which comprises a length of metal flowers and leaves that can be wrapped around a lightbulb.

For truly romantic illumination, candlelight is by far the best option. Providing a shadowy intimacy perfect for feminine boudoirs, its flickering glow is impossibly flattering—giving off an allure that cannot be recreated artificially. For best results, group a cluster of candles, varying their sizes and shapes to add perspective. Votive candles will lend a soothing spiritual feel, while candles with rose or violet petals embedded in them compound the floral vibe.

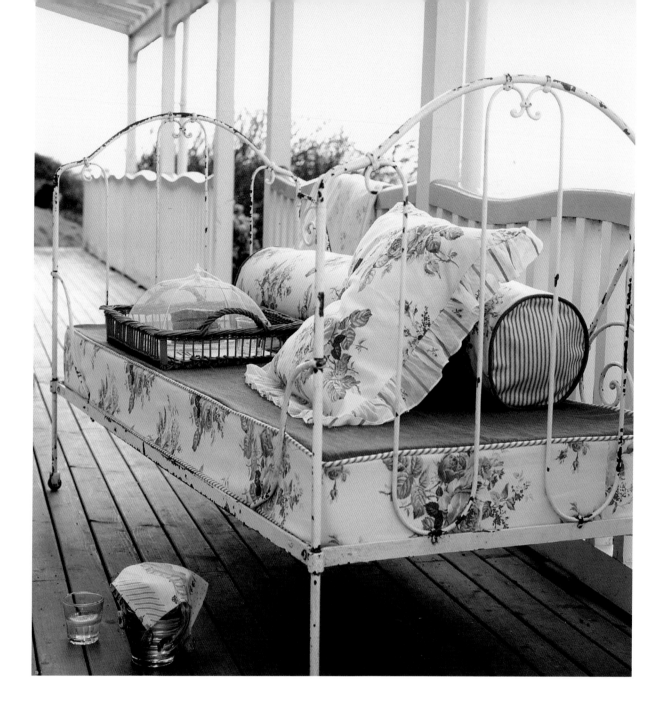

rosy seats

Although floral patterns provide the perfect foil for a diverse range of furniture, antique pieces are the best option if you want your boudoir to resonate with romanticism. Not only do slipper chairs, chaises longues, and ottomans add a touch of the femme fatale, they also provide an excellent dumping ground for clothes, bags, and other bits and pieces. Wicker furniture also works well, imbuing feminine bedrooms with a refined rusticity. Wicker can be used for chairs, tables, sofas, and stools without appearing too overdone,

and provides an excellent complement to floral upholstery. French furnishings also add a little ooh-la-la. Think wrought iron daybeds, Louis XIV armchairs, free-standing armoires, and gilt-framed mirrors propped against the wall.

ABOVE A chunky floral mattress and scattering of bold cushions soften the stark lines of this vintage daybed.
OPPOSITE Give antique chairs a new lease on life by reupholstering them in a modern fabric.

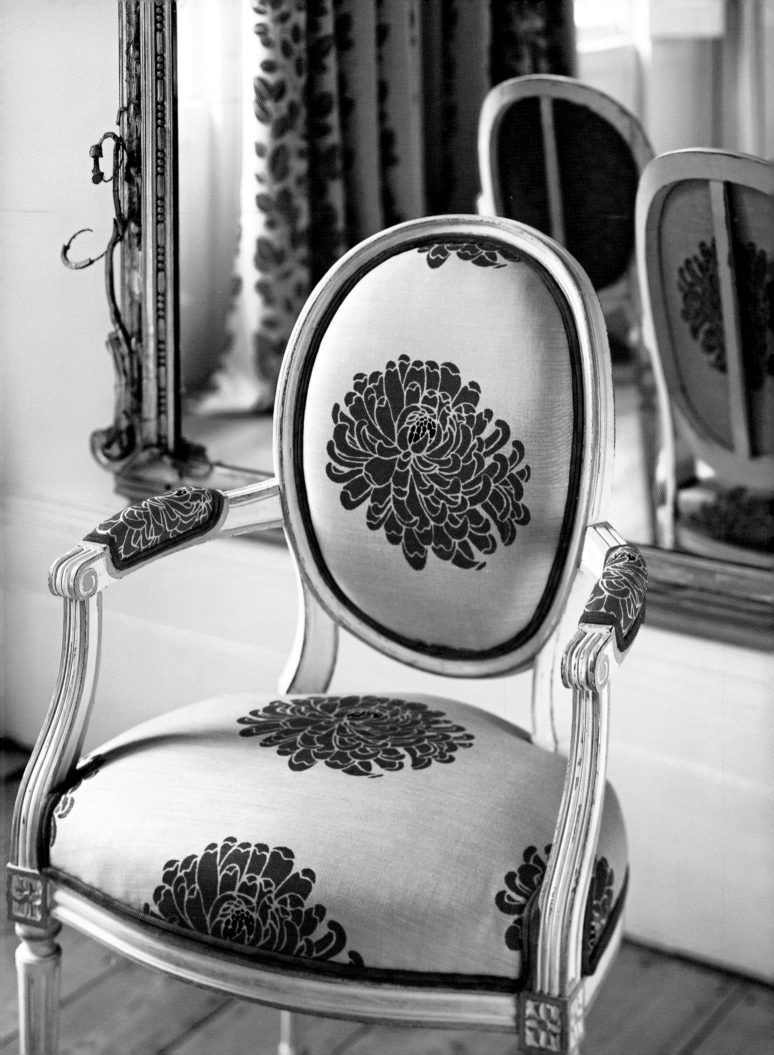

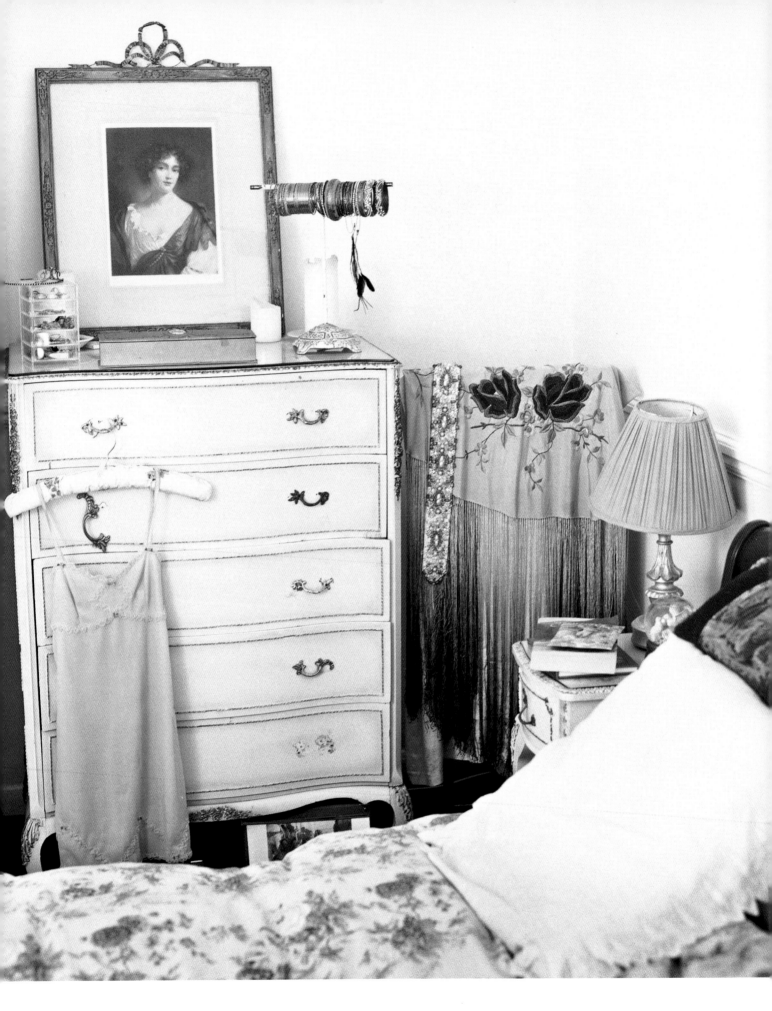

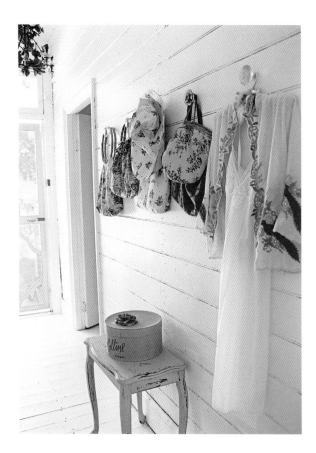

feminine fripperies

Although romantic details are a defining feature of floral boudoirs, it is important not to overdo it on the froufrou front. A few carefully chosen mementos will have a far greater impact than a mass of meaningless knick-knacks, while accessories with an old-fashioned feel will evoke a sense of timeless femininity. Good ideas include furnishing your dressing table with a monogrammed vanity set, covering the backs of chairs with delicate lace cloths, or dotting the mantelpiece with sepia photographs in a selection of pretty antique frames.

If you're lucky enough to have high ceilings, use the tops of cupboards and armoires to show off floral hatboxes or a collection of vintage textiles. Alternatively, showcase ornaments in a glass-fronted cupboard, or hang a floral tea dress on a padded hanger to create an art installation that is as fashionable as it is aesthetic. You could also tuck flowery postcards inside a picture frame or display scraps of your favorite antique chintz beneath a glass-topped table.

SCENTING YOUR INTERIOR

Ensuring that your home smells as sweet as a summer garden is an integral part of modern decorating schemes. Indeed, contemporary practices such as lighting a perfumed candle or spritzing the bed linen with lavender water have become as natural as squirting fragrance on your wrists, while matching your scent to your decor is one of the most attractive ways to finish off a design scheme.

Because of their associations with love, floral fragrances work particularly well in interiors with a feminine slant. Aromatic flowers such as carnations, mimosa, frangipani, and honeysuckle are guaranteed to create a heady ambience, while the aphrodisiac properties of rose, narcissus, and neroli have long been exploited for their ability to seduce and beguile.

Burning an aromatherapy candle is one of the most effective ways of scenting your space, as the fragrance will linger for hours after the flame has been extinguished. Although there are many different types of candle on the market, it's worth shelling out for the more expensive varieties; this way you will avoid the ghastly synthetic scents of cheaper products, while investing in a pricier candle not only guarantees more burning hours, but also a stronger, more authentic, fragrance.

Alternative olfactory products include chichi home-fragrance sprays, which come beautifully bottled in elegant glass flacons. Indeed, the trend for scenting your interior has taken off to the extent that a number of top fragrance houses are now producing scents that can be sprayed on your skin well as your sheets, carpets, towels, cushions, and upholstery.

If you prefer more naturally fragranced sprays to those you can buy in the shops, why not create your own home fragrance? Simply fill a clean plant mister with 5 fl oz (150 ml) of warm water and add five drops of your favorite essential oil. Shake the mixture vigorously before spritzing into the air.

> **TIP:** Slip cotton bags filled with dried flowers inside loose chair and sofa covers to deliver a waft of scent as you sink into the squashy depths.

OPPOSITE Keeping a pale overall palette prevents this eclectic mix of details from appearing overly fussy. The fringed shawl introduces a softer element, which is echoed by the pleated lamp shade and pretty nightdress displayed on a delicately decorated padded hanger.

ABOVE LEFT A floating dress and selection of floral bags and hats creates a fashionable art installation along this paneled wall.

fresh florals

The best way to enhance a floral decorative scheme is through the inclusion of real-life flowers. Not only do blooms breathe life into rooms, imbuing them with color and fragrance, but they are easily available, relatively cheap, and gratifyingly easy to arrange.

While bunches of jolly chrysanthemums and vases of splashy sunflowers are excellent ways to imbue your home with a sense of vibrancy, the feminine look calls for a more subtle approach. "Old-fashioned" flowers such as wild roses, daisies, pansies, and tulips tend to look better in solo displays. If you do mix your blooms, make sure that the hues are similarly subtle to avoid striking a jarring note. It's also advisable to try to make floral displays look as though they've been casually thrown together— as a rule of thumb, haphazard arrangements look more appealing than structured ones.

Flower shops are gradually realizing the value of simple blooms, and it's possible to buy seasonal branches of blossoms such as forsythia, rose hip, and catkins, in addition to more showy stems. These single blossoms are bought, or cut, while still budding so that when handling them you are less likely to damage their delicate petals; this also means that you have the pleasure of watching the buds slowly unfurl. An excellent choice for decorating large, airy spaces, willowy branches require minimal arranging and last well.

The containers you use to put flowers in are almost as important as the blooms you choose to pick, and range from heavy cut-glass vases to single-stem holders. Steer clear of conventional vases in feminine interiors, however, as this introduces a formal note that is at odds with the eclectic feel. Instead, put wild roses in a cream mug, jasmine in an earthenware pot, and camellias in a floral teapot. Alternatively, fill a simple glass jar with a spray of honeysuckle or soften the lines of an old metal bucket with a bunch of eye-popping hollyhocks.

> **TIP:** Flower heads that are good for floating in bowls of water include lilies, orchids, roses, and gardenias. Blooms and petals can be combined with floating candles shaped like flower heads.

LEFT Thread soft rose heads onto twine for a decorative twist on traditional floral arrangements.
OPPOSITE Overblown blooms breathe life into interiors.

"YOU MAY BREAK, YOU MAY SHATTER THE VASE, IF YOU WILL/BUT THE SCENT

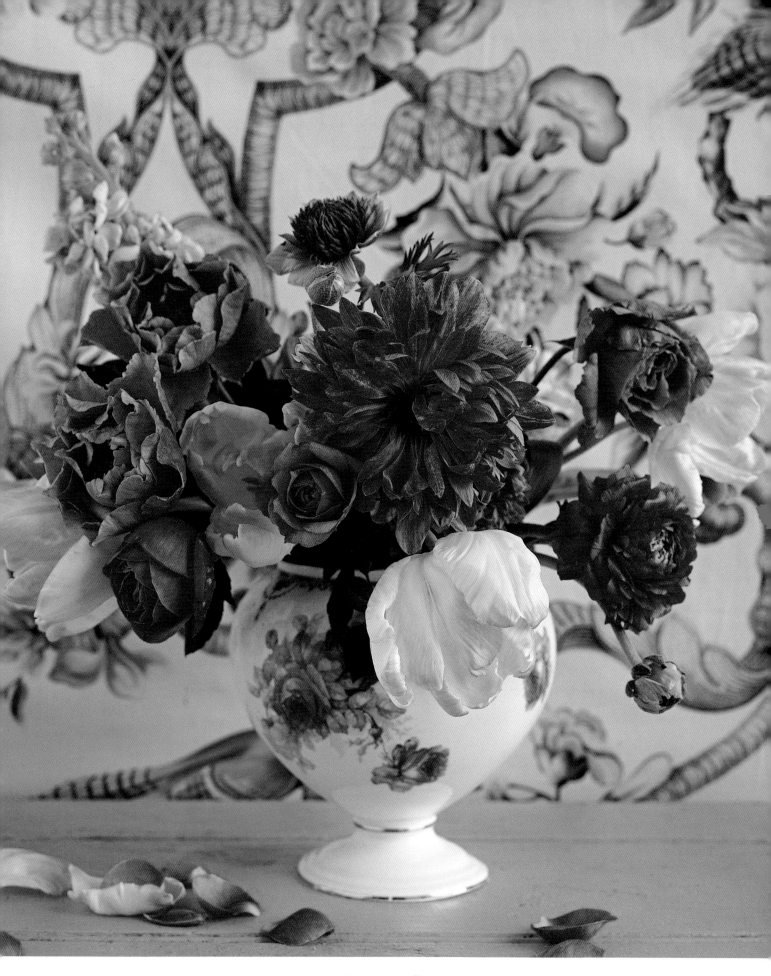

OF THE ROSES WILL HANG ROUND IT STILL." Thomas Moore, Irish musician and songwriter

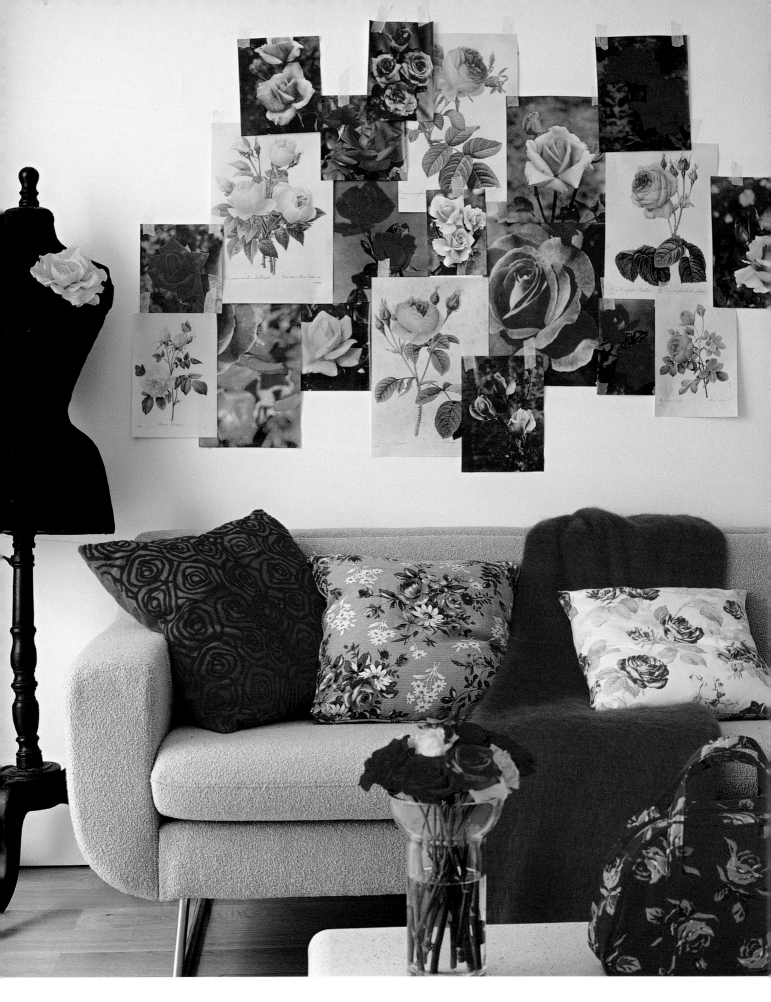

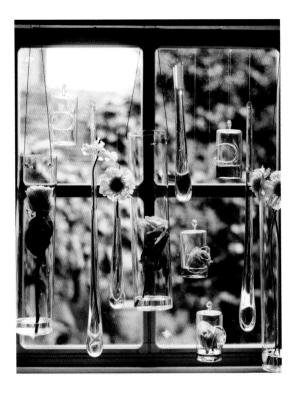

framed florals

Decorating your walls with floral pictures is one of the easiest and most effective way of introducing a botanical feel into your interiors. In addition, the wide range of choices enables you to create a variety of different looks—from sprawling montages that cover a single wall to delicate oils dotted around the room.

If you want to evoke a sense of feminine nostalgia, opt for watercolors from the mid- to late-Victorian era. Featuring spontaneous still lifes, which unfold across the canvas in an apparently random manner, antique watercolors are displayed to best effect in plain gilt or elaborate gold leaf frames. Alternatively, opt for a colorful selection of flower prints by the great eighteenth-century French painter Pierre-Joseph Redouté, or choose contemporary pastels, which will enhance a delicate palette and compound the sense of fragility.

OPPOSITE This floral montage creates a soft focal point, and complements the modern lines of contemporary furnishings.
ABOVE Single blooms displayed in a series of suspended vases offer a unique alternative to more traditional displays.

WALL MONTAGE

If you want to feature different floral images in a montage that gels rather than jars, you should:
* Choose a variety of images, but stick to a single flower type (mixing poppies with petunias is seldom a good idea).
* Vary the size of the pictures.
* Feature no more than three different colors.
* Keep your montage free from the constraints of symmetry, in order to reflect the random appearance of botanicals.
* Overlap pictures to give a spontaneous feel.
* Juxtapose close-up shots with some full-size images.
* Finally, don't forget trial and error, which will always unearth a successful solution.

DRIED FLOWERS

Drying and preserving flowers is an excellent way of providing your home with natural decoration. It's also a fundamentally simple process, involving little more than picking flowers, stripping them of their leaves, and hanging them upside down to dry.
* Flowers and other plant materials for drying should be picked close to their prime.
* Always collect more material than needed, to allow for damage.
* Use only the most perfect forms. Poor shapes dry as poor shapes.
* Only use flowers free of insect and disease damage—this becomes more obvious after drying.

* Pick flowers when they are free of dew or rain. Place stems promptly in a container of water to prevent them from wilting while you're gathering other specimens.
* Flowers continue to open as they dry, so make sure florals are not fully open when picked.
* Tie flowers securely in bunches and hang upside down in a warm, dry location for two weeks.
* Use rubber bands to dry flowers, as stems shrink during drying.
* It is sometimes difficult to develop graceful lines when making dried flower arrangements. Therefore, look for branches and stems with sweeping curves or lines that will add distinctiveness to the arrangement. Curves can also be made by shaping the branches or stems into the desired positions while they dry.

SILK FLOWERS

Although real flowers breathe life and vitality into interiors, it's not always possible to furnish your home with a perennial display of brilliant blooms. Luckily, silk flowers offer a viable alternative to the real thing, thanks to their amazing ability to mimic the soft folds of genuine blooms. Faux florals are so realistic, it's often hard to distinguish between the real and the not-so-real (you can even have the petals sprayed with scent for extra authenticity) and they are available in literally hundreds of different varieties.

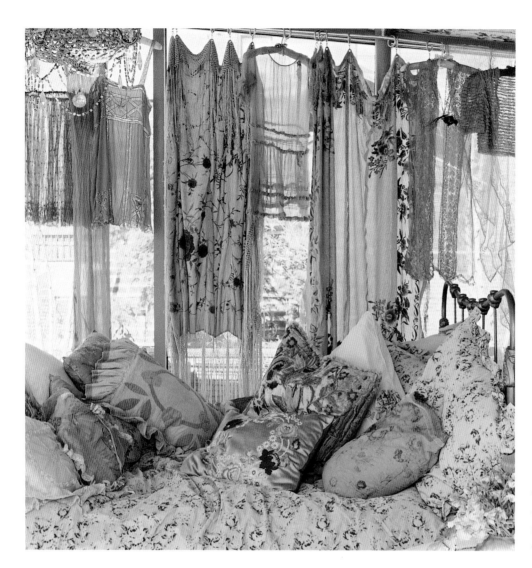

OPPOSITE Pink walls create an ultrafeminine boudoir. **LEFT** Mix and match fabrics for an eclectic feel.

bedrooms

Decorating with florals presents the perfect opportunity to create ultrafeminine flights of fancy. This is often most apparent in bedrooms, where the desire to create a dreamily romantic space can be hard to resist. And why should you sacrifice your minimalist principles to create a sigh-inducing sanctuary? Instead, choose florals that convey a subtle sense of femininity—and always remember: less is almost always more.

Whatever your tastes, your bedroom should convey a sense of ease and intimacy. This is the most personal space in the home, a peaceful retreat where you can reboot mind, body, and soul. Thus, the furniture and furnishings you select for this room should be cozily indulgent—

with the main emphasis on pleasingly soft curves, calming colors, and pretty prints.

It goes without saying that your bed is a key factor in the creation of a blissed-out boudoir; not only does a good night's sleep help to restore the spirits, but creating a comfortable nest is also paramount when you consider that we spend one third of our lives curled up under the duvet. As a result, purchasing a quality mattress is instrumental in achieving the best downtime possible. Size is also important: beds should be large enough—and luxurious enough—to spend the weekend in, with romantic styles ranging from curvy sleigh beds to magnificent four-posters and wonderful antique French *lits*.

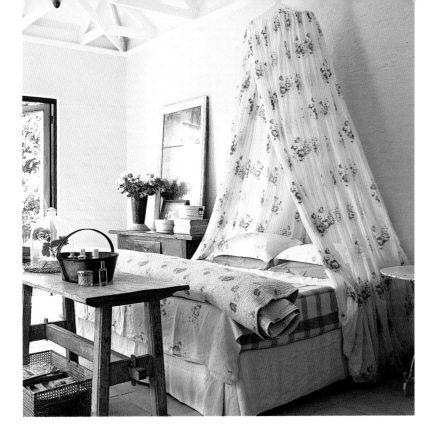

lush linens

Beds provide the perfect arena for showcasing
floral fabrics, allowing for the creation of
numerous different styles. If you want to keep
your look low-key, for example, simply combine
pale cotton or silk sheets with floral pillowcases
and leave it at that; alternatively, mix and match
darling buds with larger blooms, and top with
a satin comforter. For a sweetly feminine look,
twin bitsy sprigs with candy stripes, match
floral curtains with scatter cushions, or plump
vintage quilts on top of lace sheets.

One of the best ways to introduce texture
and warmth is to layer the bed with antique
fabrics—vintage eiderdowns combined with
age-softened linen sheets are a great way to
add a sense of timeless warmth, while a dotted
floral duvet teamed with an old-fashioned car
rug and a scattering of antique lace cushions
gives a romantic feel. To compound the romantic
look, drape lengths of muslin, voile, or net from
a ceiling corona or a tiara-shaped frame against
the back wall to create a dreamy canopy.
Whether it's plain white or patterned with
a vintage-style floral, muslin is the ultimate
in femininity and sophisticated romance.

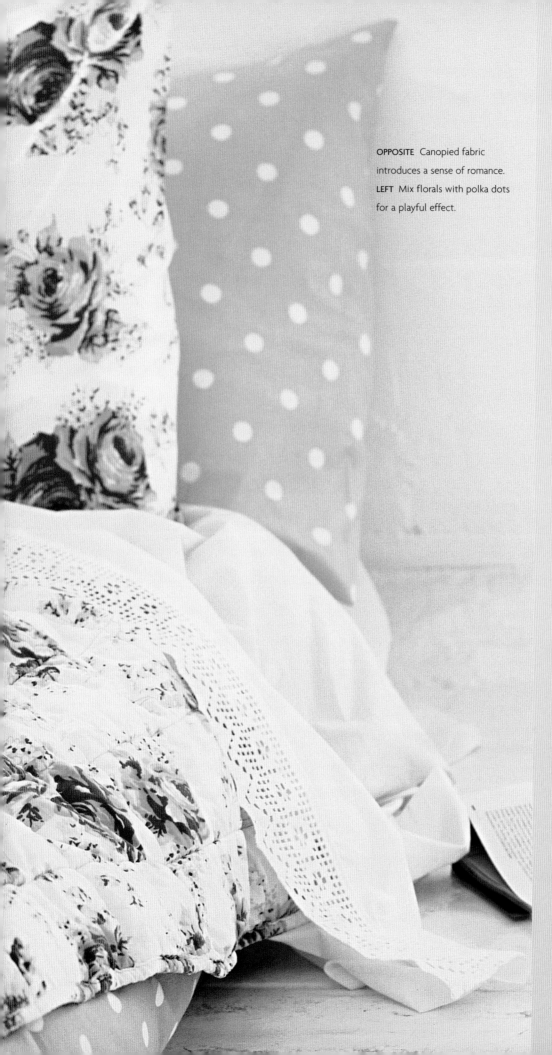

OPPOSITE Canopied fabric introduces a sense of romance. LEFT Mix florals with polka dots for a playful effect.

SCENTS OF SEDUCTION

If you want to enhance the sensual appeal of romantic-style boudoirs, opt for scents with floral notes:

❋ **Rose**
Universally recognized as the quintessential symbol of love, roses have been used to enhance moods for thousands of years; Cleopatra filled her bedroom knee-deep in rose petals to lure lover Mark Antony, while the Romans scattered rose petals on the bridal bed to reduce first-night nerves. The pungent aroma of crushed rose petals is believed to aid conception and also helps to lift the spirits. A small amount goes a long way—vaporize essential oil or light a rose-scented candle.

❋ **Jasmine**
Jasmine, with its sweet, slightly narcotic perfume, is very costly, primarily because large amounts of flowers are required to produce even a small amount of oil—the white flowers are gathered at night when the scent is more intense. Jasmine promotes relaxation and counters anxiety and depression; it also affects hormone production. It is best introduced in boudoirs in scented candles and incense sticks.

❋ **Ylang ylang**
The sweet perfume of ylang ylang ("flower of flowers") is believed to be an aphrodisiac because of its calming effect. Eastern women use it to perfume their hair as a prelude to amorous encounters. The essential oil comes from a small tropical tree native to the Philippines and Madagascar.

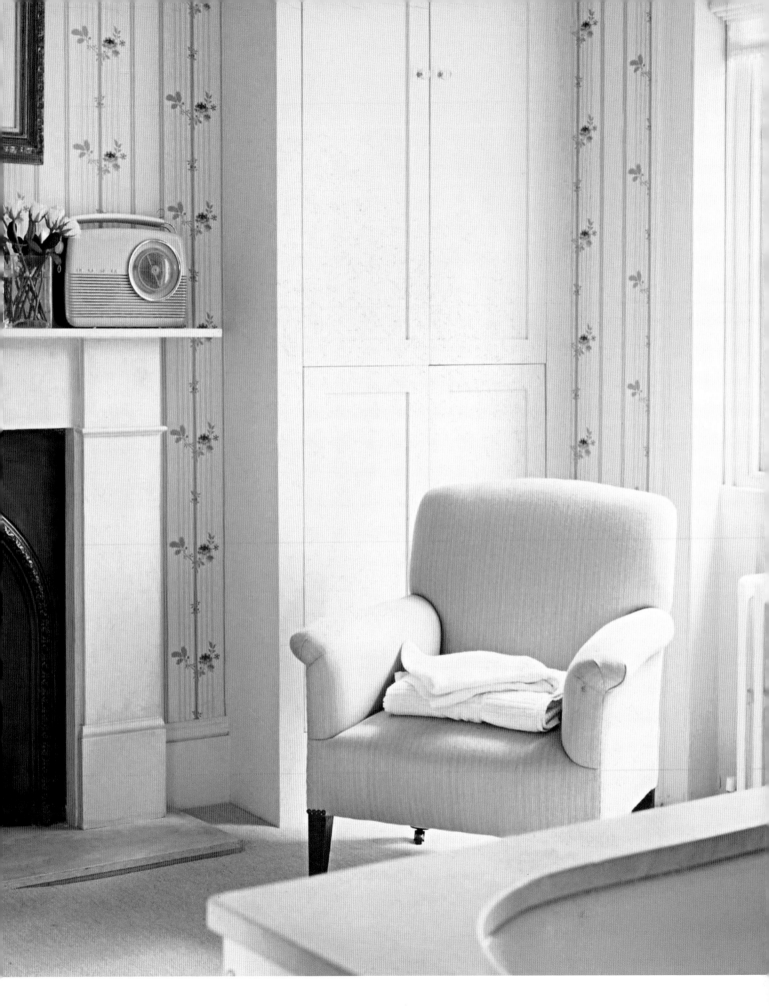

bathrooms

Often viewed as a functional space rather than a recreational one, the bathroom is frequently overlooked when it comes to decoration. Hard surfaces such as porcelain, chrome, mirror, and enamel can be off-putting, but macho materials can be easily balanced by softer, more feminine ones, helping to turn the most uninviting of washrooms into havens of peace and tranquility.

One way to soften bathroom fixtures and fittings is to include floral patterns that direct the eye away from sharp contours. A striking wallpaper depicting overblown cabbage roses, for example, is guaranteed to soften hard edges, while a funky shower curtain—frequently the bathroom's largest expanse of fabric—will also create a visual diversion. Floral fabrics introduce color and texture into potentially sterile spaces. While flowery curtains work well in larger, country-style bathrooms, roller blinds are better suited to smaller spaces, and can be easily assembled from ready-to-assemble kits. You can use almost any cotton or linen, so long as you treat it with a stiffening spray.

If you're fortunate enough to have a large bathroom, use the space to create a softer, less hard-working environment. Capacious chairs with slipcovers in cozy toweling or hard-wearing denim are ideal for providing a relaxed, loungelike feel, while floral-print upholstery can dress up wicker sofas, stools, and ottomans.

Area rugs are ideal for larger spaces, helping to introduce softness and warmth, while the new ranges of vinyl tiles—funky squares depicting photographic roses, daisies, and grass, for example—can brighten up smaller spaces.

Details make or break a bathroom. Install Victorian-style floral basins and bathtubs (either reproductions or those bought from reclamation yards) and add matching splashback tiles. Add floral trims to towels and line linen baskets with pretty sprigs. You could also put a flowered curtain around your washstand, hang floral-print laundry bags on the back of the door, and place pungent soap on petal-shaped dishes.

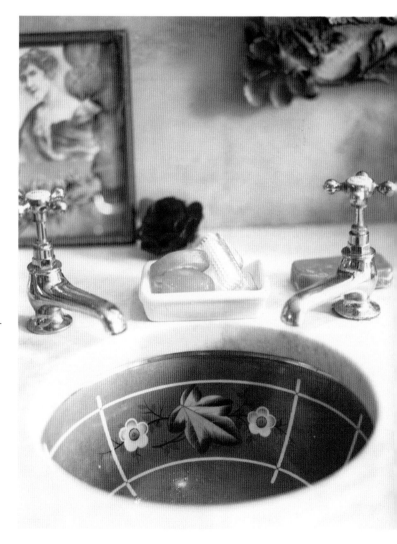

> **TIP:** A simple way to enjoy a scented bath is to wrap fragrant herbs and flowers inside a piece of muslin, tie it with string, and hang it from the faucets in running water. For a relaxing soak, try camomile or lavender.

OPPOSITE Spriggy wallpaper and an invitingly comfortable armchair soften minimalist lines.

RIGHT A pretty floral basin is the ultimate feminine fixture.

simple chic

Elegant and understated, simple chic celebrates the beauty of imperfection, and calls to mind grand European houses where the aura of old money is witnessed by faded velvets, threadbare carpets, and peeling paint. This lack of ostentation is also popular on the east coast of America, where beach houses in the Hamptons sport a similarly timeworn aesthetic. Indeed, the faded grandeur of simple chic can be easily incorporated into a variety of different styles, so long as various ground rules are strictly adhered to. Furniture should either be handed down through the generations or sourced from flea markets, for example, while floral motifs could range from overblown blooms to bitsy buds. The simple chic palette is also integral to the look, featuring sea and sky colors and lashings of white.

LEFT Floral fabric swatches depicting tiny buds and a single overblown bloom create a suitably relaxed feel.
OPPOSITE Floral wallpaper, mismatched furnishings, and untreated wooden floorboards are the staples of simple chic style, while the delicate candelabra and ornate mirror add an appealing sense of antiquity.

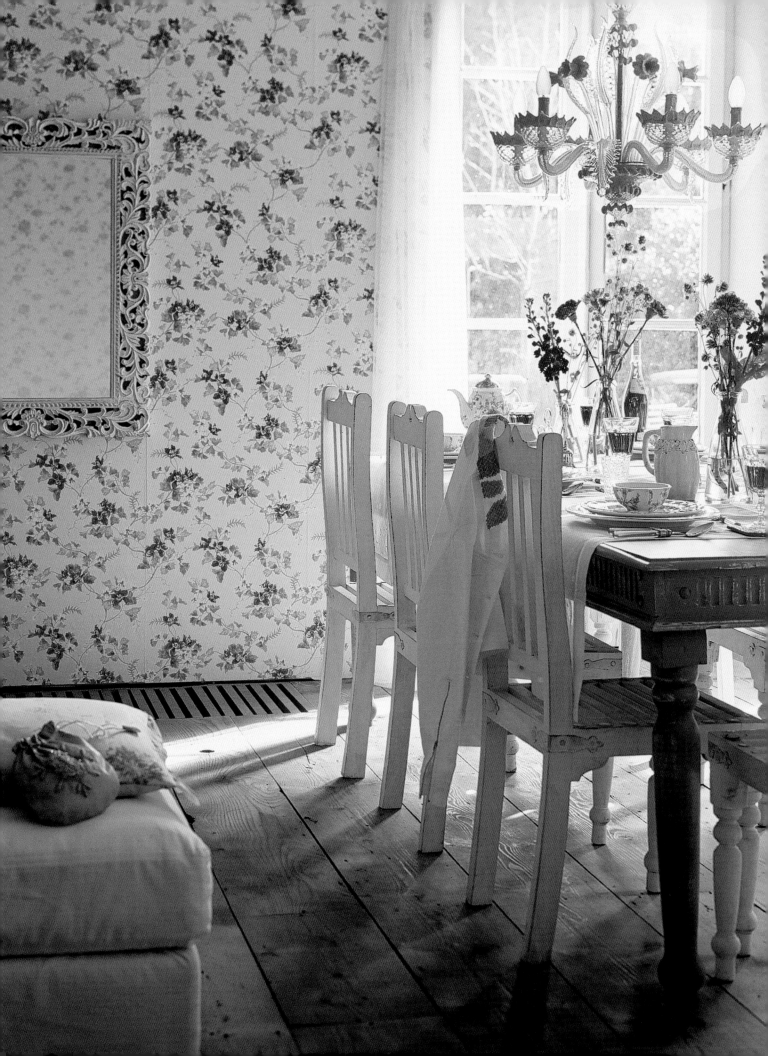

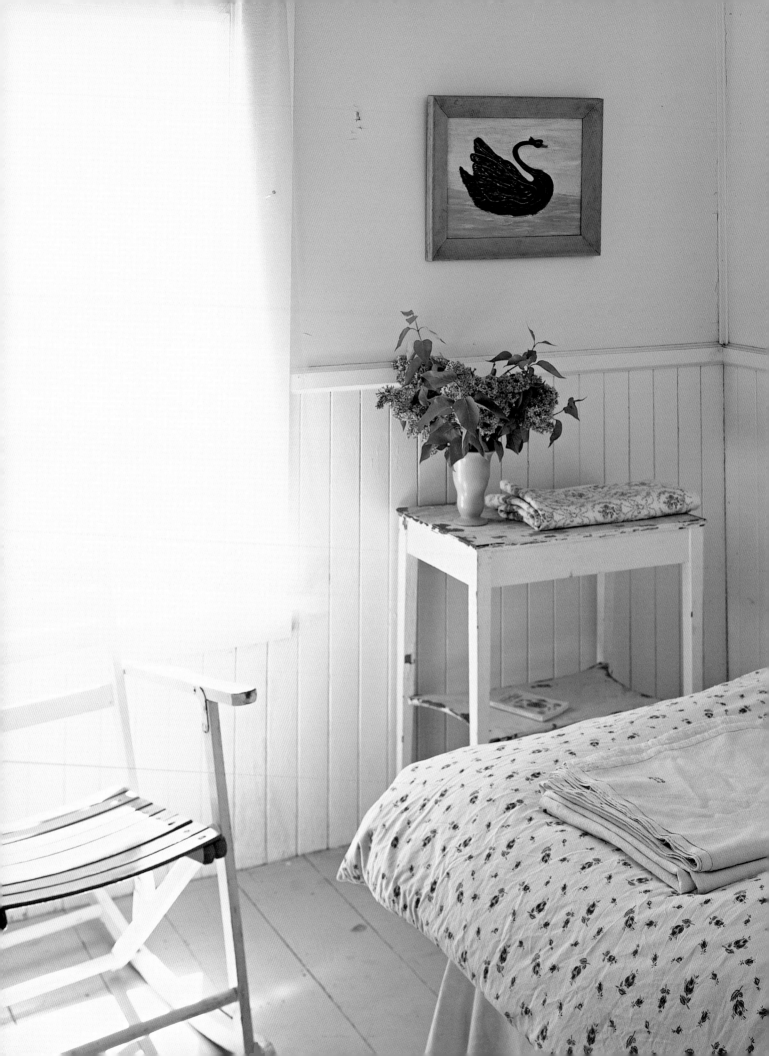

delightfully dilapidated

To create a home that's delightfully dilapidated, it's essential that your furniture and furnishings be imbued with a sense of soul; simple chic is not a look you can buy off the shelf, but rather an eclectic furnishing style that should naturally evolve over a number of years.

This relaxed style works best in rooms that are light, bright, and clutter-free. Start by painting the walls a space-enhancing shade such as duck-egg blue, wild rose, or mint green, and follow by ensuring that your flooring is both neutral and natural—stripped boards, pale carpeting, and coir matting are all perfect. Then you can introduce those carefully considered floristic elements that give a feminine feel. The arrangement of a bunch of overblown white garden roses in a creamware bowl, its glaze mottled with age, the rose petals dropping onto the chipped surface of a painted white side table, is both effortless and elegant—an object lesson in simple chic. Archival botanical illustrations taken from old books can be pinned casually to a wall or used to line the back of a dresser. Anything that has something of a history about it will fit right in. Although accessories play an important part in making the simple chic home feel warm and inviting, they rarely take center stage. Instead, decorative additions look as though they've been casually thrown together rather than carefully arranged.

Another way to compound the sense of informal ease is to dress windows with ultrasimple curtains or blinds in a neatly sprigged pattern—a space-enhancing trick that has the added benefit of looking effortlessly stylish. If your rooms are well proportioned and have large windows, create a sumptuous effect by draping the tops of windows with generous swaths of fabric with a twining motif of honeysuckle or rambling roses, so that they fall to the floor in a luxuriant puddle. Light fixtures are similarly informal, and range from grand chandeliers—it doesn't matter if you're missing a few crystal drops—to slightly battered metal wall sconces in a stylized floral design.

Furniture has two defining features—it is both elegantly scruffy and singularly comfy. Distressed wooden tables and paint-chipped daybeds sit alongside squashy sofas and oversized armchairs. Soft furnishings are often shrouded with divinely rumpled slipcovers with a faded floral motif—another simple chic staple—which help to disguise a multitude of sins, from ugly lines to garishly patterned upholstery.

OPPOSITE Matchboard half-height paneling and delicate pastels create a charming beach-house feel.
BELOW An eclectic display of ornaments gathered in front of a mirror completes the laid-back ambience.

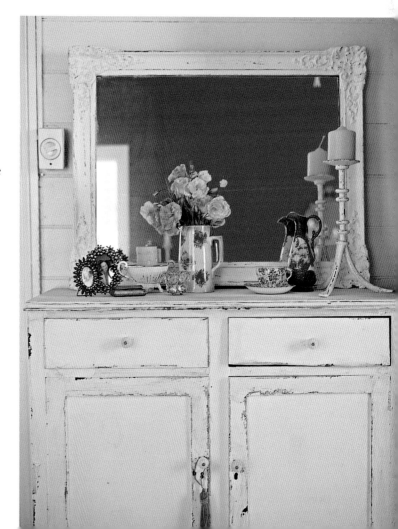

make do and mend

One of the joys of trekking around antique fairs is spotting the potential of simple chic furnishings, and working out what can be revamped and what can't. Badly broken wicker and severely mottled mirrors fall into the latter category, while salvage items such as dining chairs are worth investing in, as finding a matching set—of anything—is rarely a priority in the simple chic home. That said, it's advisable to look for similarity in height and design, and to make sure that chairs are sturdy enough to take your weight. Drop-in seat bases are another thing to keep an eye out for, as removable seats are much easier to re-cover

than ones you cannot take out. You could harmonize your whole set by using the same floral print for each seat cover, or use a bouquet of different blooms to give each chair an individual character. For a truly feminine floral feel you could make tie-on chair backs to match the seat covers—this technique works equally well with traditional ladder-back chairs with woven-rush seats.

It's not difficult to breathe new life and a little feminine flair into items sourced secondhand—all you need is a bit of imagination and a degree of decorative skill. For example, you can jazz up dilapidated dressers by adding decorative drawer knobs in jewel-bright glass in the shape of individual flower heads, or line the interior of a battered old leather trunk with a cotton floral, using drawing pins or fabric glue to secure it. A lick of paint is a great cover-up for wicker and wrought iron, while damage on the flat surfaces of small side tables or chests of drawers can be hidden by a piece of floral fabric held in place by a slab of glass.

Similarly, if you fall in love with a secondhand armchair that has a couple of worn patches, cover them up with an attractive throw rather than go to the expense of getting the entire chair reupholstered. Or use a treasured piece of your favorite botanical print fabric to re-cover just certain sections of the chair, a trick that works well if the existing upholstery is a floral print in a complementary pattern or a simple geometric one, such as a stripe. Not only is this option much cheaper, but it also provides an additional layer of texture and color in a room, making your seating more of a feature, a statement of your own ownership.

LEFT Floral cushions liven up simple furnishings.
OPPOSITE Salvage items such as paint-chipped furniture complement old-fashioned wallpaper designs.

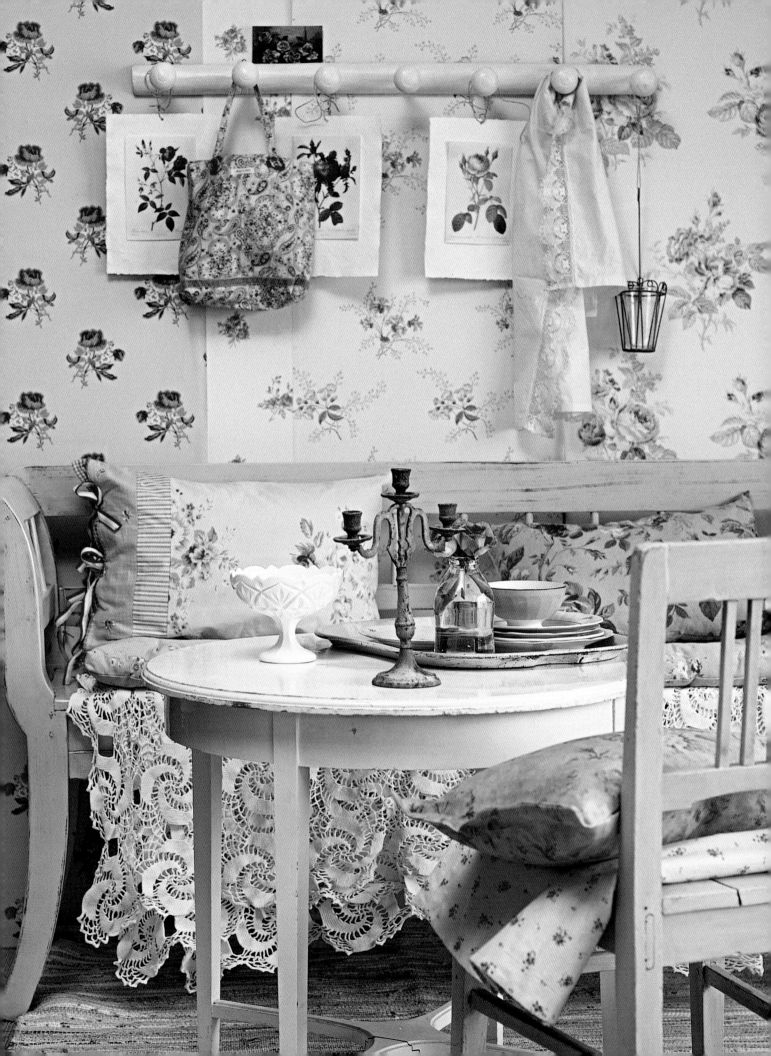

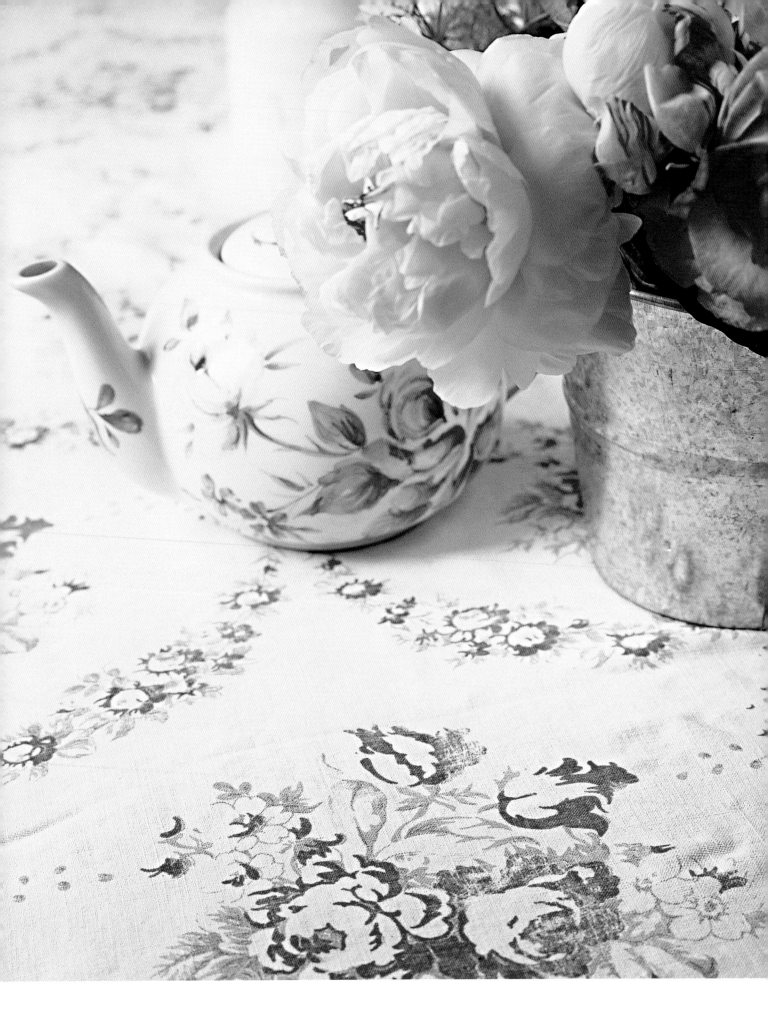

pretty prints

Faded floral fabrics are an integral part of the simple chic interior, and provide the perfect complement to white-painted furniture, neutral floors, and pastel walls. Ranging from overblown roses to bitsy buds, and set against soothing backgrounds of sea-green, silver-gray, and old-rose pink, they should be as softly appealing as a much-faded pair of jeans.

Because they're so subtle, faded florals can be used on a wide variety of furnishings without appearing too overpowering. Better still, thanks to the vogue for prints that have been purposefully drained of color, there are numerous designs to choose from. Whether you opt for a pattern from one of the new ranges of deliberately faded florals, or a vintage piece that's been genuinely sunbleached, it's advisable to take a few swatches home before making a commitment. This way, you can judge whether the color looks different in the light of your home or against your walls, as well as note how well it goes with other patterns and designs, including checks and stripes.

Fabric is one of the most striking ways to create ambience in a room, so you need to decide on the mood you want to create, and then experiment with fabric swatches, colors, and patterns to see what works best. For a girlish look, team faded florals with mirrored furniture and botanical prints, or combine with tongue-and-groove to create a beach-house feel. If you want a fresh, pretty feel, mix faded florals with cut flowers and lots of pastel-painted furniture. (For best results, use eggshell paint, which has just enough sheen to be practical and washable, but avoids the over-bright glare of gloss.)

OPPOSITE A floral tablecloth is timelessly appealing.

ABOVE Tiny buds are the leitmotif of the simple chic style.

"ROSES ARE THE BEST PERFUME. THEY DON'T TAKE OVER A ROOM, THEY LAYER IT WITH SCENT." Carolyn Quartermaine, interior designer

living rooms

The living room is the main room in the house, and for this reason is likely to be a hub of social activity—a place where family and friends gather together to exchange news, gossip, and ideas. It is also a quiet room, where you can listen to music, talk on the phone, or simply cogitate on life. As a result, comfort and flexibility are key—helping to produce a chill-out zone that is as stylish as it is adaptable.

The best way to create a relaxed lounging area is to eschew the formality of three-piece suites in favor of more casual arrangements. An eclectic combination of individual seating in different shapes and sizes—from tub chairs to squashy sofas and elegant button-back styles—is much more welcoming than stiff, coordinated suites, and can also be reconfigured to suit a variety of different social events.

The simple chic living room is calm and balanced—a place where the flow of energy is unfettered by overkill on the furnishings front. Low seating and tables compound the loungelike vibe, as do nineteenth-century French metal daybeds, which look great with striped ticking mattresses and floral cushions. Leather furnishings also have a part to play in laid-back living rooms, thanks to their classic appearance and ability to age beautifully, while wicker, available in a variety of weaves, promotes a similarly relaxed feel and works well in a wide variety of surroundings.

TIP: Try flipping over a woven floral fabric. The underside can produce a wonderfully muted effect, perfect for that shabby look.

RIGHT Streamlined seating, lashings of white paint on floors and walls, and wide floorboards all contribute to the a sense of serenity in this fabulously spacious living area.

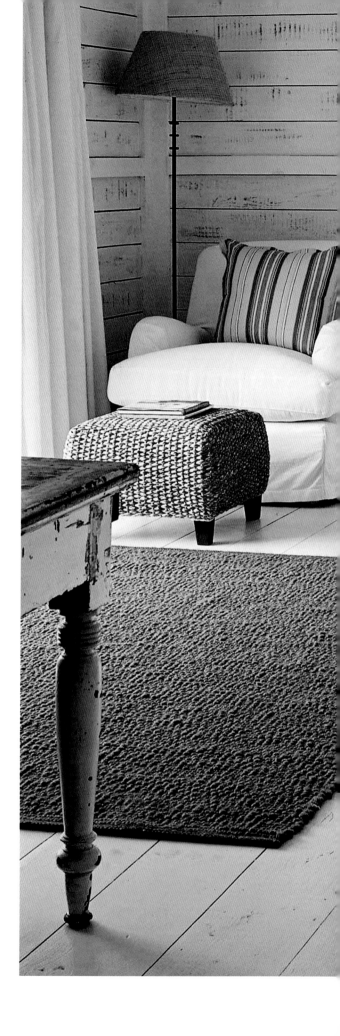

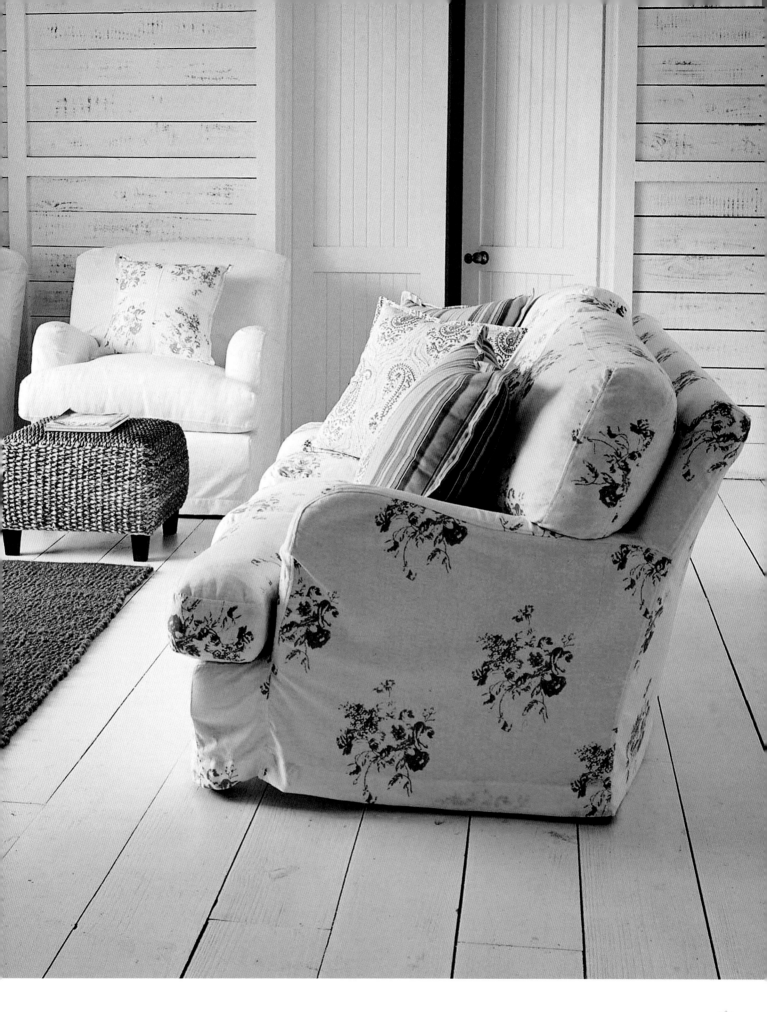

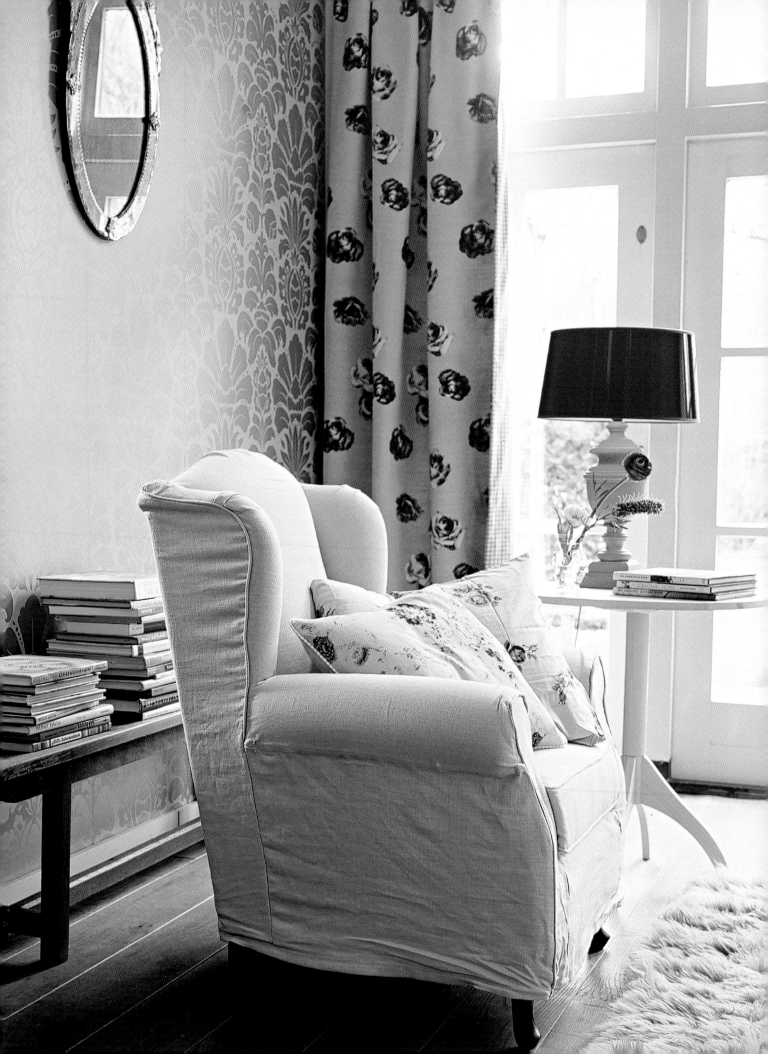

cool cover-ups

The epitome of simple chic style, slipcovered furniture is fashionable, functional, and fuss-free. Traditionally used to protect chairs from wear and tear—as well as to prevent upholstery from fading in the sun—cotton covers instantly transform the look of a room, introducing a casual elegance that matches the insouciance of simple chic style. Slipcovers are an excellent way of hiding a multitude of sins, helping to disguise garish patterns and extend the life of threadbare sofas at relatively little expense. They can also alter the appearance of furnishings so they fit a decorative agenda; for example, a cotton shift dramatically changes the proportions of a wicker sofa, helping it look heavier and more substantial, while a boxy club chair is transformed into an elegantly feminine seat following the addition of a slipcover with a pleated skirt.

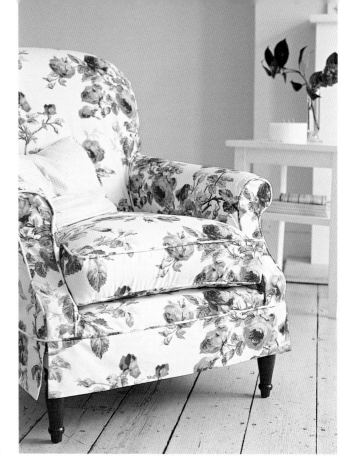

Fabric-wise, it's advisable to choose a closely woven medium-weight material that's capable of withstanding a lot of hard wear. In almost every instance, durable and easy-to-wash cotton is the best choice. Linen has an appealing texture, but pure linen wrinkles easily, so a linen–cotton blend is better. In addition, natural fibers such as linen and cotton cling to upholstery much more effectively than synthetics—and also hold their shape better. For an elegantly draped effect, choose light-weight velvets, moires, muslins, and poplins.

The fact that slipcovers can be taken off and washed adds to their appeal—repeated exposure to soap and water makes them look, and feel, increasingly tactile. Denim, in particular, responds well, as do chenilles and chintzes, which lose their stiffness, becoming softer and less shiny. But remember, before any natural fabric is sewn up, it should be preshrunk, otherwise you may discover that your covers are suddenly too snug after their first laundering.

Whether you choose to cover your furniture in patterned or plain slipcovers is, of course, dependent on personal taste. Pale cotton covers sporting a splashy floral print will certainly add a dash of individuality, while opting for plain covers gives you the perfect excuse to include a barrage of blooming cushions; it's also possible to balance out a profusion of florals with one or two chairs covered in a color pulled from the print. If you decide to use neutral fabrics, you can add interest through texture—quilted cotton, damask, and linen all provide tactile variety, for example. Upholstering furniture in a pale color also means that you need to make sure the existing upholstery fabric is paler than your slipcover, or it will show through.

Although this look promotes furnishings with a minimum of embellishment, it is possible to incorporate a few decorative flourishes without compromising the plain-Jane premise. Variations on the basic slipcover shape include skirts with boxed or kick pleats, ruffles, double ruffles, and flanges.

OPPOSITE Furniture slipcovered in neutral linen imbues chill-out zones with a homely feel.

ABOVE A floral armchair looks best in a plain room.

eating areas

The simple chic dining experience is an informal affair in which enjoyment is prized over etiquette. Tables tend to be large and scuffed as opposed to neat and gleaming, and seating is comfortable, although not necessarily uniform—Lloyd Loom wicker chairs can be teamed alongside wrought iron garden seats, while small folding stools complement long wooden benches. Just remember to soften hard seats with floral pads, cushions, and throws.

While the timeworn patina of beautifully shabby tables deserves to be shown off, antique cloths also have a role to play. Darned and patched white linen is the smart option, while cotton styles trimmed with delicate lace provide the perfect setting for floral plates and silver tea sets. Patterned sheets, or any other length of fabric, also make excellent table covers—sun-faded florals look particularly pretty, as do plain cloths with embroidered or appliquéd flowers. Even plasticized cottons or waxed oilcloths are bearable, since there is now such an attractive variety of floral designs to choose from.

Informal table settings are a key feature in the dining arena, offering myriad decorating choices. To create textural contrast, mix a hodgepodge of china, glass, and silver on a rough tabletop, or combine dainty floral teaware with hessian placemats and chunky candles. For an ultrafeminine look, scatter an antique tablecloth with petals freshly gathered from the garden and add a selection of smooth white porcelain. Alternatively, place milky white china on a crisp, lace-trimmed tablecloth for a charming old-fashioned feel.

China exerts the greatest impact on table settings—allowing you to create your own personal style from a wide array of different styles. Ideas include mixing the same floral pattern but in different groups of colors, or mixing and matching completely different patterns for a wildly whimsical effect. Another idea is to collect different pieces in the same color—dusty rose, for example—so that you end up with an eclectic set of different plates, bowls, and cups, all in the same faded pink.

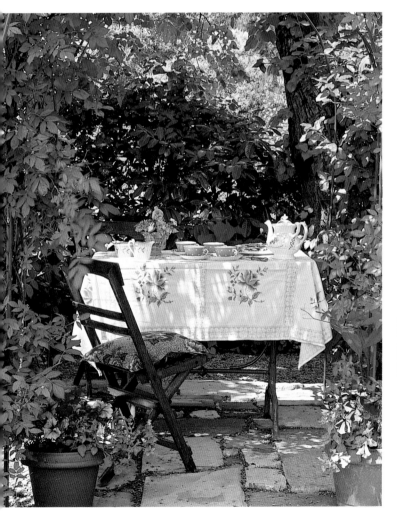

TIP: When buying china, look for pieces with elegant flowing lines; a good shape enhances all designs, regardless of color or pattern.

LEFT An iron garden table is softened by a floral cloth and mismatched china.

OPPOSITE White paint unifies the utilitarian table and chairs, while the striped ceramics provide a nice complement to the white plates, glass tumblers, and flowery cloth.

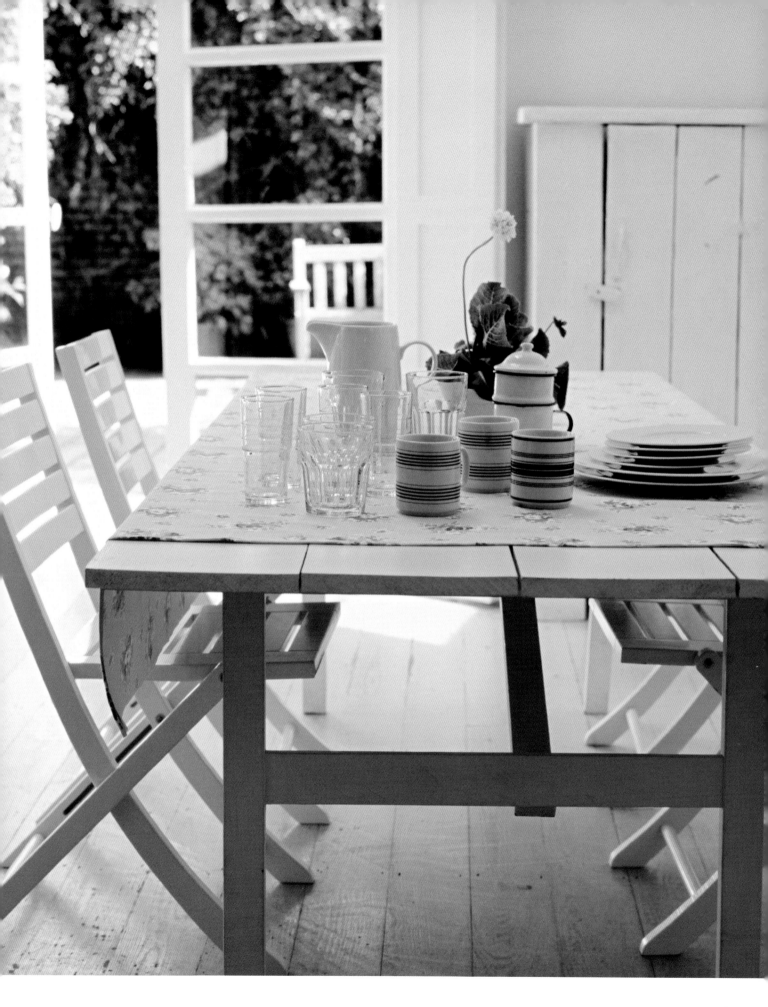

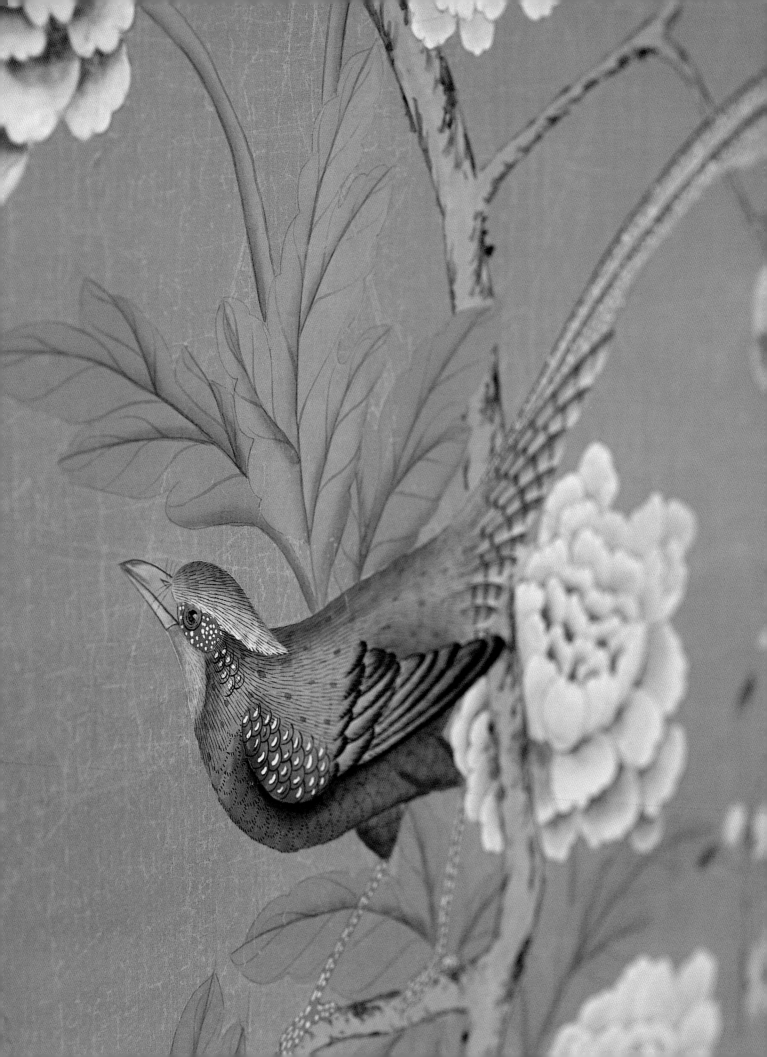

exotic florals

Although fitting your home with exotic furnishings is hardly a new concept (westerners have been importing silver, porcelain, and lacquerware from the east since Roman times), it is an undeniably rewarding one, providing the opportunity to create interiors that are every bit as dramatic as they are distinctive.

Whether you favor the sleek modernity of **ASIAN GLAMOR** or the itinerant appeal of **GLOBAL CHIC**, exotic decor imbues rooms with a sense of immediacy, offering a vibrant alternative to the toning taupes and clean contours of modern minimalism. Vivid patterns and jewel-bright colors add a life-affirming feel while touchy-feely fabrics introduce textural interest. To complete the worldly effect, introduce a selection of authentic global accessories.

Not surprisingly, florals fit the exotic profile perfectly—with cultural motifs ranging from stylized Indian roses to Chinese lotus blossoms and Caribbean hibiscus. Best suited to **BEDROOMS** and **DENS**, exotic florals can also brighten transitional areas such as hallways and stairs.

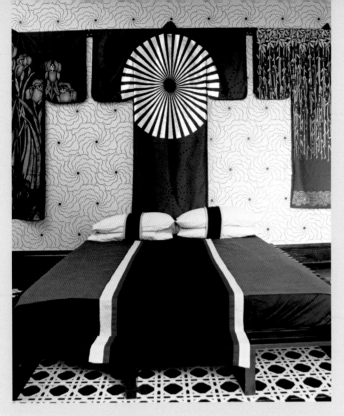

LEFT Japanese kimonos make beautiful wallhangings and soften the linear decor of this bedroom.

OPPOSITE A Shoji panel, a Japanese tea set, and some magnolia branches give this modern interior an eastern feel.

fusing east and west

A far cry from the practice in Victorian times, when furnishing your home in "exotic" style basically meant overkill on the chinoiserie front, today's interpretation places its emphasis on fusing different design elements from around the world. Particularly appealing to those cool itinerant types who favor impromptu interiors over planned ones, furnishing your home with a vibrant cultural mix allows for liberated design schemes that juxtapose east with west and north with south to evoke feelings of warmth and spontaneity.

One of the main advantages of decorating with modern exotica is the ease with which you can pull off the look. Requiring significantly less time and effort than other design styles, its mix-and-match approach allows for a relaxed, almost-thrown-together look that can be as rambunctious or as restrained as you like. For example, a Javanese daybed scattered with kilim cushions will lend a genuinely ethnic ambience and set the tone for the whole room, while something as simple as a fringed shawl draped over a side table gives a semi-ethnic feel without compromising the western aesthetic.

Opting for a global palette will also infuse interiors with a faraway feel. Mix fuchsia and scarlet with threads of gold for a sense of modern exotica, or combine dark earthy hues for a spicy oriental feel. Team purples, reds and browns with modern furnishings for a modern hippie vibe, or fuse eye-popping Caribbean shades in magenta, ultramarine, and yellow to conjure a sense of island life.

Like color, fabric can instantly change the mood of a room, introducing warmth, pattern, and texture. It is a key feature in the creation of exotic interiors, and you can choose from a wide range of global styles, including brilliant lengths of sari silk, Indonesian batiks, Japanese kimonos, and Chinese chintz. Unsurprisingly, florals are a central motif in exotic interiors, imbuing interiors with an organic energy that compounds the sense of vibrancy.

TIP: Add potted orchids or sprays of blossoms to enhance an oriental theme. Cut orchids last for up to two weeks, as long as you remember to recut the stems.

"I' THE EAST, MY PLEASURE LIES." William Shakespeare

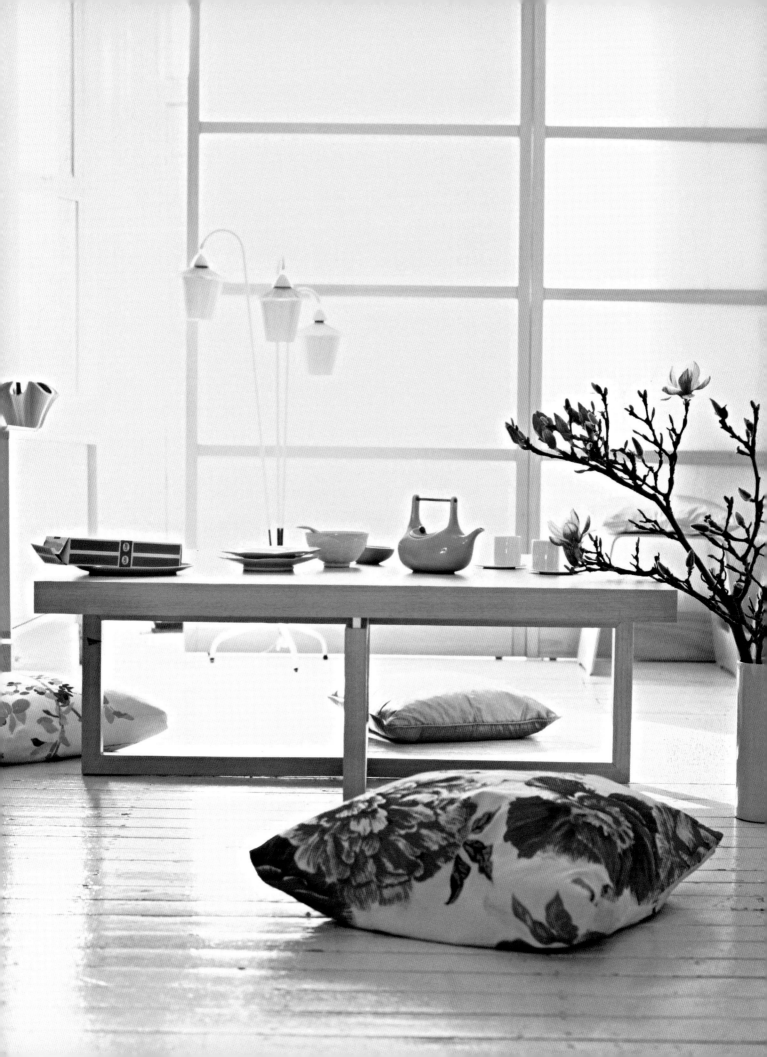

asian glamor

Although delicate vases and glossy lacquerware have been imported from the east since Roman times, it was not until the sixteenth century that trading links between Europe and Asia saw an influx of brightly colored textiles. From China came resplendent silks embroidered with lustrous metallic threads, while India exported pretty, block-printed cottons that could be washed without losing their vibrancy.

Furnishing your home with orientalia is still popular, although the modern interpretation is sharper and more streamlined than the intricate styles of yesteryear. Particularly favored by fans of color and pattern, Asian style incorporates shining silks, flamboyant florals, quirky accessories, and ambient lighting.

LEFT The stylized blooms commonly depicted on eastern fabrics are a quintessential feature of exotic interiors, adding a faintly graphic feel rather than a naturalistic one.
OPPOSITE A mix of floral prints gives this room a bohemian feel, while the classical statue provides a quirky contrast.

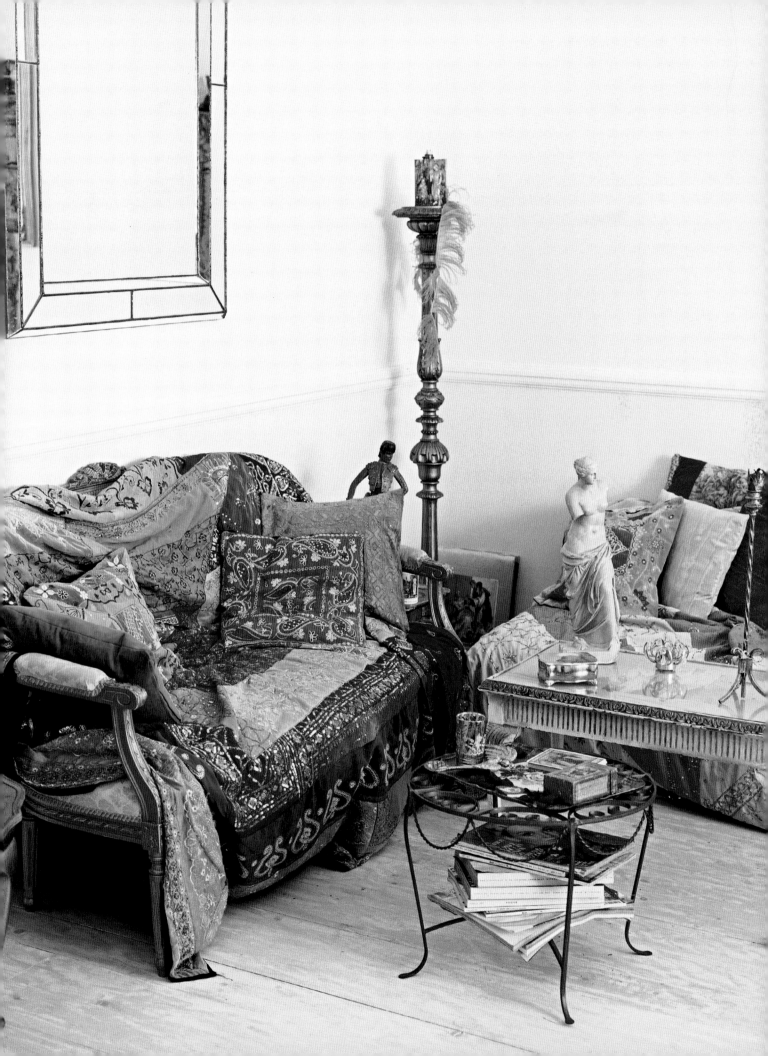

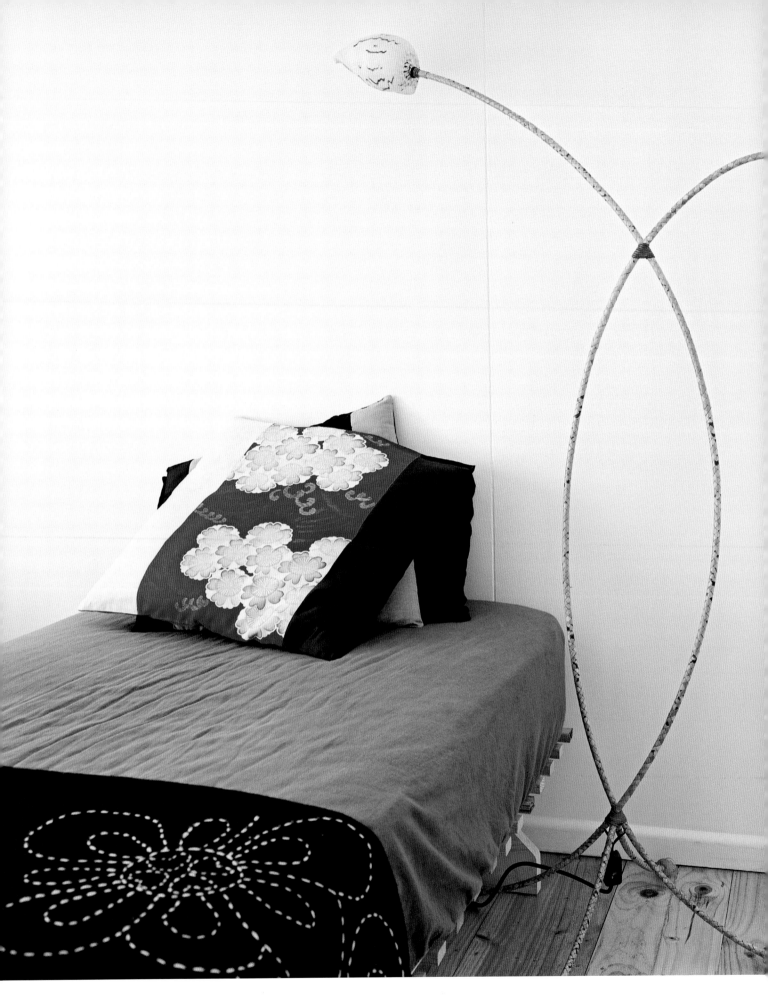

OPPOSITE A combination of red, black, and white introduces a sense of exotica. **LEFT** Prop a Chinese panel depicting cherry blossoms on a dark wood mantel for a contemporary eastern look.

oriental colors

While the Chinese view red as the color of happiness, westerners have always been wary of its aggressive connotations, fearing that an overkill of scarlet in the home will stir up feelings of anger and resentment. Certainly, red has received its fair share of bad press over the years—though more on psychological grounds than aesthetic ones—with design gurus warning that having a red-painted bedroom, for example, is likely to cause nightmares, as well as stir up arguments with your partner.

Without a doubt, introducing brilliant swaths of red into your interior is not for the fainthearted. However, there are numerous shades of this fabulously rich hue—from cherry to cinnabar and burnt umber to brick—that will guarantee a vibrant color injection without

appearing dramatically over the top. In addition, the seductive properties of fiery shades help to create a womblike feel, imbuing your interior with a sense of coziness and warmth.

Another way to incorporate red into your interior successfully is by teaming it up with similarly striking shades. The dynamic pairing of red and black has prevailed in eastern design schemes for centuries, and it can be given a modern slant by adding gray to the mix, while red and gold offer a slick sense of exoticism that cannot be rivaled. It's also possible to introduce exotic hues through a handful of carefully chosen accessories. For example, an emerald wallhanging will perk up a room in an instant, while a black lacquer stool or scarlet lamp shade will compound the look.

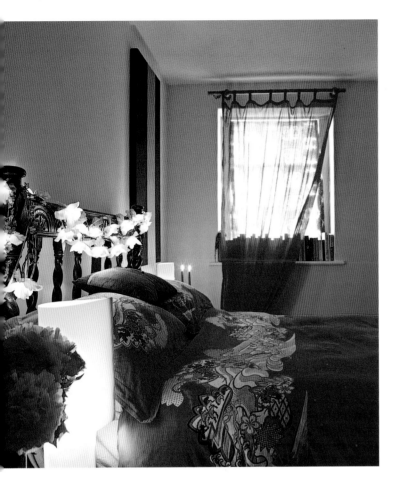

low lighting

Integral to Asian decor, ambient lighting creates a seductive aura that helps to compound the laid-back, lounglike vibe. For best results, eschew the stark illuminations of modern track lighting in favor of a variety of different light sources, which will create a series of glowing focal points around the room. It's also advisable to replace halogen spotlights, which tend to be too harsh for exotic design schemes, with softer, pendent styles that will emit a more subtle glow.

As a general rule of thumb, traditional lighting styles work best in exotic interiors, introducing a calming complement to the bright colors and vivid patterns of oriental decor. That said, a contemporary–modern mix also works well, helping to compound the eclectic feel. A quirky or unusual light fixture adds an element of surprise, for example, and can help to provide a stylish contrast to more pedestrian styles used elsewhere.

For the most soothing illuminations, choose hanging lanterns, pendants, or simple floor and table lamps. Not only do fixtures such as these cast intriguing pools of light and shadow, they can also be individually controlled, allowing you to match your mood to your lighting. To enrich a vibrant decorative scheme, opt for wall lights, which create intense pools of color in the surrounding area. To compound the atmospheric feel, use low-wattage bulbs, to make saturated shades appear deeper and more luminous.

Colored lighting is another option in exotic interiors, evoking a seductive feel that is in keeping with Asian-style interiors. On a practical level, colored lighting is also an extremely effective way of brightening up dingy corners, hallways, and passages. Choose traditional Chinese paper lanterns, patterned with bright florals in shades of pink, yellow, red, and green, or suspend a string of multicolored fairy lights along a mantelpiece to create a playful party feel everyday.

As is the case with a variety of decorative schemes, candlelight provides the most ambient of all illuminations—its flickering shadows evoking feelings of mystery and depth. For the best results, cluster groups of candles together to create a feeling of spiritual intimacy, or place them in colored-glass lanterns, so that they glow like a cache of exotic jewels.

> **TIP:** Compound the seductive ambience of a moodily lit interior by burning candles fragranced with eastern-inspired scents such as jasmine, orange blossom, frangipani, honeysuckle, and lily-of-the-valley.

ABOVE LEFT A string of fairy lights threaded through the bars of a wrought iron headboard give this glamorous boudoir a seductively ambient glow.

OPPOSITE Delicate floral motifs combined with a spot of calligraphy make for a pretty light fixture.

"THE KEY TO ORIENTAL STYLE IS TO CREATE A SIMPLE

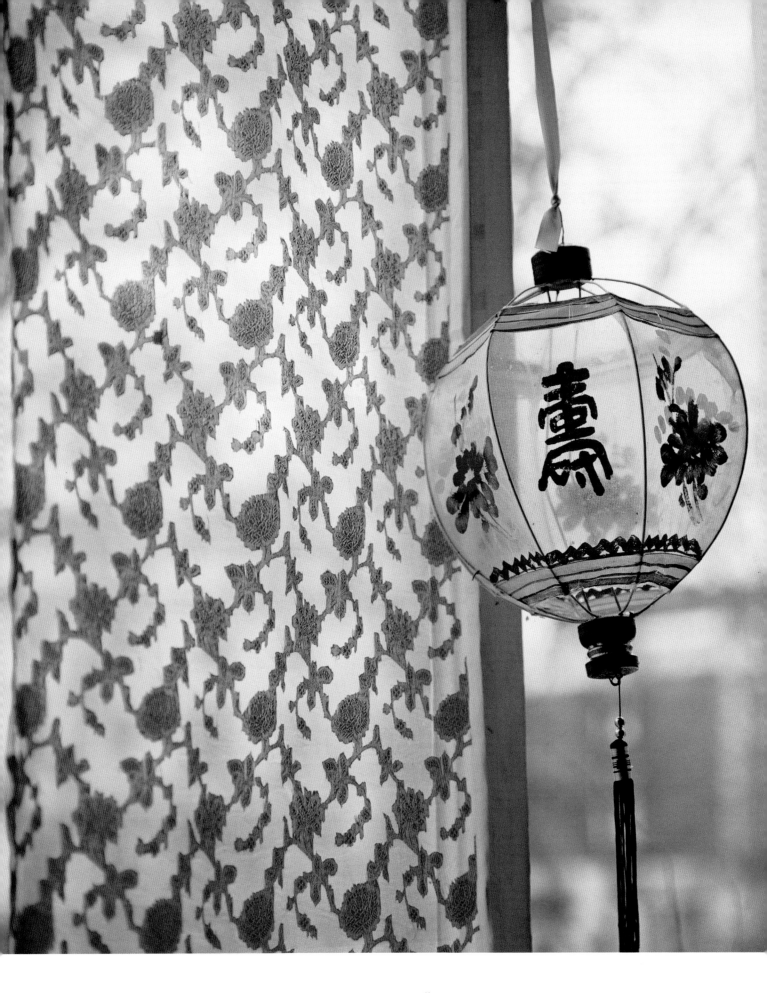

BACKGROUND AND THEN ADD CONTRAST." Kelly Hoppen, interior designer

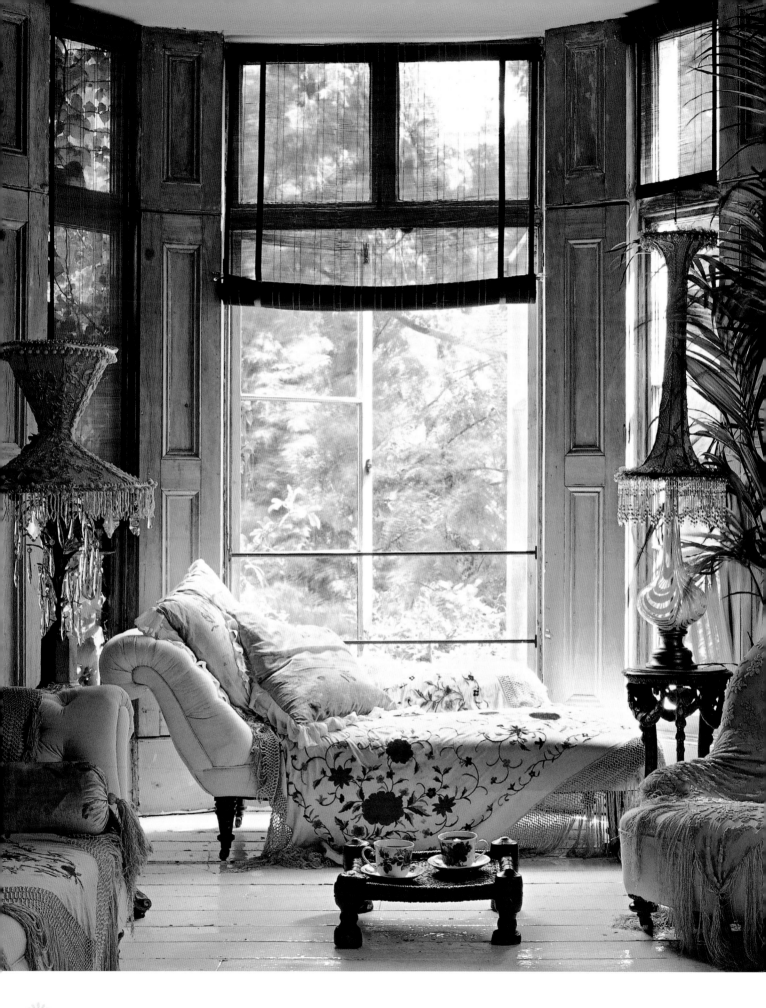

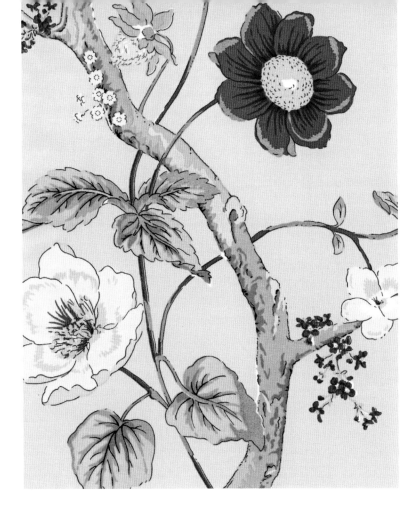

flowers of India

Often cited as one of the most original and creative sources of patterned textiles in the world, the Indian subcontinent has been exporting fabrics to Europe and the United States for hundreds of years. Placing an emphasis on exuberant, brightly colored designs, India's love affair with botanical patterns is an integral part of domestic life—with an exquisite profusion of floral decoration adorning textiles, floor tiles, rugs, stonework, furniture, and architecture. To recreate a similar sense of abundance in your own home, choose fabrics and furnishings emblazoned with traditional Indian motifs such as tulips, lotus blossoms, and flowers from the Tree of Life.

OPPOSITE Draped Indian shawls give the furniture in this elegant drawing room a wonderfully bohemian feel.
ABOVE Chintz has remained a popular furnishing fabric in Europe and America over the past 300 years.

CHINTZ

Chintz was first introduced to the west from the East Indies during the seventeenth century. Its dazzling floral imagery and brilliant colorfast hues provided a sense of otherworldliness that was hugely appealing, while its shiny, dust-repellent finish made it a popular choice for drapes and upholstery.

Not surprisingly, English and French textile manufacturers began to develop their own versions of the fabric. Although the new-look chintz continued to feature natural motifs, the original loosely depicted patterns of flamboyant florals and exotic birds gradually evolved to include tighter formations of cottage garden blooms such as roses, daisies, sweet peas, tulips, and carnations.

Today, there are chintz prints for every taste and decor, ranging from full-blown lilies to diminutive primroses. Additional patterns include romantic florals on delicately colored backgrounds and vibrant perennials set against one or two tones. The original chintz designs of the seventeenth and eighteenth centuries are still a ubiquitous feature in many modern interiors—their mellow sunbleached appearance providing a warm lived-in feel that complements contemporary lifestyles. In fact, such is the demand for faded chintz designs that manufacturers are now artificially aging fabrics to look as though they've been around for hundreds of years.

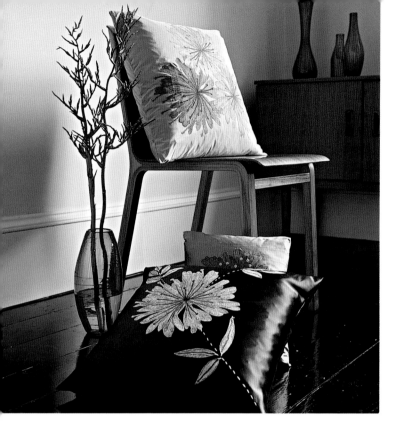

the silk route

Originally cultivated in China, silk became popular in western design schemes during the nineteenth century, when it was snapped up by homeowners keen to inject their interiors with some oriental glamor. Not surprisingly, silk furnishings were an instant hit—imbuing rooms with a sense of wanton luxury.

Silk introduces a sense of timeless opulence that compounds the extravagant feel of exotic design schemes. In addition, its inherent style defies changing trends in home furnishings, enabling it to work as effectively in modern interiors as it does in traditional ones.

Available in numerous exotic shades—from mandarin orange to emperor purple—silk fabrics often sport floral motifs. These range from printed styles, as witnessed on Japanese kimono silks, to the more intricate embroidery of Chinese fabrics. For a truly authentic feel, choose traditional florals that have been used to represent the seasons for hundreds of years. These include a combination of bamboo, pine, and plum blossoms for winter; iris or magnolia flowers for spring; peony or lotus blossoms for summer; and chrysanthemums for winter.

Embellished fabrics are also a key feature of Asian interiors, providing a decorative element that adds character and originality. Better still, there are numerous applied fabrics to choose from, including intricate designs that combine appliqué with patchwork, as well as embroidered motifs on a plain background.

You can also customize your own fabrics, thanks to the variety of decorative accessories available. Beads, buttons, and bows are available from haberdashers, while suppliers of Indian fabric sell a dazzling array of metallic threads, spangled trims, and different-size sequins. As well as helping to make embellishing your own soft furnishings gratifyingly accessible, this also cuts down on cost.

The best thing about embellishing fabrics is the fact that almost anyone can do it. Simple additions, such as tacking velvet ribbon along the edge of a throw, can be achieved by the most clumsy of seamstresses, while tacking felt flowers onto a woollen cushion is similarly straightforward. To embellish your fabrics with ethnic sparkle, decorate with beads, sequins, and glass buttons; alternatively, trim lengths of cloth with tassels, satin cord, or metallic ribbon to evoke a glittery harem feel.

> **TIP:** If silk is not to your taste, try one of its rich relations. Velvet introduces warmth and texture in a variety of shades, while devoré is similarly exotic, thanks to the chiffon floral patterns burned into its deep pile. For a textural feel, opt for damask, which sports fruit and flower motifs in an intricate weave, or multicolored brocade patterned with delicate chinoiserie blooms.

ABOVE LEFT Chrysanthemums have been a favored motif on Chinese silks for hundreds of years.

OPPOSITE Sari silk provides a romantic canopy for this magnificent gold and magenta bed.

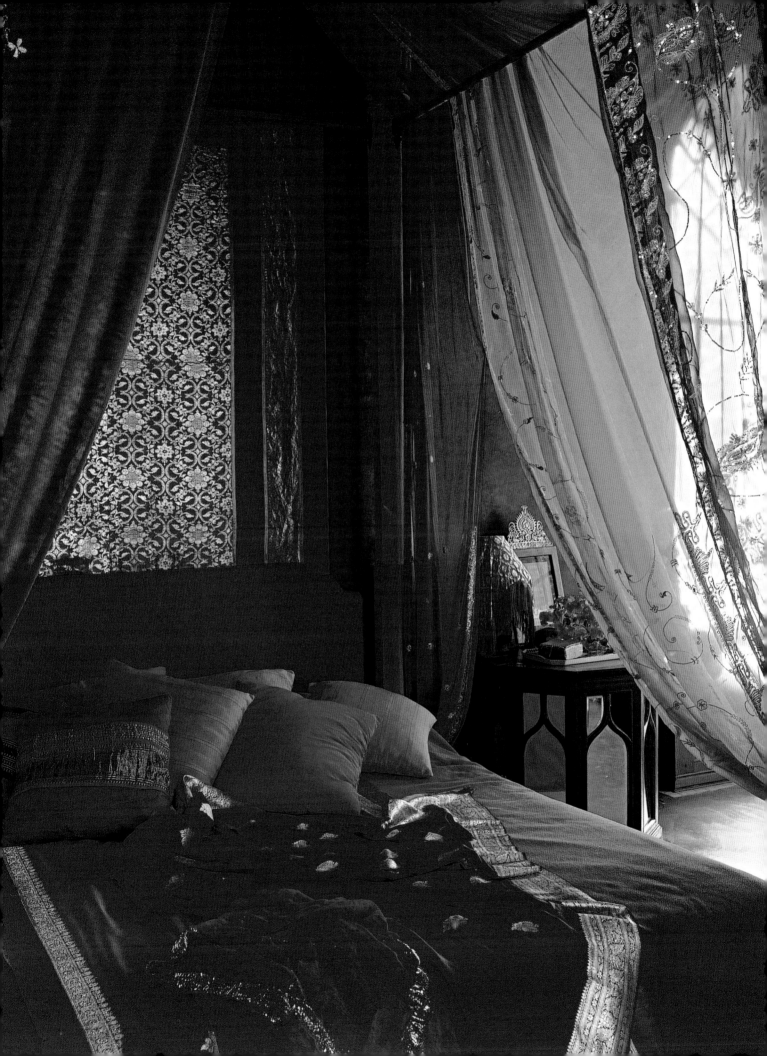

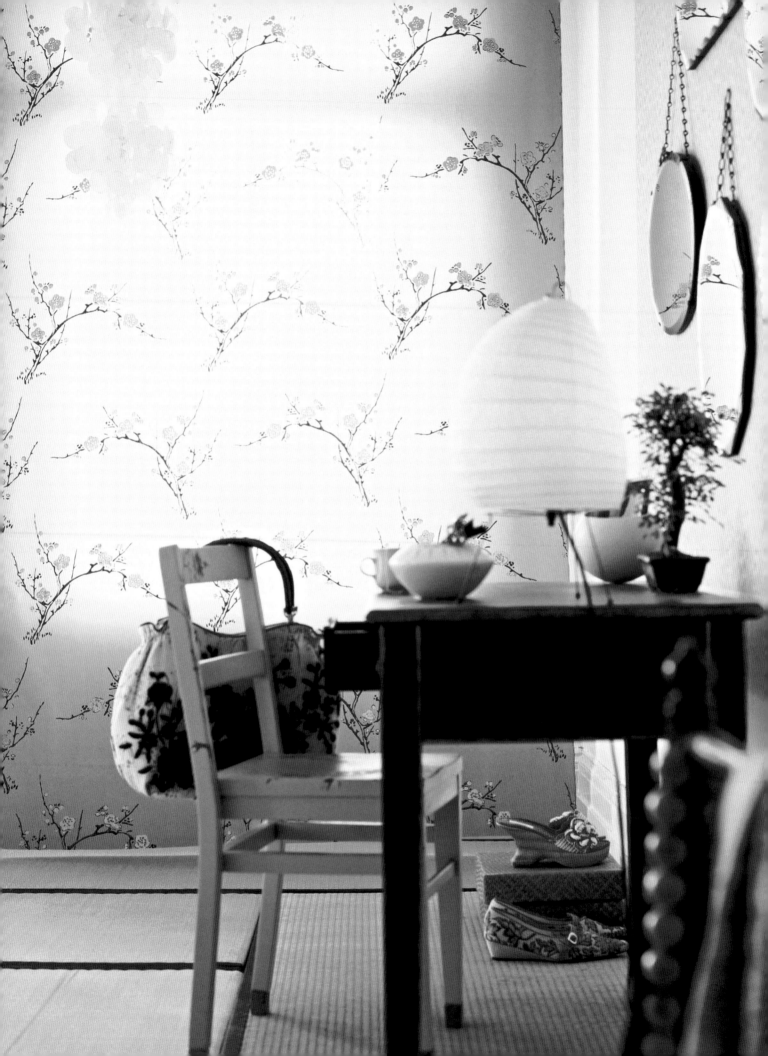

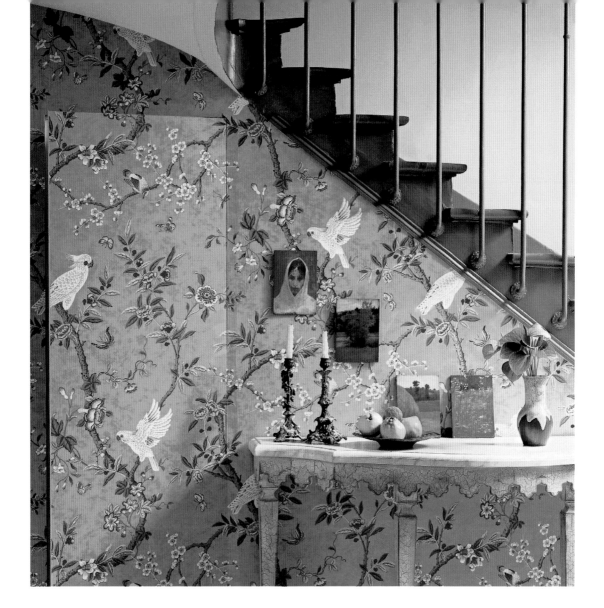

chinese wallpaper

Chinese wallpaper has a long and venerable history in western interiors, having graced the walls of grand European houses since the 1600s. Falling in and out of fashion during the intervening centuries, wallpaper is currently enjoying a revival—with styles ranging from traditional chinoiserie to modern exotica.

Reproduction papers of traditional Chinese designs are a particularly popular choice in contemporary homes. Featuring delicate repeating motifs of blossoms, birds, and branches, they work especially well in grand hallways and formal drawing rooms, where their natural elegance enhances classical proportions. To create a seamless fusion between old and new, combine a traditional Chinese print with modern furnishings; alternatively, team with translucent colors to help lift your look into the twenty-first century.

If the soft shades of jade green, sky blue, and pale gold are a little dull for your liking, why not try a splash of modern exotica? Scorching pink peonies on an ebony background will create a seductive feel in hideaway dens, while graphic chrysanthemums on an emerald backdrop breathe life into transitional areas such as stairways and landings.

OPPOSITE Cherry blossom wallpaper and a fragile paper lamp prevent the dark wood table from appearing too overbearing.
ABOVE Chinese wallpaper gives a hallway an eastern flavor.

Creating a bedroom with soul is simple, so long as you follow your instincts rather than the dictates of a glossy magazine. Establishing a look to reflect your appreciation of different cultures is the cornerstone of global style.

❋ The presence of fabric adds warmth and texture. Traditionally used to insulate homes from the cold, wallhangings have a decorative rather than functional purpose in contemporary interiors. A single wall hung with a rich fabric can make a sophisticated statement, while layers of shimmering textiles on sofas and daybeds help to build a sense of mystery and intrigue.

❋ Rugs are the quintessential floor covering in ethnic interiors, introducing a sense of warmth and domesticity. The rich colors and intricate patterns of Persian kilims and handwoven oriental designs provide a layer of textural interest as well as a decorative focal point.

❋ Enhance the appearance of exotic fabrics by complementing them with a range of similarly themed ornamentation. The delicate perfection of cherry blossoms is suited to bedrooms, where the light contrast of soft blooms on wintry branches is the perfect touch in minimalist decors.

❋ A selection of Japanese blossom prints provides the perfect accompaniment to a kimono wallhanging, while a Chinese floral vase will enhance the intricate appeal of silk-embroidered linen.

bedrooms

Traditionally soft and sybaritic, bedrooms are the perfect place for displaying a variety of exotic textiles. Used for seat and cushion covers, as well as for bed linen and tablecloths, luxurious materials such as velvet, brocade, and damask soften the strong lines of modern decor, while floral fabrics transform design schemes from simple to sumptuous in an instant.

If you want to create a boudoir that resonates with exoticism, silks from India, Cambodia, or China are a must. Available in numerous luminous shades, silk drapes in moody violet or a chair upholstered in soft gold give an extravagant feel, while silk sheets add an inimitable sense of glamor. If you want to incorporate an exotic feel but are wary of too many bright colors, introduce accents of exotica, instead. A scattering of bright cushions on a neutral sofa or a floral throw tossed over the back of a chair will both do the trick nicely.

One of the best ways to transform your bedroom into a touchy-feely zone is to incorporate a variety of seductive textiles. Soft and enveloping, fabrics such as velvet, damask, and devoré are as attractive as they are sensual. To complete the luxury look, cover one wall with a floral wallhanging, or team velvet drapes with a richly embroidered quilt.

A bold contrast of materials is another key feature: a length of filmy netting draped over a cane bedframe provides a nice mix between floaty and functional, while a crewelwork bedspread placed on top of satin-trimmed sheets juxtaposes rough with smooth. Create contrast through the introduction of pattern—a gallery of Audubon prints will enliven an otherwise bare boudoir, while bold-scale chintz cushions on a contemporary sofa will soften sleek lines. For a restrained effect, drape a side table with a length of plain cloth and cover it with a smaller piece of chintz. This suggests a sense of organic abundance without going over the top.

OPPOSITE A beautiful screen provides the perfect complement to the blue-and-beige color scheme of this modern bedroom, while ambient lighting helps to compound the sense of serenity.

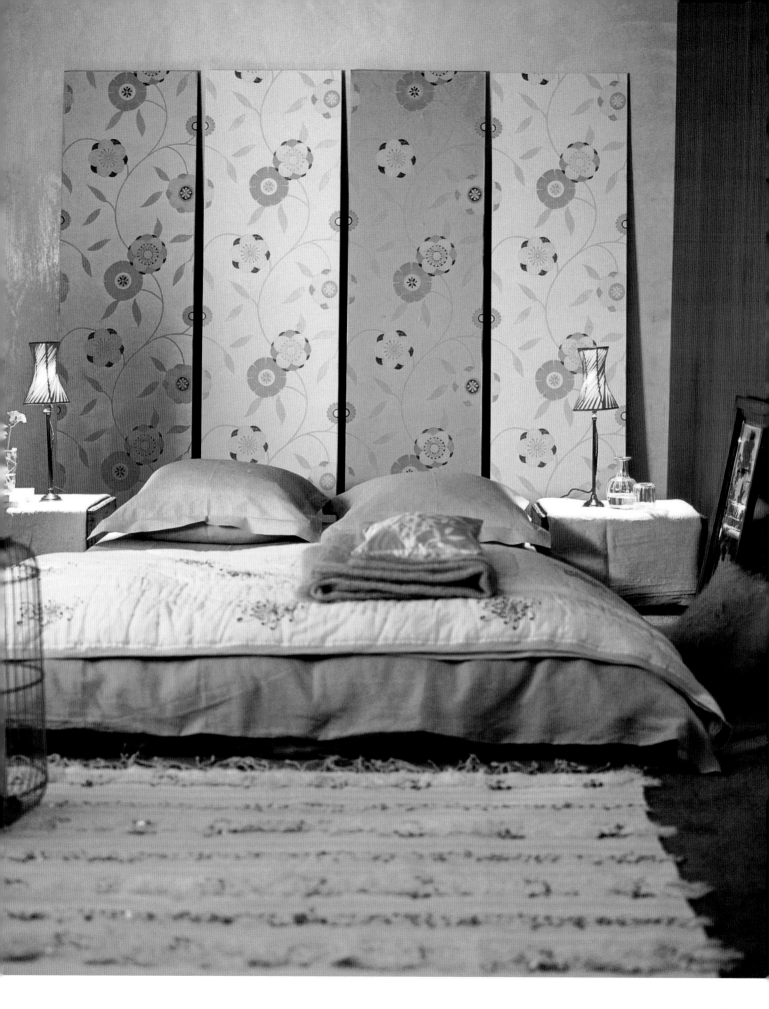

global chic

Thanks to the increase in travel opportunities and advances in communications systems, global style is fast becoming the decorative scheme du jour—with homeowners adapting a variety of exotic design elements into their interiors. Indeed, our heightened appreciation of different cultural heritages is such that it is now perfectly acceptable to juxtapose a Balinese table with an Islamic mirror or a French armoire with a Turkish kilim.

The belief that home decor should reflect personal style is key to global style. Instead of following established guidelines, contemporary homeowners want their schemes to reflect who they are and what they believe in. By allowing your heart to rule your head, it's possible to create a global interior that incorporates different cultural elements within a modern framework.

LEFT Simple stylized florals in meandering designs, introduced in neutral shades, add an itinerant feel.

OPPOSITE A graphic screen is the focal point in this sitting room, while the carved desk and bamboo ladder add a sense of exotica.

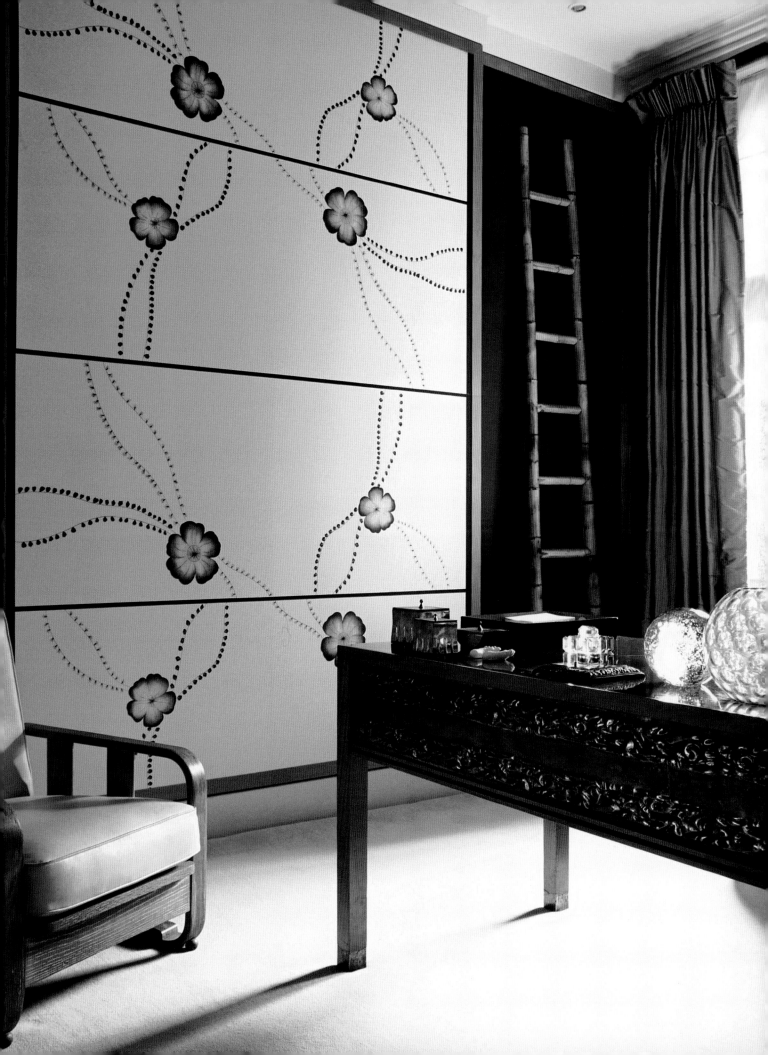

floral artistry

Floral designs applied directly onto walls in the form of murals or painted decoration is an age-old practice that has subsequently been replaced by framed movable pictures. However, the current emphasis on interior design schemes with soul, plus our preoccupation with all things natural, have resulted in a trend for botanical paint effects customized to suit the personality of the owner.

Wall-size depictions of flowers, leaves, and branches are perennially popular because they offer an attractive aesthetic that's easy to replicate. Roses and daisies are relatively easy motifs to render onto walls, but it is oriental-inspired lotus flowers and chrysanthemums that lend themselves particularly well to this medium, suffusing interiors with a sense of sophistication and exoticism. One of the simplest flowers to decorate your walls with is the cherry blossom. The national flower of Japan, this delicate bloom is revered for its fragility and transience (Japanese cherry blossoms open all at once, and the petals fall after about a week to ten days). Not surprisingly, it has inspired eastern painters for generations, and looks just as attractive on western walls as it does on oriental furnishings.

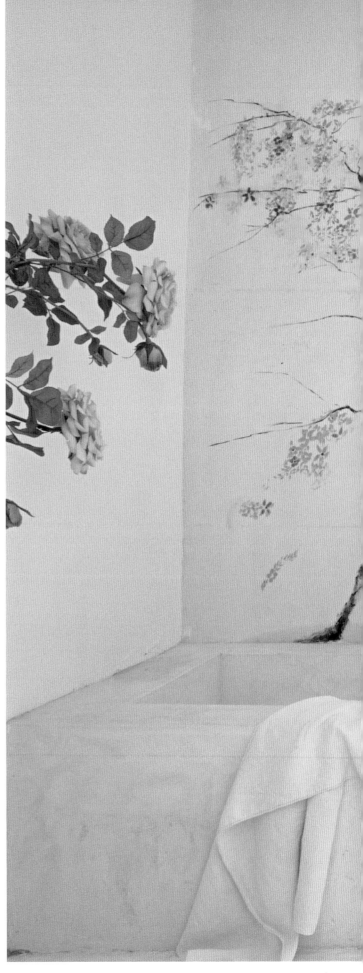

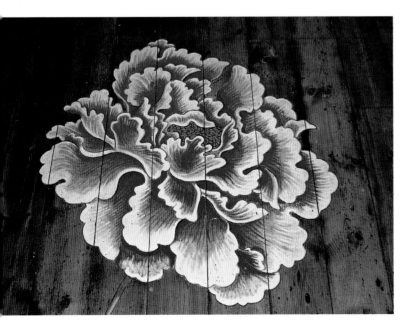

FREEHAND PAINTING

Wall paintings have a spontaneity that even the most beautiful stenciling cannot match. Understandably, many people are diffident about applying their artistic skills, although it is not really so difficult. To make the job easier, you need to be realistic in your choice of design—flat, two-dimensional treatments that rely on shape and color rather than modeling and perspective for their effect are easiest to achieve. And remember, you don't have to paint anything strictly representational—it's decorative shape and color that are important, not botanical realism. Even amateur artists can pull off a decorative paint job, so long as they work within their technical limitations, and stick to a few guidelines:

✳ Paint your floral decoration on a focal wall, but make sure that it's not too big, otherwise it will become abstracted or get lost.

✳ Restrict a painted design to one wall only. A scene that engulfs the entire room is likely to be overwhelming.

✳ There are no hard-and-fast rules about proportion. Instead, use your eye to determine the most pleasing design.

✳ Remember, botanical representations do not have to be accurate. One of the joys of painting freehand is the fact that a little stylization only serves to increase the arty, organic effect.

OPPOSITE An oversized lotus flower makes a bold statement in the center of a stripped wooden floor, introducing an unusual decorative element.
THIS PAGE A hand-painted branch of cherry blossoms creates an appealing backdrop in this modern bathroom and softens the stark lines.

eastern florals

As a general rule of thumb, eastern floral arrangements tend to focus on the beauty of one or two blooms rather than the varied styles of western displays. As a result, the exotic interior benefits from striking arrangements such as a single tiger lily in a clear vase or a collection of willow branches in a decorative Chinese pot. Other ideas include brightening up a dark corner with a life-affirming orchid or floating a gardenia in a bowl of water and surrounding it with a display of candles of differing heights.

It's also possible to change the feel of a room through the introduction of mood-inducing flowers. If you want to thwart negative energy, for instance, arrange a bunch of peace lilies in a see-through container and put them in a space where they can breathe. To harness feelings of love and romance, display a single rose in a simple single-stem vase; alternatively, place bamboo shoots in an earthenware pot if you are in need of some good luck.

Exotic flowers lend themselves particularly well to solo displays—their vivid coloring and pure shapes serve to create exquisite pieces of living art. Offering the perfect option for those who are short on time or money, single-stem arrangements are quick and easy to effect. Indeed, all you're required to do is make sure that your flower is cut to the right height in order for it to be displayed to its best advantage.

It's also important to select your containers with care. Plain receptacles such as clear vases, test tubes, milk bottles, and tall drinking glasses are all ideal, helping to compound the elegance of your arrangements, without detracting from their singular and natural beauty.

"EARTH RETURNS. KISSES FROM SKY. IN BLOSSOMS." Haiku poet

LEFT Single-stem displays are a hallmark of eastern floral arrangements, allowing each specimen to be enjoyed. **OPPOSITE** A simple vase of exquisite blooms breathes life-affirming energy into this ultramodern interior.

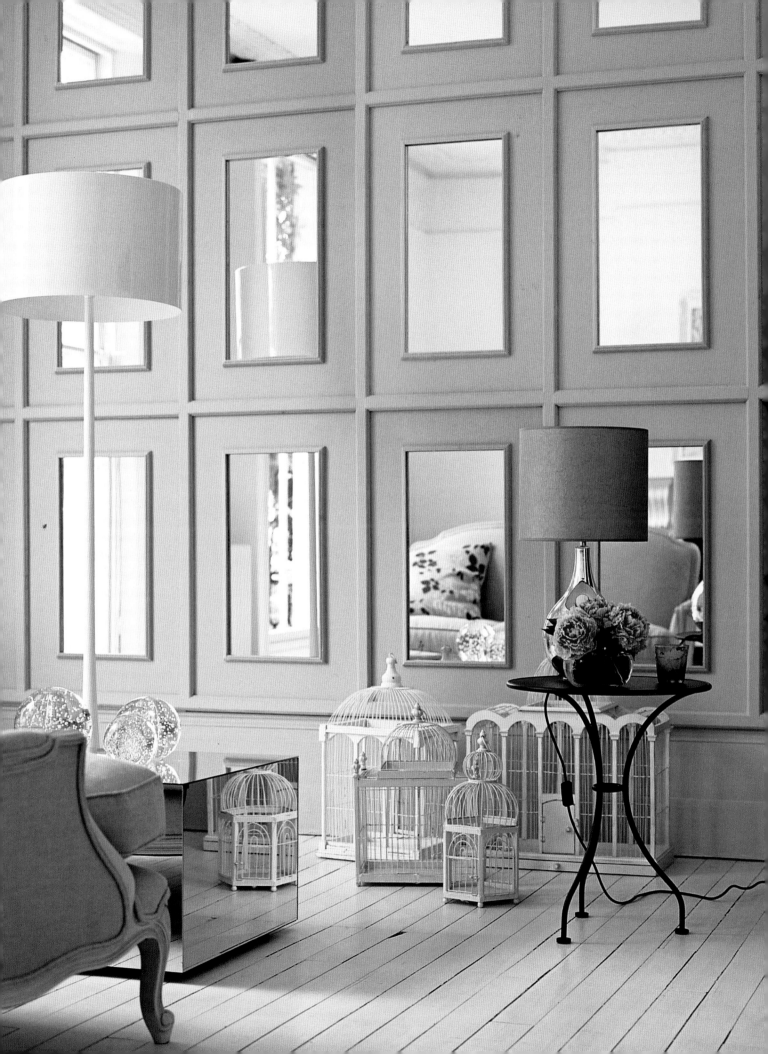

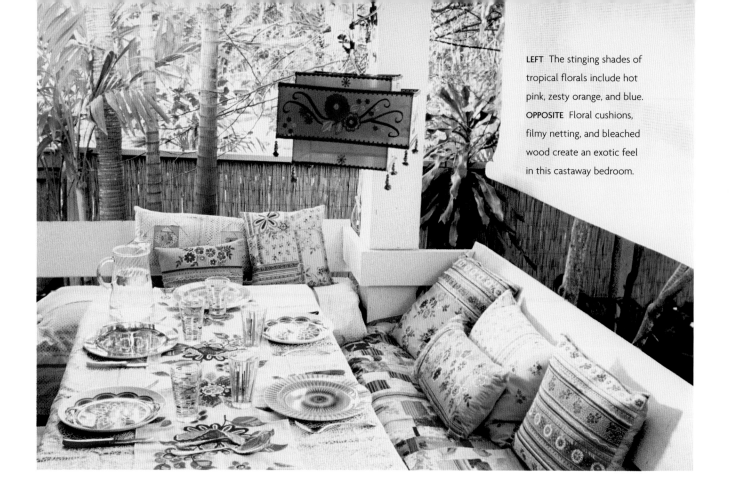

tropical florals

The tropical look is a dominant theme in home furnishings, drawing on influences from the West Indies and island paradises such as Hawaii, Tahiti, and Bora Bora. These far-off locales epitomize the ideal of "getting away from it all," so it's no wonder that people want to surround themselves with evocative exotic elements.

Focusing on an intense profusion of pattern and color, island decor is cool, vibrant, and relatively easy to recreate. It's best suited to rooms that are awash with natural light—key features include lots of white and colored paint, wicker furniture, floral cottons, bleached wood, lace curtains, patterned linoleum, and antique maps.

Unsurprisingly, the introduction of bright, even clashing, colors is the fastest way to create a tropical look. Shades of vibrant turquoise, stinging yellow, and emerald green are vividly reminiscent of island life, while the hues of exotic plant species such as bougainvillaea, hibiscus, poinsettias, and philodendrons inspire shades of pink, orange, red, and purple.

To create an authentic Caribbean feel, bright paintwork is a must. Window frames picked out in a vibrant hue will perk up the place in an instant, while door panels are similarly enhanced with a splash of brilliant paint. Another way to suggest a tropical feel is to remove an integral door and replace it with a bead curtain. Or, use a translucent panel of floral fabric or a more flamboyant design and attach it by ties to the door frame to create the sense of a breezy thoroughfare. To take the effect a step further, replace solid interior doors with hinged pairs of louvered panels painted in light pastel shades.

To complete the hot-country look, furnish with a selection of brightly colored accessories. A coral-pink radio, a thermos patterned with frangipani, or a kitsch garland of plastic flowers are all that's needed to evoke a sense of tropicana. Striking floral prints also work wonders, while distressed wood is another feature of island style. Keep your eyes peeled for picture frames, chairs, and tables in patchy shades of violet and pistachio.

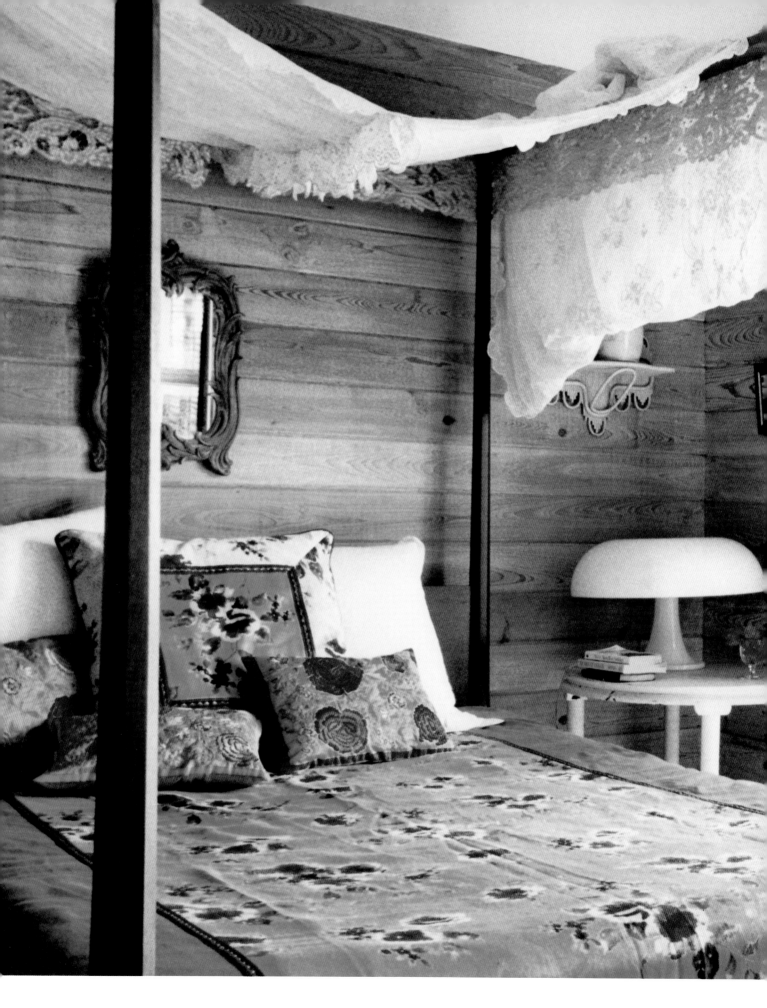

dens

To create a living area with a global feel, it's essential to include a variety of far-flung furnishings. Items such as carved wooden tables, desks inlaid with mother-of-pearl, and divans covered with floral throws all fit the bill, as do lacquered chests and Japanese-style futons. To evoke a colonial feel, include cane and wood pieces, first introduced to Europe by the East India Company in the seventeenth century.

As practical as they are pretty, daybeds offer the ideal seating option in ethnic dens. Set against a wall in order to capitalize on space, they provide an extra sleeping area for overnight guests, as well as present the perfect showcase for a variety of exotic fabrics. Cushions are another option, helping to dress up drab daybeds in an instant. To create backrests, simply pile the arms at either end with a selection of flowery pillows.

The classic chaise longue also works well in ethnic dens—its swooping back and low elevation suggest a laid-back, loungelike vibe. To complete the look, furnish it with fabrics in contrasting florals, or up the glam factor by juxtaposing velvet upholstery with throws embellished with beads, sequins, and tassels. Even modern sofas can be given an ethnic makeover. New upholstery in painterly florals will evoke a moody bohemian look, while layered fabrics—from mirrored Indian cloth to embroidered shawls and floral kilims—will build a sense of depth and intrigue.

For a blinds-down, lights-out kind of look, choose ambient illuminations that will create an intimate feel. A fringed shawl tossed over a light shade will imbue your den with a seductive aura, while Noguchi-style paper lanterns emit a soft glow that is equally evocative. For a far eastern flavor, opt for shades delicately crafted out of bamboo, or recreate the sense of balmy nights with a galaxy of twinkling tealights.

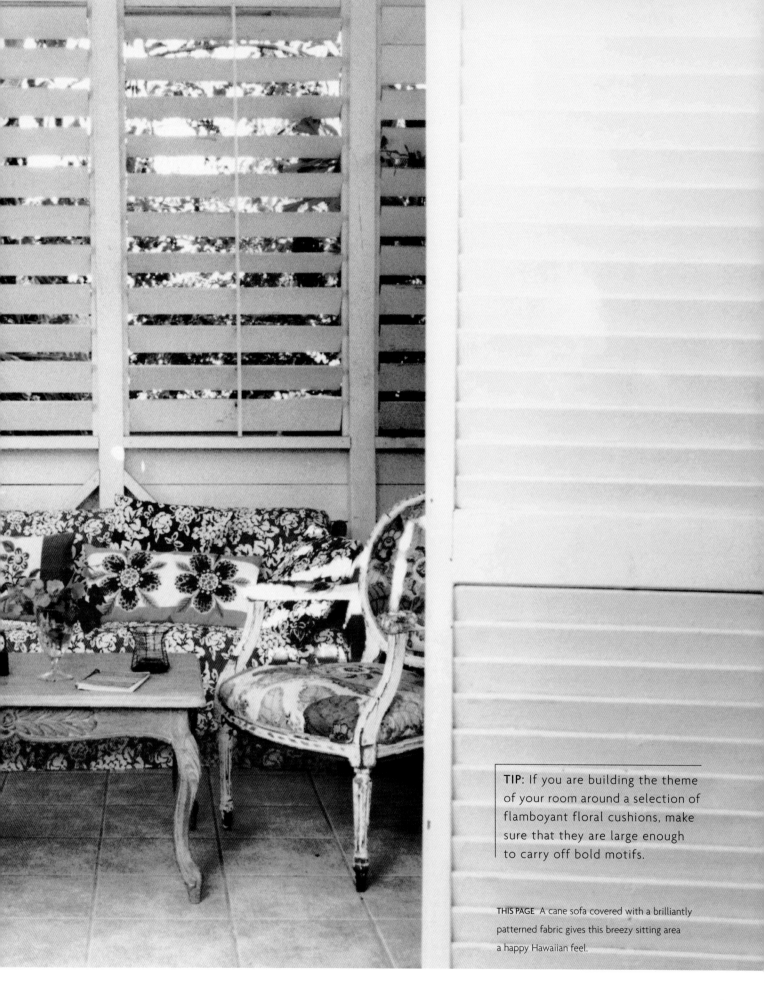

TIP: If you are building the theme of your room around a selection of flamboyant floral cushions, make sure that they are large enough to carry off bold motifs.

THIS PAGE A cane sofa covered with a brilliantly patterned fabric gives this breezy sitting area a happy Hawaiian feel.

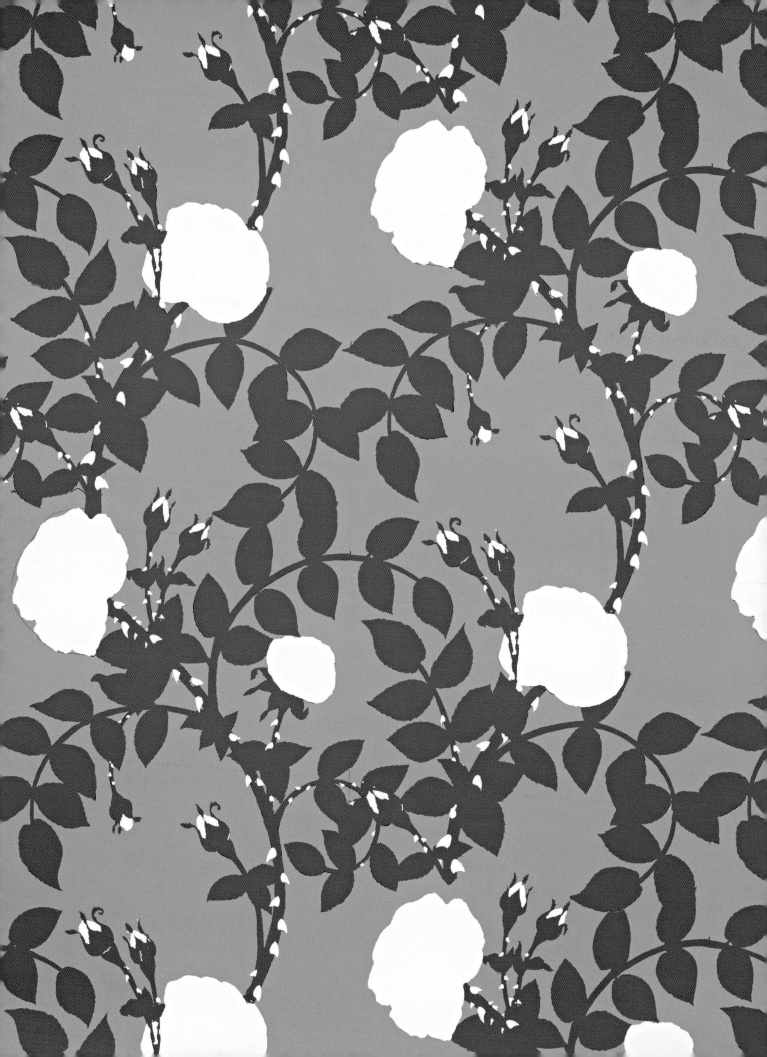

funky florals

While quaint rose prints and darling sprigs will always be popular, what looks freshest today is their aesthetic opposite–graphic plants and stylized flowers that are as flashy as they are funky. Indeed, nothing changes the look of a room as quickly as a brilliant splash of pattern and color, but remember– a little goes a very long way.

Best suited to sleek, modern interiors, funky florals are not for the fainthearted. Whether you opt for **MODERN GRAPHIC** style or a look that resonates with **DESIGNER CHIC**, decorating with bold botanicals provides the perfect complement to stark minimalist spaces, injecting them with life and vibrancy.

Funky florals work best in minimalist areas, where their ebullience is guaranteed to have maximum impact. Functional spaces such as **KITCHENS** and **BATHROOMS** are ideal, while pared-back **LIVING ROOMS**, preferably with high ceilings and wooden floors, provide the perfect canvas for eye-catching prints across walls, floors, and soft furnishings. To complete the look, add a selection of graphic accessories–such as lamp shades, ceramics, cushions, and throws.

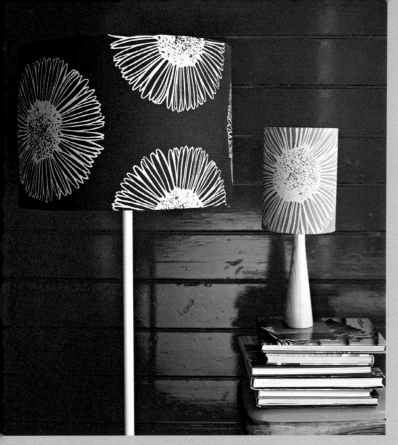

bold botanicals

Furnishing your home with funky florals need not be overwhelming, so long as you stick to a few basic guidelines. First, start with a pattern, fabric, or motif that you really love, and then use it to make a single statement. A wall hanging depicting a bold bloom has a truly modern edge, and can be used to make a striking focal point. Restricting the use of a particularly vibrant fabric to smaller areas, such as cushion covers, is similarly effective, helping to kickstart neutral interiors to life.

For a decisively modern look, contrast is key; clashing colors such as pink and scarlet flowers will always be successful because no one single color predominates. It's also important to remember that while strong shades can appear overpowering, they are often easier to work with than subtler hues that are harder to define. That said, homeowners who cannot abide the idea of living with vivid purple and brilliant orange can opt for bold botanicals

in earthier shades, which can be equally life-affirming and give a softer, more feminine feel.

Funky florals can be used in a wide variety of applications, including wallpaper—a medium that is currently enjoying a fabulously modern makeover. Ranging from bold botanicals that have been printed using traditional methods to new, computer-generated designs, the selection is as varied as it is vibrant. Indeed, modern technology has revolutionized wallpaper design to such a degree that it is now possible to buy floral motifs on a more exuberant scale than was previously thought possible.

Fabric-wise, funky florals are best treated simply. Rugs featuring stylized flower heads make a wonderfully warm counterpoint to polished wood or stone floors, while vigorously patterned upholstery breathes new life into soft furnishings. One of the main advantages of covering furniture with funky fabrics is the surprise element; reupholstering the seats on antique dining chairs with a splashy floral print adds a wonderfully modern retro feel, while using a contemporary abstract fabric on a 1950s sofa provides an interesting juxtaposition between the old and the new.

Simple vases of single types of flower are the best way to complete a funky interior. Offering a complementary splash of color, they are used to enhance bold design schemes, rather than make a decorative statement of their own. Thus, a vase of gerberas softens the harsh lines of modernist kitchens, while a basic bunch of black-eyed Susans can echo the hues of a yellow and black wallhanging.

ABOVE Striking lamp shades funk up this rustic-looking room.
OPPOSITE The bold colors and enormously oversized motifs of this ultramodern print used on the bedding and the walls create a design scheme that is daringly dramatic.

"NOBODY SEES A FLOWER, REALLY; IT IS SO SMALL, WE HAVEN'T TIME, AND IT TAKES TIME—LIKE TO HAVE A FRIEND TAKES TIME." Georgia O'Keefe, artist

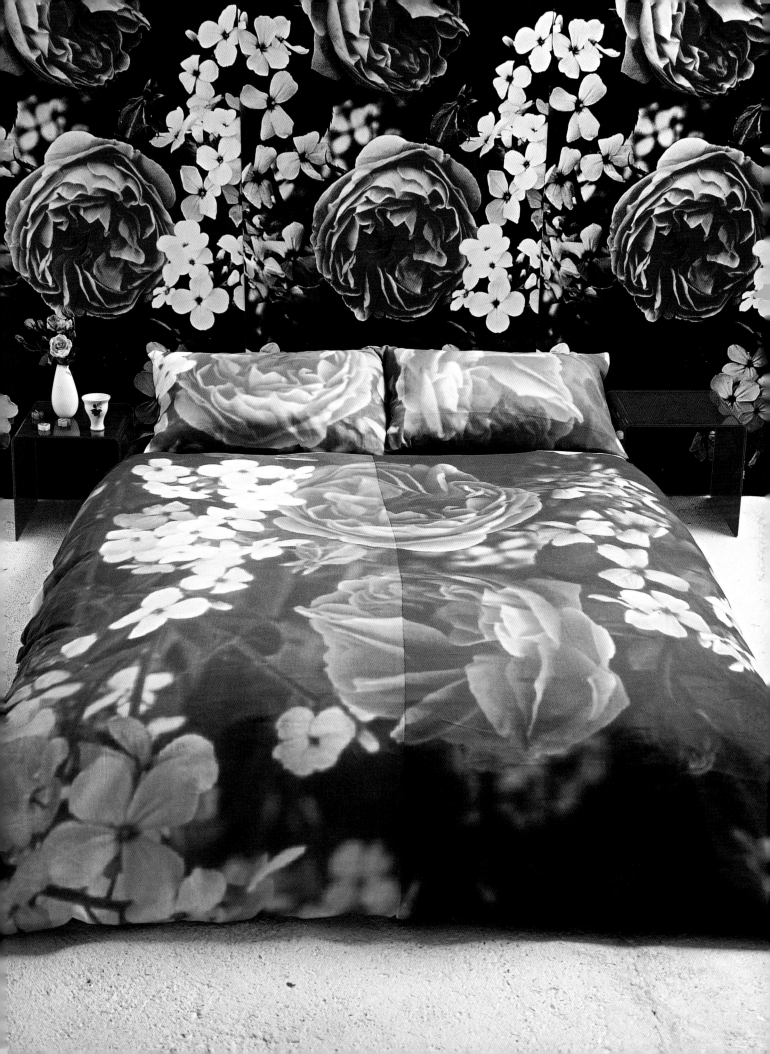

modern graphic

The modern graphic look is both sleek and sophisticated. At the very opposite end of the design spectrum to country cottage style, it appeals to homeowners who favor sprawling urban spaces over cozy cluttered ones.

The key elements of the modern graphic style include a monochromatic palette, streamlined furnishings, and wallpapers and fabrics depicting stylized floral patterns. Digitized images featuring oversize blooms are also integral to the look, while modern artworks in acid-bright hues provide an arresting focal point on stark white walls. Alternatively, you can use modern screens and funky bead curtains to introduce accents of pattern and color.

LEFT Bold repeated motifs, a plain background, and a minimal palette are the hallmarks of funky floral designs.
OPPOSITE An ultramodern fabric by British designer Jasper Conran give this classically shaped sofa an instant update.

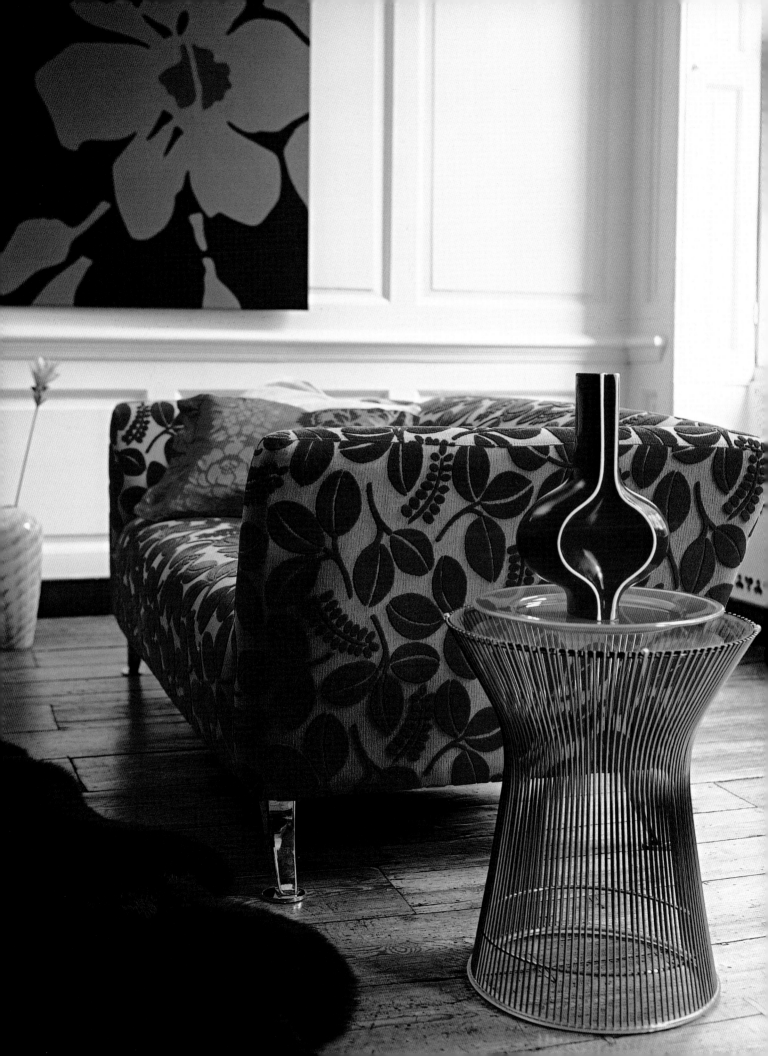

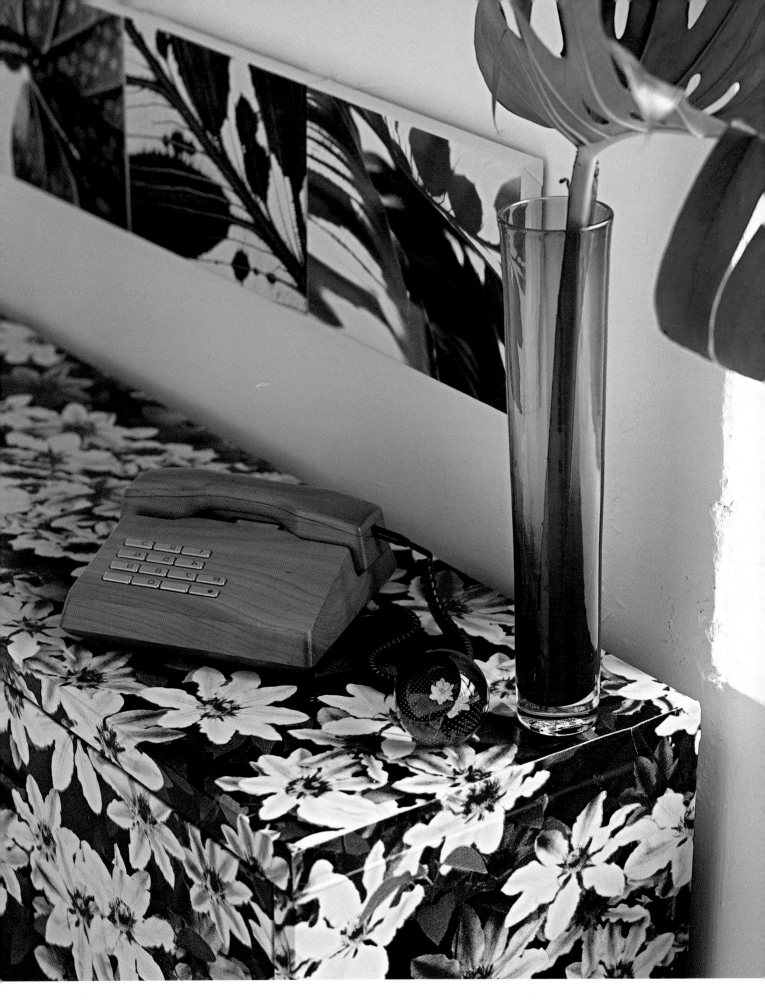

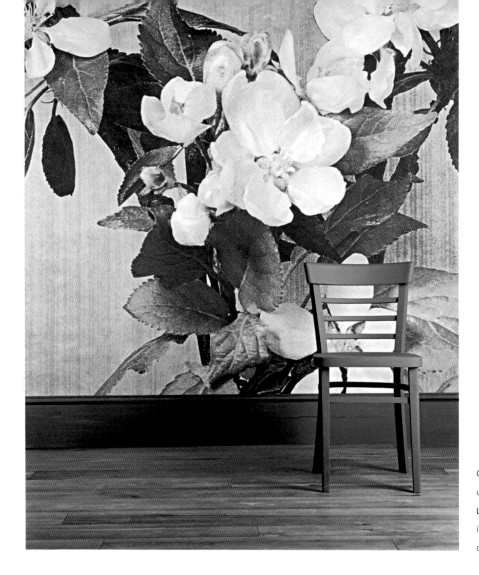

OPPOSITE Digital designs can be
used on furniture as well as on walls.
LEFT Outsized photographic
images offer a modern spin
on traditional wallpaper.

digital florals

Digital technology has sparked the biggest
wallpaper revolution since the first wallpaper
printing machine was patented in 1839. As a
result, canny computer users are now able to
play around with size and scale, producing
wallpapers radically different from the rambling
patterns and repeat motifs of yesteryear.

Customizing images to suit the walls of
your home is also becoming increasingly
popular, and a growing number of businesses
are producing designs to order. Capable of
turning simple floral patterns into throbbing
masses of abstract color, digital technology
also enables the manipulation of photographic
images. This technique is particularly
successful with botanical prints, which can be
dramatically enlarged to reveal intricate details
such as veining, mottling, and bristling hairs.

It's also possible to transfer realistic floral
images onto fabrics, thanks to recent advances
in laser printing. Offering a vibrant sense of
immediacy, a close-up of a brilliant flower head
makes a striking motif on a plain blind, for
example, while transferring photographic
florals onto cushions brightens up a neutrally
upholstered sofa in the same way that an
abstract painting breathes life into a blank wall.

Hologram projections—the twenty-first
century's answer to the photo mural—are
another way of introducing larger-than-life
florals into your home. Capable of changing
the look or mood of a room at the flick of
a switch, all holograms require is a projector
and transparencies of your favorite images.
These could include flower-filled fields, alpine
meadows, or close-ups of exotic blooms.

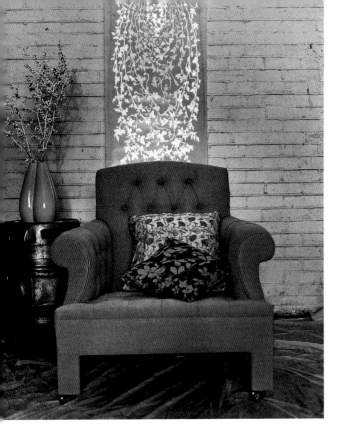

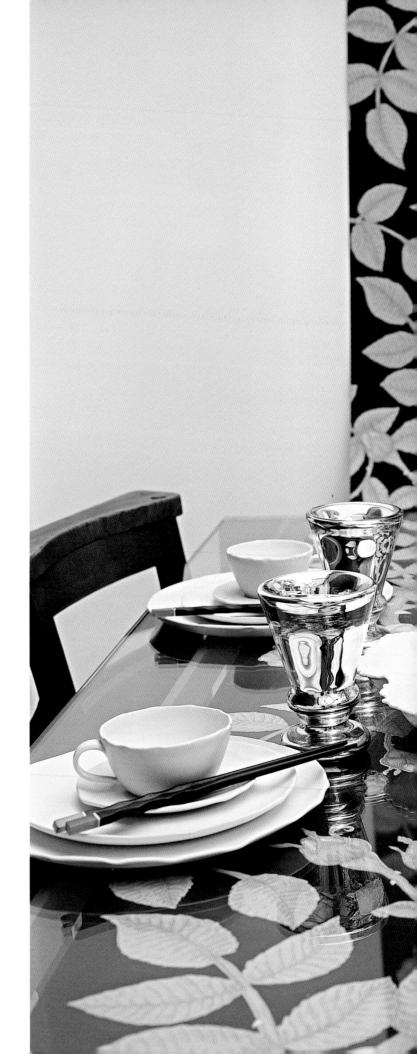

blooming banners

If you like the concept of funky wallpaper but don't want to commit to allover coverage, why not incorporate a decorative banner instead? A most effective way to introduce an arresting focal point, a single vertical strip takes on the prominence of a work of art. In addition, banners also create an interesting sense of contrast as the pattern contained within the strip creates a striking contrast to plain-painted walls.

Currently sporting motifs large enough to fill an entire strip of paper, contemporary designs include a graphic selection of oversized florals. Bold botanicals in acid hues are very popular, together with more free-ranging designs that appear to be climbing the walls. For best results, choose screen-printed styles, which involve the production of small runs of exquisite handmade papers in which the patterns are large enough to render repeats almost unnoticeable.

ABOVE Luminescent florals on a delicate Perspex banner contrast with the rough bricks on either side.

RIGHT A monochromatic strip on the wall, echoed on the tablecloth, sets the tone for this modern dining room.

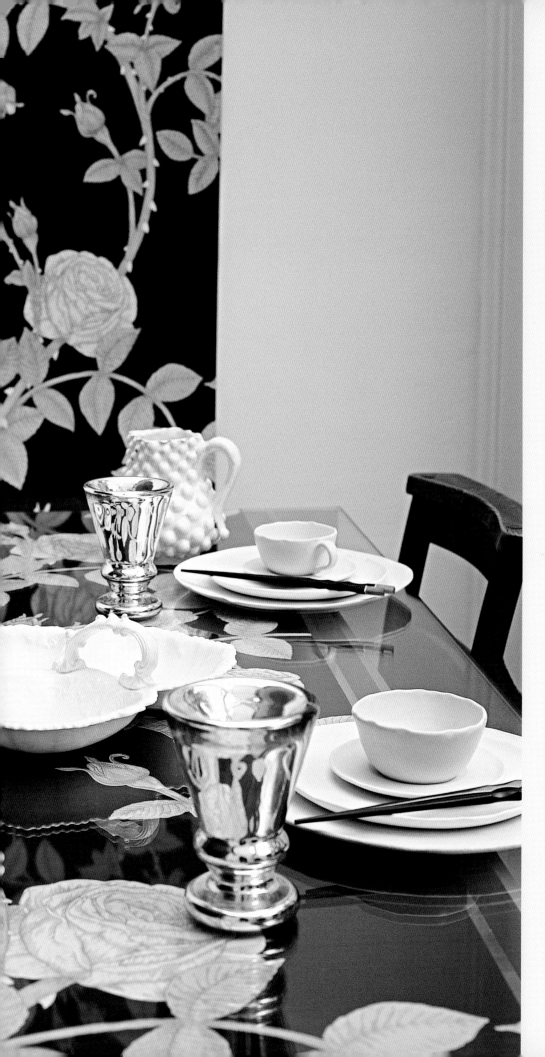

HANGING BANNERS

❋ Banners work best in minimalist rooms where their graphic appearance is guaranteed to have maximum impact.

❋ Use banners to add a new dimension to a room. For example, a collection of three vertical strips, hung at intervals, will break up a long expanse of wall, while horizontal strips provide a counterbalance to high ceilings.

❋ If your space is on the small side, make sure that your banner is in proportion to other furnishings.

HANGING PICTURES

❋ Strong images need lots of space around them, so remove any unnecessary ornaments from the room, and keep furnishings and furniture to a minimum.

❋ Modern paintings look best hung on walls painted in a strong color, which will bring them alive in a way that paler walls seldom do.

❋ When hanging a group of images, plan your arrangement by laying out pictures on the floor first, working from the middle picture outward.

❋ If you're hanging a small group of pictures, keep the spacing tight.

❋ Avoid dotting pictures around a room. They will look lost.

❋ When you're deciding on which wall to hang a particular piece, and at what height, sit or stand in the place you spend the most time to judge the effect.

❋ Creating a theme with pictures is an effective way of unifying a variety of different media.

screen savers

A far cry from the fussy styles of the Victorian era, modern screens are as decorative as they are functional. Indeed, contemporary room dividers are fast becoming an integral feature of twenty-first-century interiors, with styles ranging from Perspex panels to semitranslucent scrims.

Screens are best suited to larger rooms, where they create a cozier, more approachable feel. If you want to make room dividers a feature of your interior, opt for traditional folding styles that have been given a modern makeover. These could feature a riot of brilliant blooms set against a startling white backdrop. Alternatively, choose transparent room dividers, which will add structure without compromising space and light.

TIP: Make your own funky room divider by covering an ordinary screen with floral images cut out from magazines.

OPPOSITE A transparent screen etched with floral motifs introduces pattern and color into this minimalist interior.
THIS PAGE Floaty scrims offer a fabulously funky alternative to more traditional room dividers.

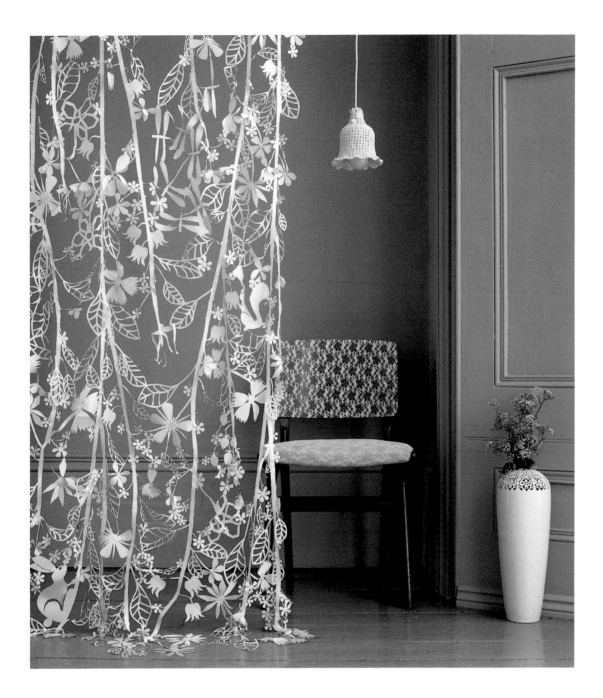

blooming beads

Using bead curtains is a great way to add an element of fun to your interior. Available in numerous different designs—from strings of plastic flowers to bamboo sheets with a floral design painted on them—bead curtains work best in open-plan areas, providing a decorative divide between kitchens and living rooms, and between bathrooms and dressing rooms, for example.

If bead curtains are a tad unsophisticated for your liking, why not opt for Tord Boontje's ultramodern take on traditional room dividers? Featuring a mix of flora and fauna, the talented Dutch designer's stunningly fragile-looking curtains are actually made from superstrong synthetic paper, which can easily be cut to the desired length with a pair of scissors.

ABOVE Tord Boontje's screen creates a fabulous floaty feel.
OPPOSITE Bead curtains add a playful feel to funky interiors.

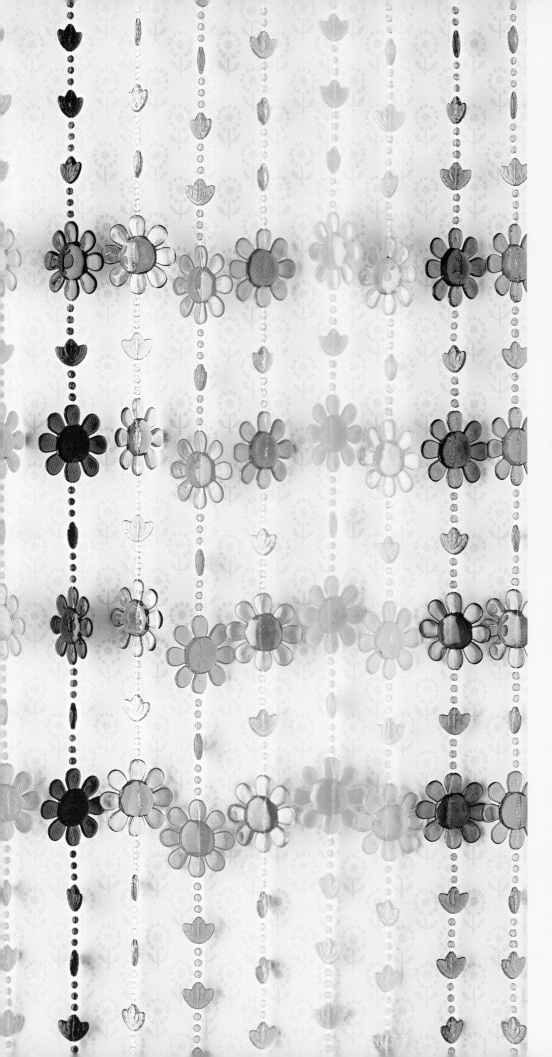

HOW TO MAKE A BEAD CURTAIN

Bead curtains are very simple and easy to make. All you need is thick string; floral patterned/shaped beads; a dowel 4 in (10 cm) longer than the width of your doorway; and two hooks.

✳ Cut the string into pieces 8 in (20 cm) longer than you want the finished curtain to be, to allow room to tie knots in the string and to attach it to the rod.
✳ Tie a knot at one end of your string. This end will become the bottom of this curtain strand.
✳ Thread beads onto your string. The size of the beads determines how many you need. If you don't want the curtain to feature too many floral beads, introduce plainer styles, tying knots in the string after threading on each group of beads.
✳ When you have finished each length of beads, tie a knot in the top end next to the last bead, ensuring that you have 6 in (15 cm) of string available for a loop at the top.
✳ To prepare your doorway for the curtain, attach a hook to the outside edge of the door frame on either side. Your dowel will settle into the hooks, making the curtain stable yet easy to remove.
✳ When all of your strings have been decorated, make a loop at the top of each one and slide the dowel through. Place the rod into the hooks and slide each strand along it to create the right spacing.
✳ If you don't want your curtain pieces to slide around, tie them directly to the dowel rather than making a loop. This will attach the pieces firmly to the rod and keep them in place.

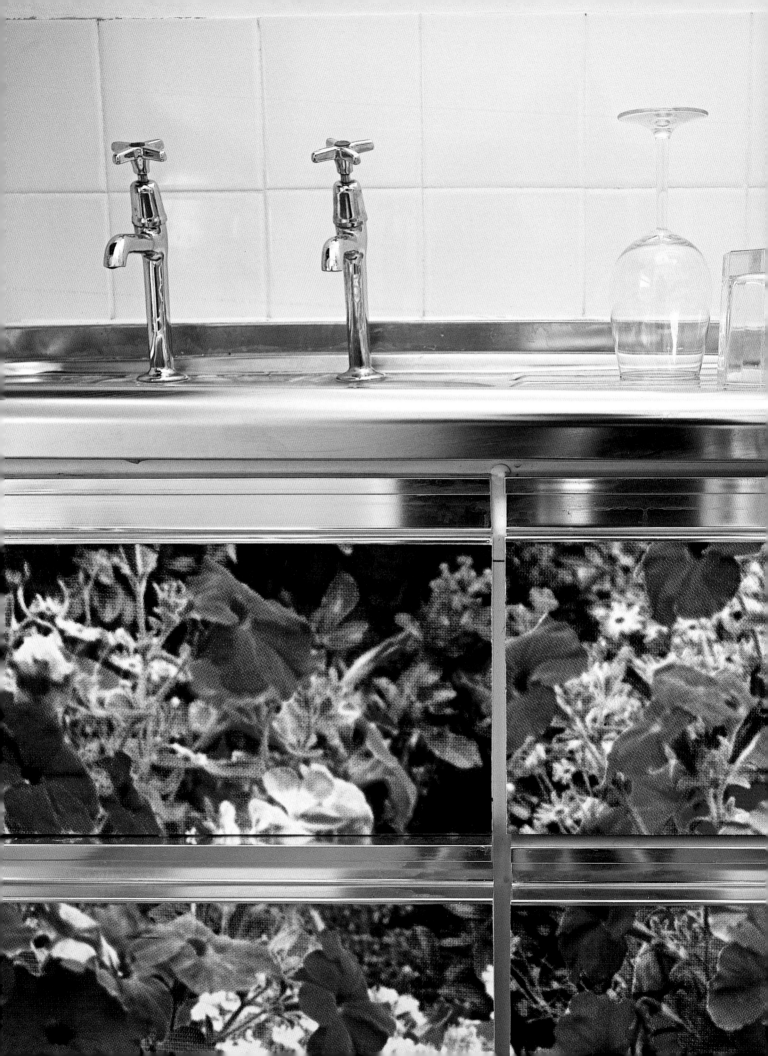

OPPOSITE Floral drawers give a lighthearted feel.
THIS PAGE A monochromatic print stretching the width of the wall and an antique candleholder enliven this minimalist kitchen.

kitchens

In keeping with modern graphic style, the funky kitchen is sleek and professional. Fitted units, smooth-sliding drawers, and gleaming surfaces reflect the minimalist approach, while appliances (refrigerator, dishwasher, etc.) are artfully disguised behind a façade of streamlined panels.

The antithesis of their wholesome country cousins, funky-style kitchens feature top-of-the-line stoves and achingly hip appliances. This does not prevent the odd splash of brilliant pattern from breaking through, however. Indeed, bold botanicals are particularly well suited to industrial-style kitchens—their throbbing hues help to soften the harsh lines of modern fixtures and fittings.

Not surprisingly, computer-generated images fit the look perfectly—with larger-than-life florals imbuing walls, floors, and blinds with vibrant energy. Even ceramic tiles have been given a modern makeover, and include photorealistic styles that provide a quirky contrast to smooth expanses of stainless steel.

Displaying floral china is another way of introducing pattern and color into your cooking space. If you want to maintain the streamlined look, choose white plates with a minimal floral print on each. Alternatively, introduce chintz designs to provide an element of contrast and surprise—or an eclectic selection of chinaware, which should be linked by color or style of motif for the best effect.

bathrooms

Originally viewed as a purely functional space, the bathroom has upped its profile over the past fifty years, evolving from the fashionable pastels of the sixties and seventies to the all-white vogue of the eighties—a look that has retained its popularity to this day.

The funky bathroom is coolly minimalist, combining streamlined fixtures and fittings with splashes of pattern and color. For best results, team a white suite with fitted units, which will help to maximize space as well as create a blank canvas for decorative additions such as a bold botanical print or a screen decorated with floral motifs. If your bathroom is big enough, add a chair with a vibrantly upholstered seat, or dress the window with a graphic floral blind. To create a more vibrant effect, paper or stencil the walls with a striking design—but remember to balance the look by keeping the rest of your furnishings plain.

Accessories also help imbue bathrooms with a funky twist. A graphic bathmat or shower curtain patterned with brilliant blooms will breathe new life into neutral bathrooms, while floral towels, a selection of modern ceramics, or a brilliantly patterned laundry basket will all have a similarly striking impact.

BELOW Jazz up your washing space with an oversized floral photographic print that will bring the outside in.
OPPOSITE A traditional screen painted with splashy blooms injects a jolt of energy into this white bathroom.

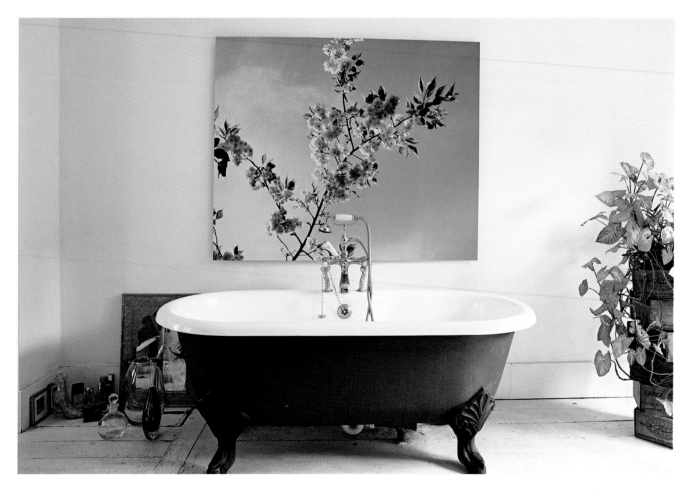

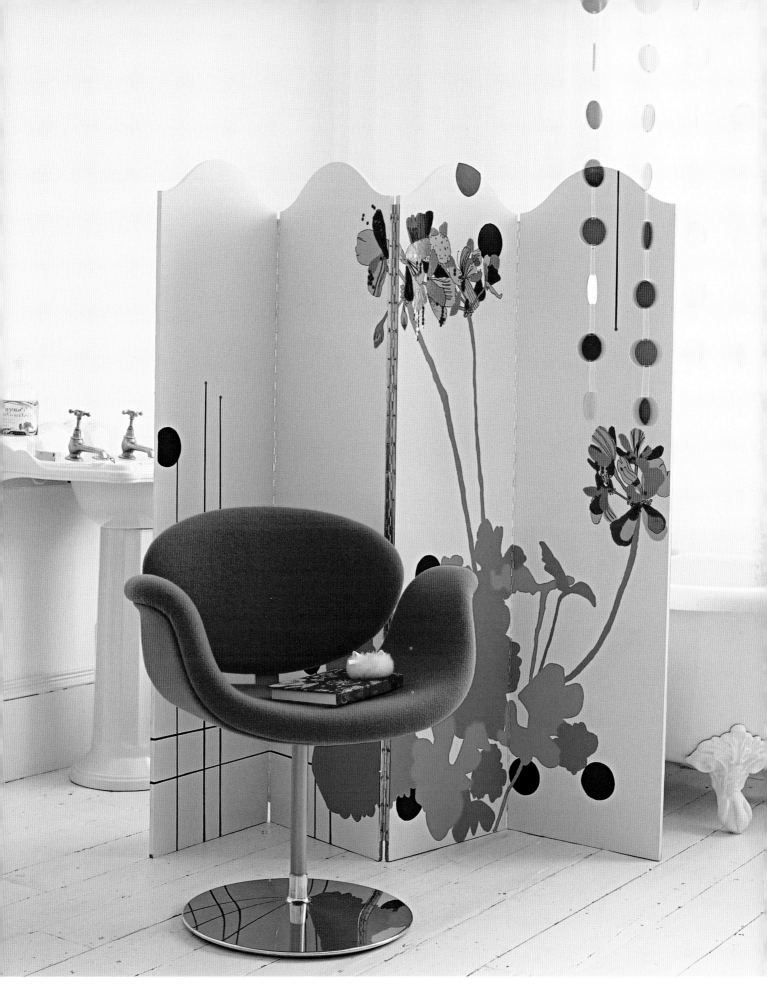

designer chic

Since the mid-1990s, when fashion designers started to diversify into home furnishings, the trend for hip homeware has snowballed. Kicking off with scented candles and the odd aromatherapy cushion, heavy hitters such as Calvin Klein and Paul Smith are now stamping their sartorial signatures on bed linen, cushions, and ceramics. As a result, the fashion for designer homeware has filtered down to the masses, with chains such as Nautica, French Connection, and Monsoon producing photograph frames, towels, and tablecloths. Not surprisingly, florals are big news in designer furnishings. As popular off the catwalk as on it, motifs range from exotic blooms to splashy silhouettes, and embroidered buds to retro sprigs.

LEFT Graphic floral motifs appeal to fashion designers who want their home furnishings to be as eye-catching as their clothes.
OPPOSITE Supergraphic upholstery—the ultimate in statement furniture—is fast becoming a popular trend.

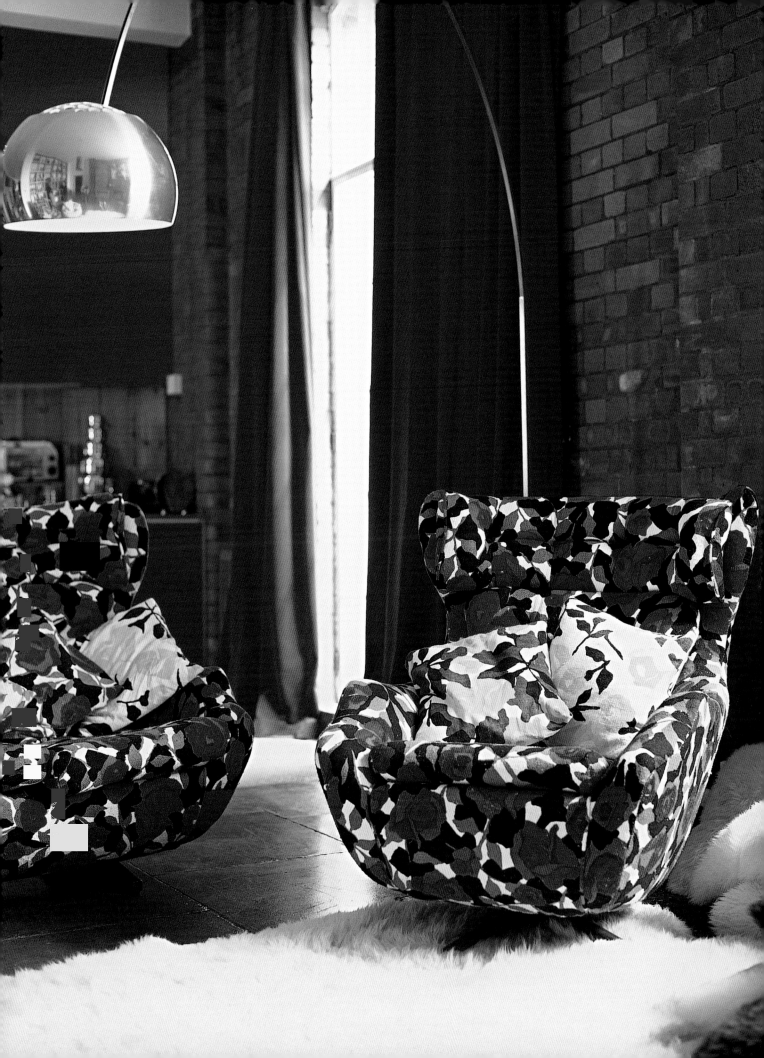

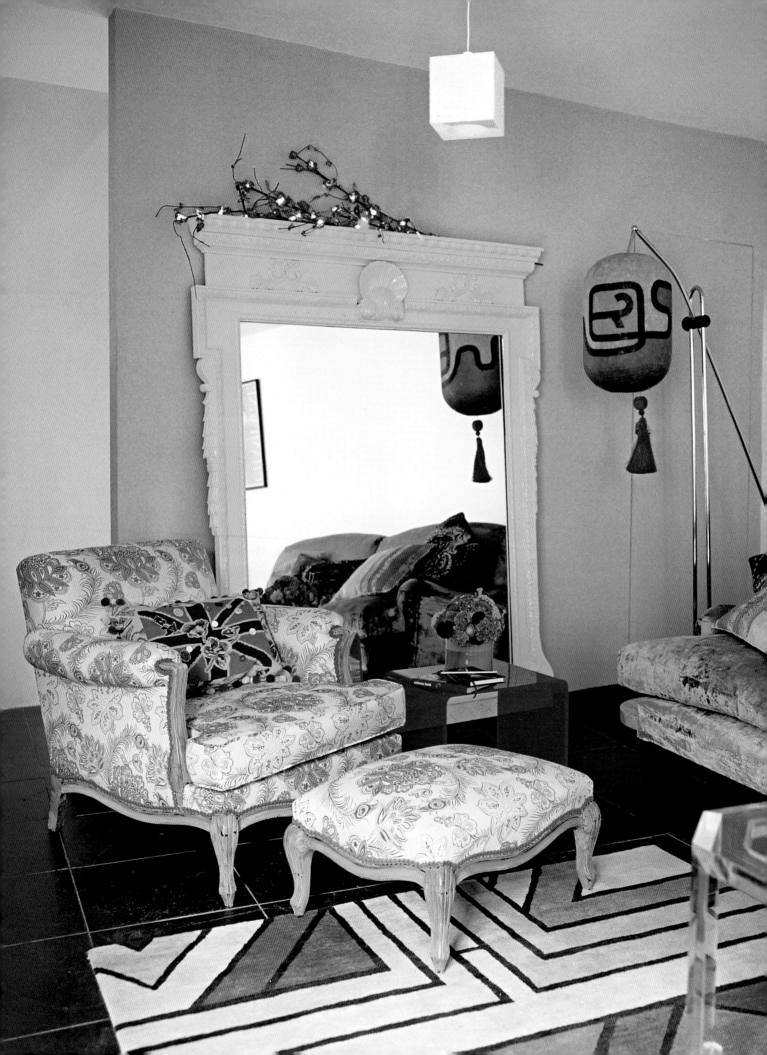

the fashionable look

The vast collection of Ralph Lauren, the king of floral fabrics, ranges from ponderous blooms to bitsy sprigs in navy, green, and red. Designed to be mixed and matched with a variety of plaid, ticking, and denim fabrics, Lauren's soft furnishings epitomize fashionable rusticity. For a similar effect, opt for Tommy Hilfiger's Connecticut Farmhouse range, which combines florals with checks and stripes to create a charming "down-home" effect.

Fans of the monochromatic look will love Donna Karan's Hibiscus bed linen, which features graphic black florals on a white background. Offering the perfect solution for fashionistas who want their interiors to be as cutting-edge as their clothes, Karan's bed wear looks most dramatic when it is combined with contemporary furniture and a stripped-wood floor. Alternatively, team with dark drapes and a deep-pile carpet for a softer, more seductive feel.

For ethnic glamor, try Kenzo Maison's home collection, which takes its cue from tribal colors. Teaming floral-printed silks alongside a host of textural fabrics in plum, ocher, and cocoa, the Kenzo look suits smaller rooms such as studies and dens, where its moody hues and delicate detailing can be properly appreciated.

Renowned for his ability to combine modern tailoring with British romanticism, Jasper Conran produces home furnishings that are as sophisticated as his suits. Following the introduction of his ultrasleek ceramics, the designer's new Sprig collection features stylized florals on gem-bright backgrounds. Available in fabric and wallpaper, Sprig works wonders in minimalist lounging areas, where its graphic impact breathes life into walls and furnishings.

OPPOSITE Matthew Williamson's furniture is as funky as his clothing.
RIGHT Floral fabrics by Missoni (top) and Cacharel (below) are currently de rigueur in fashionable design schemes.

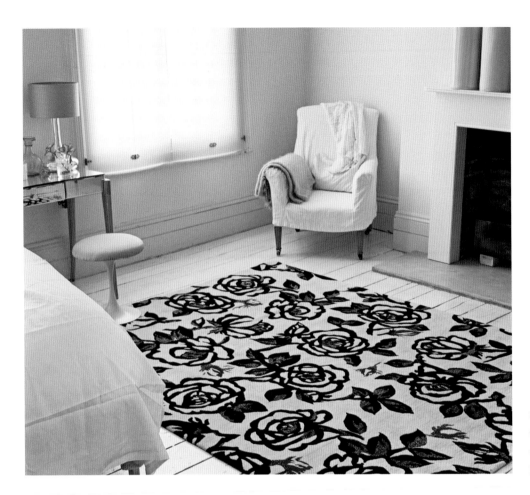

LEFT Lulu Guinness's rose rug brings
this minimalist sitting room to life.
OPPOSITE A graphic floor covering
by Diane von Furstenberg.

designer flooring

Thanks to the ongoing fashion for minimalism, floors have become an increasingly important feature in modern interiors, with stripped wooden boards consistently claiming the number one spot. Indeed, such is the popularity of timber flooring that, up until recently, alternative styles have languished on the backburner, with uninspiring styles ranging from prickly seagrass to ubiquitous oatmeal.

In response to this, contemporary designers are now producing a variety of funky floor coverings. Featuring bold botanical patterns, these new-look carpets include Cath Kidston's Rose Bouquet design, which depicts scarlet flower heads in full bloom on a bright blue background. For a more muted style, choose her Rosebud pattern, featuring red buds on an "antique white" background.

The best way to incorporate a boldly patterned carpet into your interior is to choose a design that provides the room with a color scheme, then pick out individual shades and echo them with paints, fabrics, and accessories. In smaller spaces it's best to use repeat motifs so the scale of the design can be matched with compact furniture and neat small-print fabrics.

If you are wary of using wall-to-wall carpeting, stick with rugs, which contain the design within a defined area, rather than allowing it to take over the entire floor. For the funkiest styles, choose one of the designs from The Rug Company, such as Diane von Furstenberg's realistic roses on a bloodred background or Marni's Tibetan wool styles, which feature a variety of naïve florals in pink, yellow, and mauve. Alternatively, British Lulu Guinness's monochromatic rose pattern looks fabulous on stripped wooden floors, while Missoni's striped rugs can be mixed and matched with a variety of floral fabrics in similarly vibrant colors.

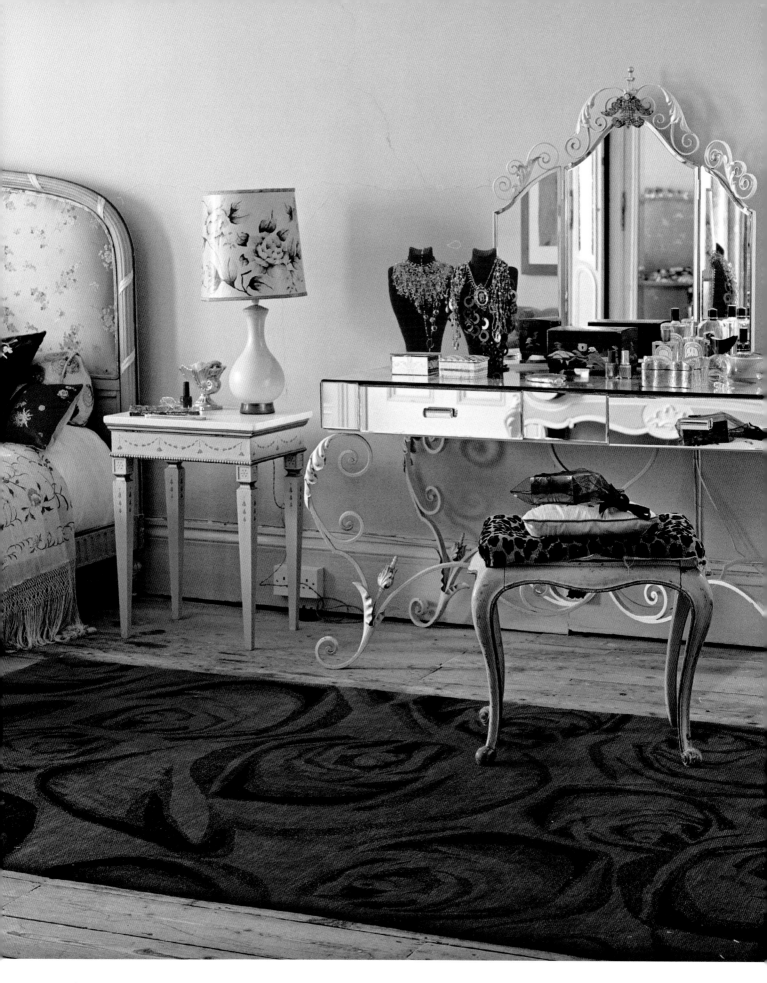

"FLOWERS OF ALL HUE, AND WITHOUT THORN, THE ROSE." John Milton, poet

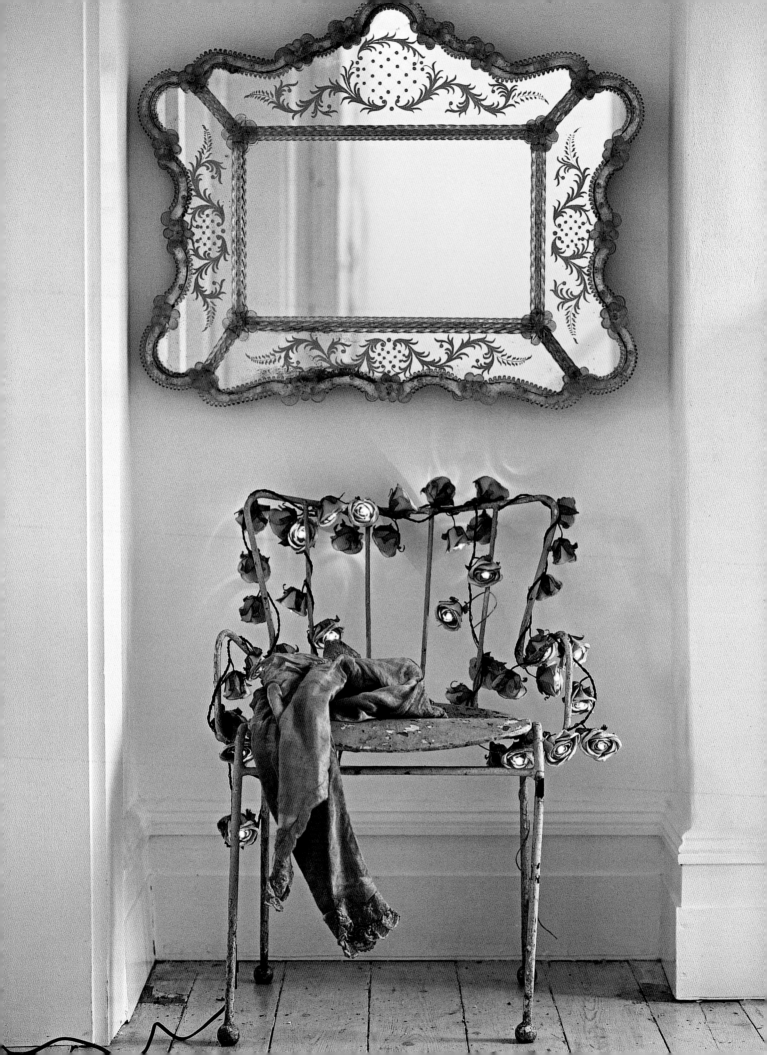

floral fairy lights

Offering twinkly illuminations at the flick of a switch, fairy lights have a gaudy glamor no longer confined to the Christmas tree. Indeed, fairy lights have fast become one of the coolest home-furnishing accessories around—with hip homeowners using them to glam up a variety of furnishings, from headboards to bookcases.

Although basic white fairy light styles will undoubtedly imbue your home with a glitzy element, there's a wide selection of alternative designs to choose from. These range from multicolored plastic flower shapes to larger styles, with petal-shaped shades from old-fashioned roses to hibiscus styles in scorching shades of red. It's also possible to buy wall-sized nets of fairy lights, which offer a funky alternative to traditional prints and paintings.

EIGHT WAYS TO DISPLAY YOUR FAIRY LIGHTS

☀ Give your interior extra sparkle by draping a string of fairy lights across windows, doors, picture frames, and bookcases.
☀ Hang fairy lights around a mirror or above a working fireplace to maximize the glittery effect.
☀ Trail a string of lights encased in protective rubber tubing along the floor to create a serpentine look.
☀ Twist fairy lights into funky floral shapes, and tack them onto the wall using small cable clips. A naïve flower head above a dressing table makes a glittery focal point, while clusters of all-white lights give the impression of spring blossoms.
☀ Thread them through banisters to liven up a dull staircase, or twine them between slatted chairs backs.
☀ Mix and match multicolored lights with plain ones to create a gaudy, fairground feel.
☀ Twist fairy lights around plant pots to glam up your greenery.
☀ Choose flashing designs to create a dodgy disco vibe.

TIP: Fairy lights should be treated with utmost care—their delicate wiring frequently causes broken fuses.

OPPOSITE Floral fairy lights draped on a chair add a sense of romance.
ABOVE LEFT Tiny illuminations create a funky disco feel.

living rooms

Effortlessly chic—as well as perennially fashionable—black-and-white design schemes are a great way of jazzing up your interiors. Whether you're seeking the complete graphic effect or something a little more intimate, the monochromatic look allows for design schemes that are as striking as they are seductive.

One idea is to team off-white walls with soft black upholstery. To soften the effect, accessorize with floral cushions in contrasting shades of orange and red. Alternatively, you can combine white paintwork with a two-tone floral wall hanging and introduce accents of color via lime green glassware or a turquoise throw. For a truly modernist feel, team up a monochromatic palette with materials such as suede and bouclé to add a sense of texture and warmth.

If you like the black–and–white look but don't want to go the whole hog, incorporate a single monochromatic design feature and leave it at that. In order for this method to be truly successful, however, you must ensure that the other furnishings in the room balance out the look, and that any additional patterns collaborate with the overall effect.

Decorating with a select group of black and white accessories is another way of showing off your sense of style. Items such as a checkered photo frame or a two-tone vase will introduce a gently graphic feel, while bunches of flowers are equally effective; use velvety black tulips to create a sense of sophistication, or a vase of dark purple pansies to compound a moody ambience.

TIP: To prevent colored spines from disrupting a sleek monochromatic look, cover books with plain black or white jackets.

RIGHT Soft shades of black contrast with harsher ones to create a monochromatic scheme with a variety of patterns.

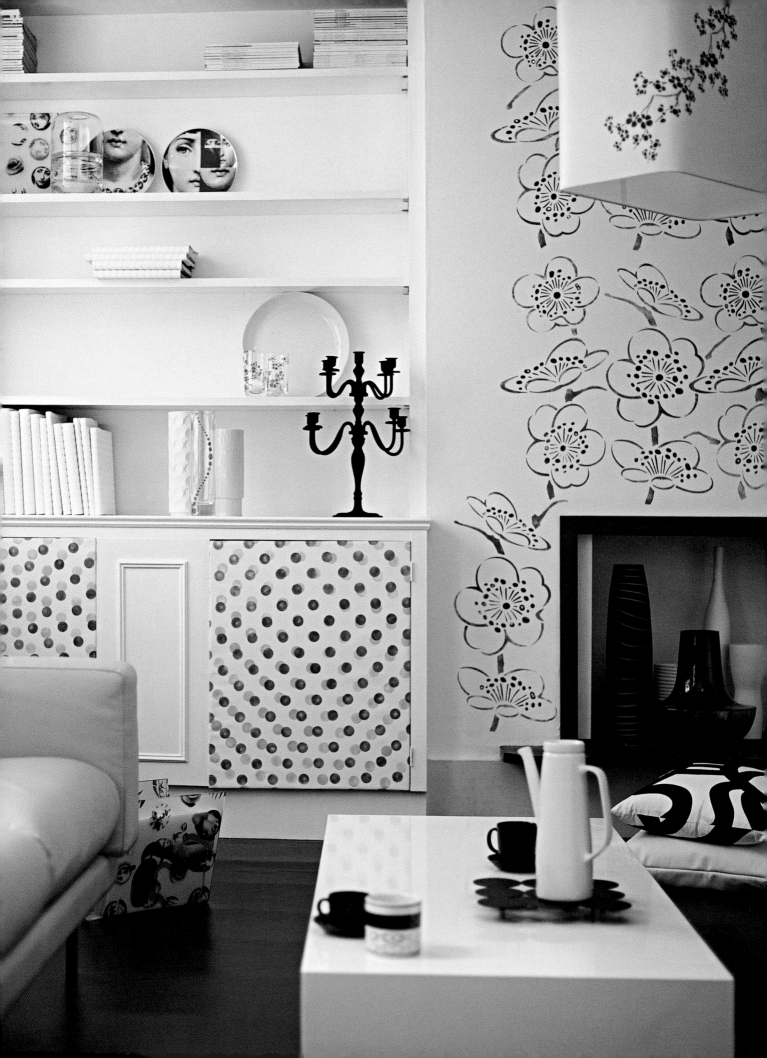

retro florals

In a world that is less than secure, there is something very comforting about retro designs. Lurid wallpapers that your grandparents might have had bring a warm rush of recognition, while chunky ceramics patterned with sixties florals are similarly evocative, conjuring an era that was ablaze with energy and innovation.

Spanning the fifties, sixties, and seventies, retro style is currently enjoying a renaissance, its bold patterns and vivid hues providing an appealing contrast to the sleek lines of contemporary interiors. Indeed, the very success of the modern retro look depends on the juxtaposition of old and new and patterned and plain.

It is a look that is easily adapted to suit a variety of architectural styles, from slick city apartments to rustic farmhouses—and furnishing with retro pieces imbues interiors with a sense of character and history. Ranging from the sleek linearity of **MIDCENTURY MODERN** to the ebullience of **FLOWER POWER**, the look is best suited to smaller rooms such as **HOME OFFICES** and **DENS**, where its cozy familiarity can be exploited to the fullest.

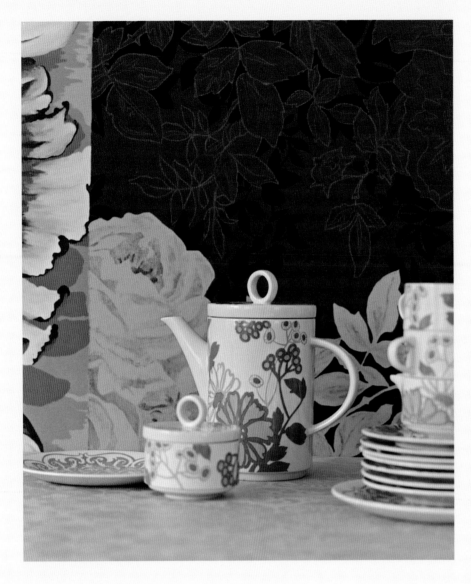

LEFT The straight lines of these solid-looking ceramics are typical of sixties chinaware—as are the bold floral motifs.

OPPOSITE A floral cushion and shag-pile rug warm up this minimalist space.

flashback furnishings

Appealing to a new generation of collectors, the fashion for retro furnishings has been fueled by the likes of interior decorating magazines such as *Elle Decor* and *Wallpaper*, while modernist props on popular TV shows like *Big Brother* and *Frasier* have compounded the trend.

In addition to this, people are redefining the way they live in the twenty-first century. New types of homes, such as minimalist loft-style apartments, are much better suited to the cool lines of modernist furnishings, while bold floral patterns complement stripped wooden floors and neutral-colored walls.

The fashion for collecting retro designs is also flourishing, thanks to the wide variety of items that are available to buy from both the high and low ends of the market. Vintage pieces, ranging from inflatable chairs to fiber-optic lights, can be sourced from auctions and antique fairs, while smaller items such as Whitefriars glass, Midwinter china, and lava lamps can be found in flea markets and junk shops.

It is also possible to buy modernist furniture from a select group of shops specializing in design classics. The availability of retro furnishings has also increased, thanks to furniture companies such as Herman Miller and Parker Knoll reissuing classic chairs, tables, and sofas by designers such as Verner Panton, Joe Colombo, and Hans Wenger.

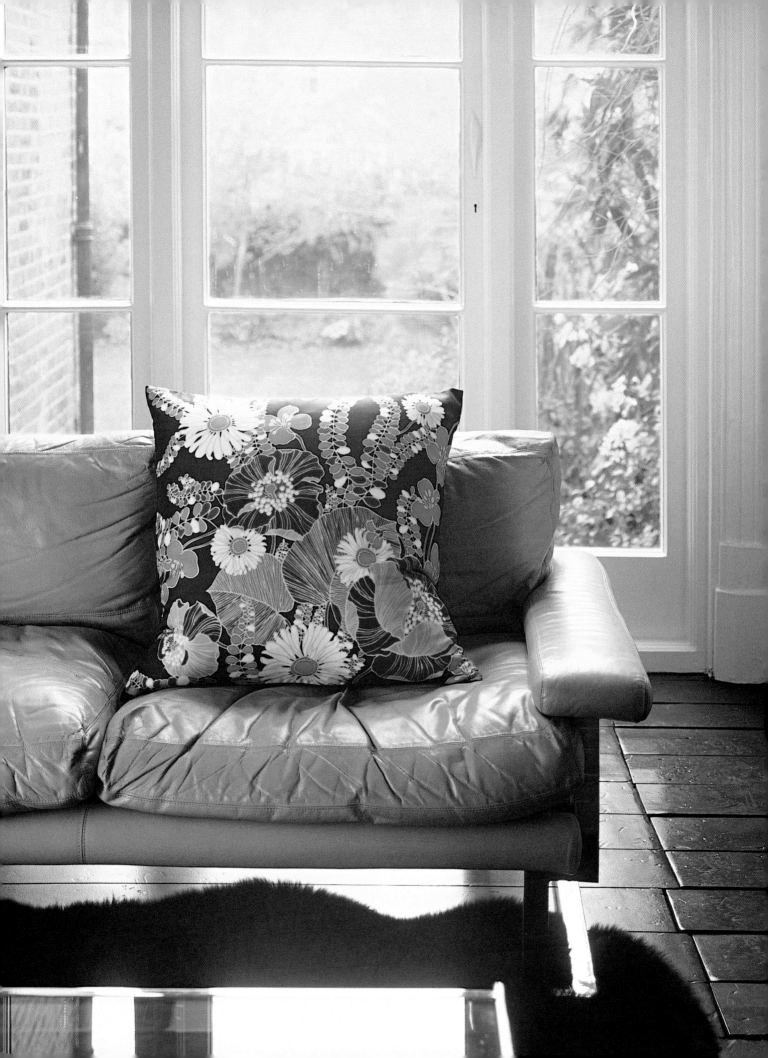

midcentury modern

Most attractive to homeowners who want coolly minimalist homes, the midcentury modern look is currently enjoying a resurgence, its fluid furnishings and neutral palette imbue contemporary interiors with a sense of authentic fifties style. Natural materials such as leather, wood, and slate are also integral to the look, providing an earthy feel that adds texture and warmth, while graphically designed prints introduce pattern and color. Indeed, fifties prints are as bold as they are beautiful—their stylized botanical motifs provide a striking contrast to the spartan lines of midcentury decor. Color-wise, the focus is on organic shades of green, orange, and brown, while occasional splashes of purple and red compound the retro feel.

LEFT Bold stylized botanicals in vivid hues are a quintessential feature of fifties design schemes.

OPPOSITE Wood-paneled walls and streamlined furnishings create a cool Scandinavian feel, while flashes of orange—on the lamp shades and the floral cushions—enliven a neutral palette.

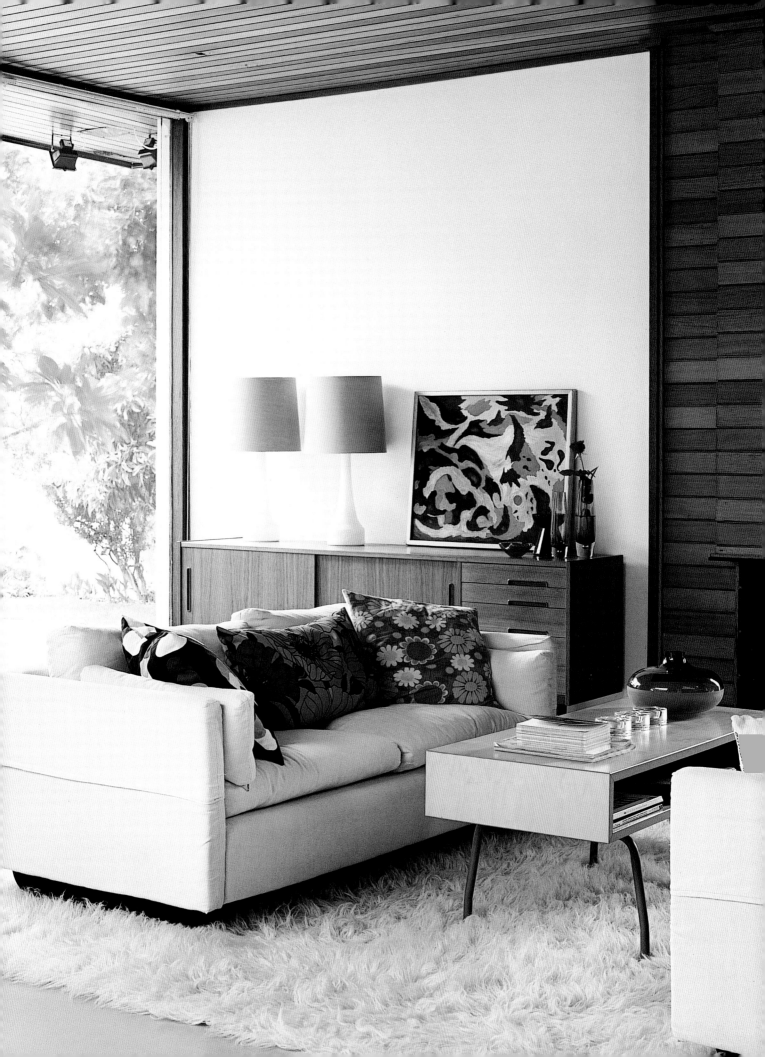

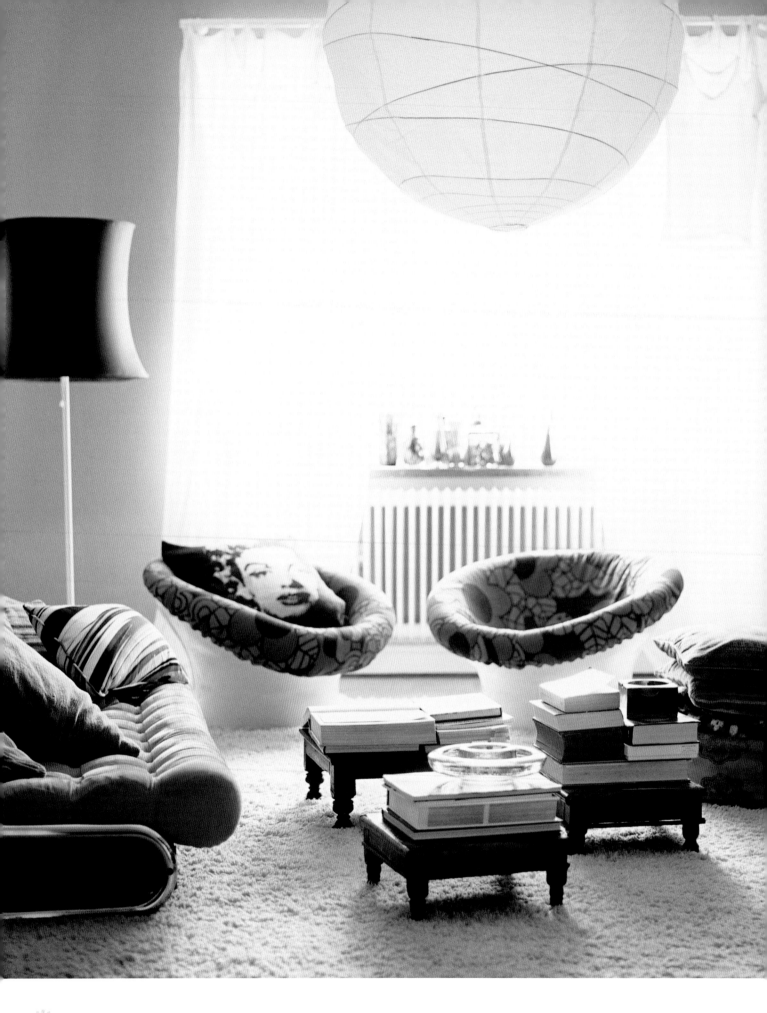

the modern retro look

Best suited to light rooms with big picture windows or sliding glass doors, fifties interiors favor the "less-is-more" approach. It therefore is essential you clear your space to create a clutter-free backdrop for midcentury furnishings such as Arne Jacobsen's teak-faced Ant chair or George Nelson's multicolored Marshmallow sofa.

The fluid lines of postwar furniture, crafted from materials such as plywood, laminate, and tubular steel, create an organic feel, which is compounded by the addition of amoeba-shaped coffee tables and sunburst mirrors. Linear styles are also reminiscent of the period, and include sleek consoles, cabinets, and sideboards with smooth sliding doors.

The presence of streamlined furniture works particularly well in Scandinavian-style rooms where the walls or ceiling are paneled in wood strips. Indeed, Nordic design was a major influence in fifties interiors, focusing on open-plan elevations fitted out with blonde-wood furnishings and light-colored fabrics.

Textural furnishings help soften the spartan lines of midcentury interiors. To recreate the look, introduce shag-pile floor coverings, leather upholstery, and fabric lamp shades, or cover throw pillows with a bold floral fabric. Alternatively, hang a strip of brightly patterned cloth down one wall to create an arresting focal point that is as pretty as it is punchy.

To complete the midcentury look, furnish with a selection of retro accessories. Available from antique markets and Web sites specializing in vintage collectibles, items include colored glassware, bubble lamps, ball clocks, and melamine ceramics with geometric outlines.

OPPOSITE Modular furnishings, oversized florals, and a shag-pile rug evoke a nostalgic feel in this midcentury interior.

ABOVE RIGHT The graphic styling of a bold two-tone floral wall hanging introduces a fabulously retro feel.

PANELS & HANGINGS

Covering panels in a zany floral fabric will introduce a retro feel. If your fabric is sufficiently strong, you can simply staple it over a made-to-measure frame. With a less substantial fabric, the piece may need to be backed with lining or an iron-on interlining. When stapling fabric onto a frame, start at the center of one side and staple it in place, then staple the center of the opposite side, then the center of the two opposing sides. Next, move out to the corners, again working on opposite sides.
❋ Choose a length of fabric—5 ft (1½ m) is a good size.
❋ Fold over the two sides and bottom edge by 2 in (5 cm) and hem. Fold over the top edge to make a sleeve around 1½ in (4 cm) deep, and stitch in place.
❋ Insert a bamboo cane into the sleeve and then tie strong cord to each end of the cane to suspend the wall hanging.

DECORATIVE DETAILS

Whether you opt for an ultragroovy or supersophisticated design scheme, you can be sure to find a wide variety of accessories:

❋ **Kitsch**
Lava lamp
Beatles poster
Fiber-optic light
Litho-printed tea set
Blow-up chair
Disco ball
Plastic flowers
Target table
Psychedelic panel
Beanbag chair

❋ **Cool**
Bubble TV
Andy Warhol's Flower 11 series
Verner Panton's Pantella lamp
Plywood chaise
Potted daisies
Leather cube
Monochromatic print
Eero Aarnio's bubble chair

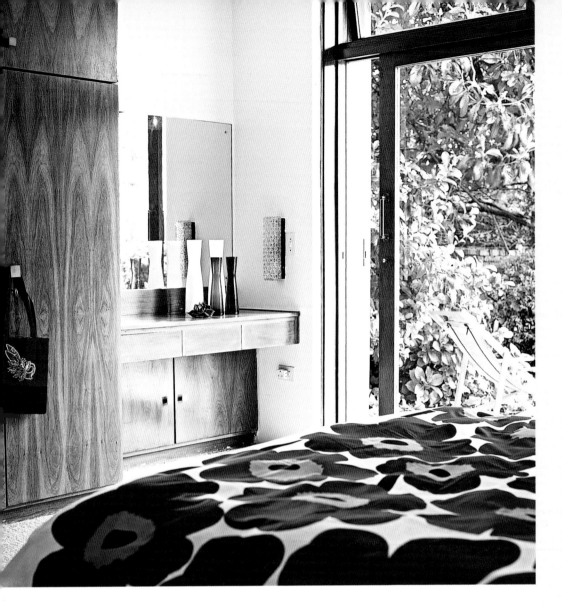

FLORALS BY MARIMEKKO

Currently enjoying a popular revival, furnishings by Marimekko are being snapped up by those homeowners who love the vivid immediacy of its retro prints. As accessible today as they were during the fifties, the Finnish designs are instantly recognizable, their dynamic shapes and vibrant hues fast reclaiming the number one spot for funky floral designs.

Founded in 1951 by visionary designer Armi Ratia and her husband, Viljo, Marimekko pioneered the trend for lifestyle marketing, offering exuberant dress fabrics that were also used to create soft furnishings for the home. Indeed, the company's remarkable history—from its early years through the height of its success during the sixties and seventies—is one of the great design success stories of the twentieth century.

These days, the reintroduction of Marimekko's classic designs has seen a further expansion into the home-furnishings market. Items such as cookie tins and melamine plates jostle with throw pillows, shower curtains, and bed linen, while the company's trademark poppy print is available in a range of retro colors, including red and purple, yellow and orange, and black and white.

Best suited to minimalist rooms that are large enough—and light enough—to withstand the impact, Marimekko designs provide the ultimate in modern retro style.

archival florals

Although tracking down genuine wallpaper and fabrics from the sixties and seventies may take time and effort, it's perfectly possible to source retro prints from specialist shops and Internet sites such as e-Bay selling period collectibles.

Often only available in one or two rolls, vintage papers are best suited to smaller rooms such as hallways, closets, and dens—while rare scraps can be used to cover screens, panels, and headboards. If you want to cover a larger area, your best option is to buy a reissued print. Wallpapers by the likes of Australian designer Florence Broadhurst are now all the rage—limited editions of her famously theatrical florals grace the walls of hip inns and hotels across Britain and America.

ABOVE Marimekko's signature best-selling poppy print compounds the Scandinavian feel in this utilitarian bedroom. **OPPOSITE** A panel covered with vintage wallpaper by Australian designer Florence Broadhurst provides a nice alternative to allover wall coverage.

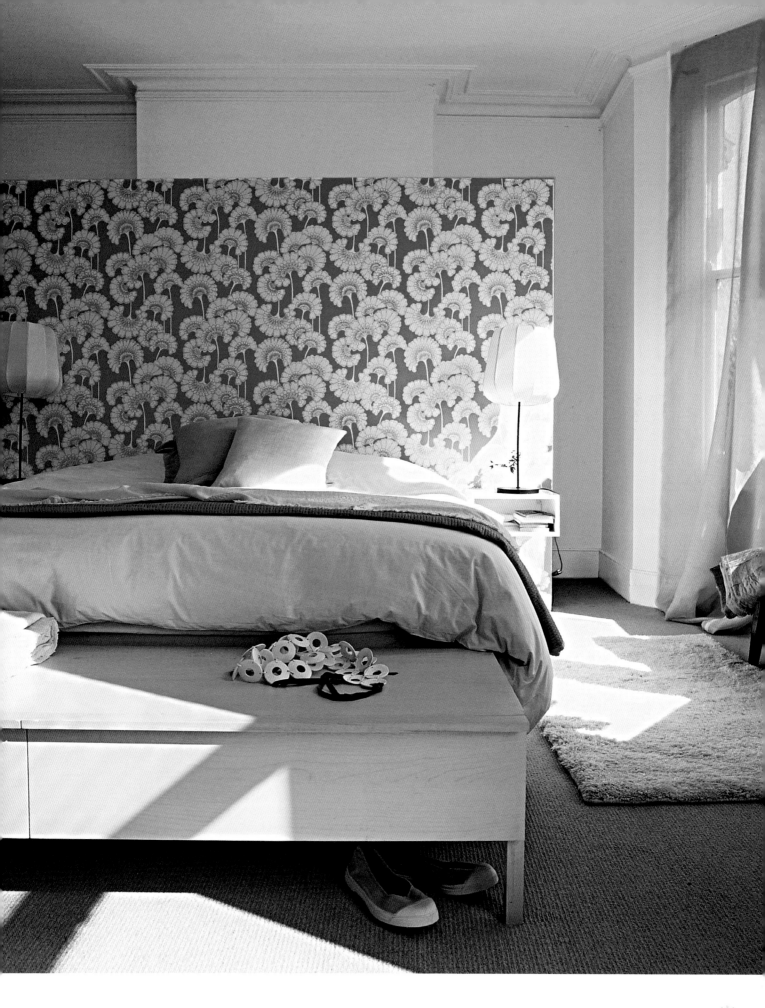

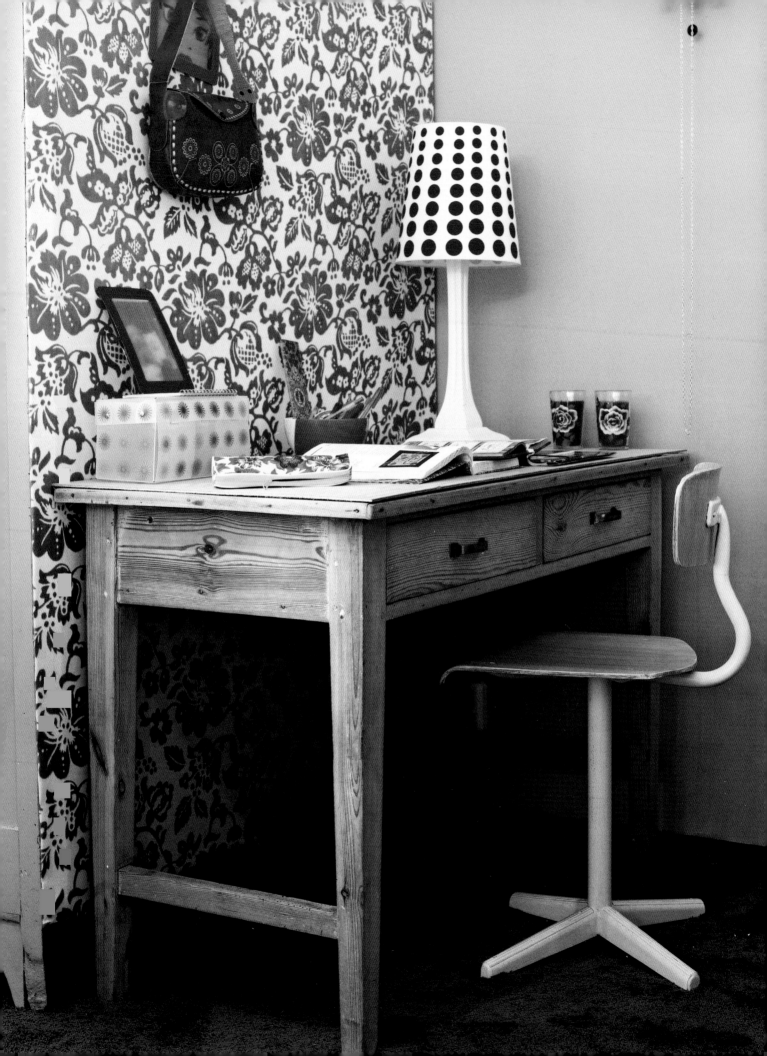

home offices

In the space of a single generation, computer technology has revolutionized our professional lives, allowing many of us the luxury of working at home. Not only does this offer an escape from the trials of the daily commute, but it also lets us devise a working environment where the decor reflects our aesthetic sensibilities.

Whether you want to create a serious home office or an "admin" corner for catching up on paperwork, retro furnishings provide an appealing combination of classic elegance and functional style. Indeed, midcentury designs such as Marcel Breuer swivel chairs were created specifically for office use, while Charles and Ray Eames's steel units, complete with alternating shelves and drawers, offered the ultimate in stylish storage.

To soften the industrial lines of office furniture, introduce pattern and color via wallpaper and upholstery. Covering office chairs with a vintage floral is an excellent way of jump-starting your space, for example, while retro wall hangings introduce a homey feel. If you want to keep your walls plain, use old-fashioned papers to decorate a variety of objects, ranging from box files to bulletin boards.

It's also possible to create a midcentury modern look through the addition of a few key details. An Anglepoise lamp, wire wastebasket, and fifties Ericofon will all help to conjure the ambience of an old-fashioned study, while a chunky schoolroom clock or wooden geometry set are guaranteed to compound the vintage feel.

flower power

Although contemporary designers are now producing a raft of funky floral motifs, nothing beats the bold blooms of the sixties and seventies. Indeed, the retro appeal of vintage florals has seen a number of homeowners cashing in on the key elements of Flower Power style—floral wallpaper, streamlined furniture, psychedelic colors, and low-level seating are reinterpreted to suit the modern home.

Flowers, especially simply drawn ones, were the quintessential symbol of the sixties—appearing on fabrics, ceramics, and wallpaper. Originally inspired by the hippie movement, when flowers were poked down the muzzles of guns to protest against the Vietnam war, floral motifs revolutionized home furnishings, injecting interiors with a vibrancy that had never before been witnessed.

LEFT Originally inspired by more elaborate Art Nouveau styles, sixties florals were simplified over time.

RIGHT A chrome table gives a midcentury feel, while the modular lamp and floor cushion are reminiscent of the sixties. The elements are brought together by a soft pink palette.

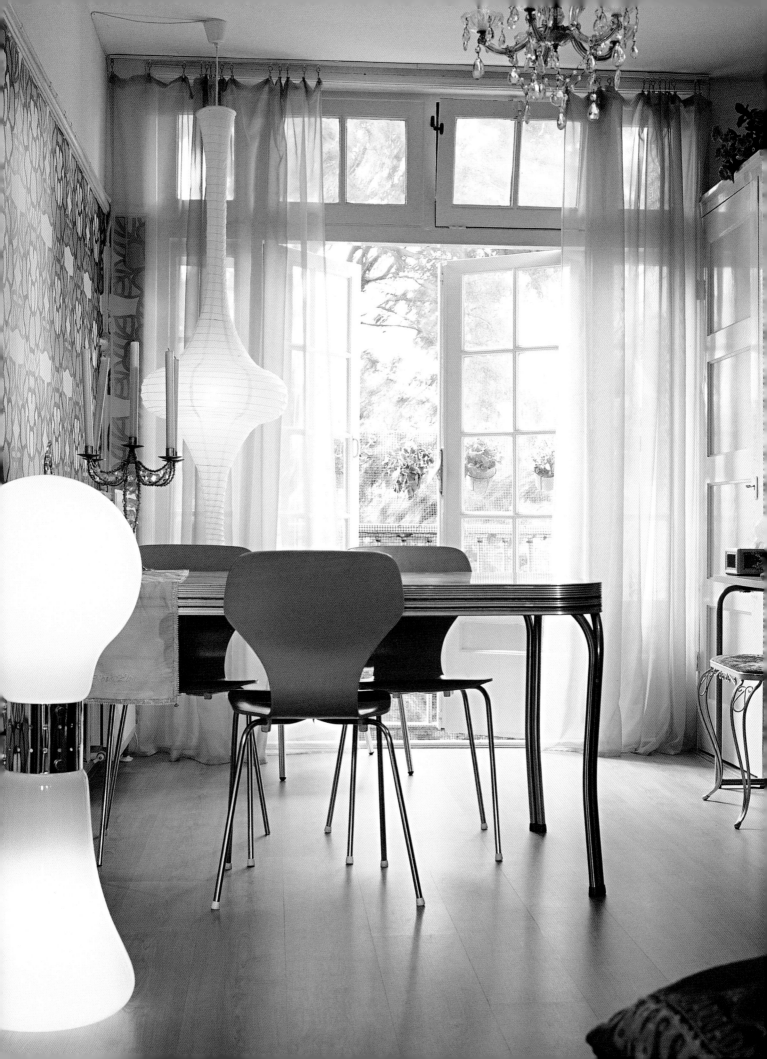

sixties psychedelia and seventies kitsch

Taking their cue from the stylized botanicals of Art Nouveau, sixties florals evolved as the decade drew on. Becoming increasingly childlike, their naïve outlines were brilliantly enhanced by a palette of acid-bright hues as the fashion for drug-induced psychedelia gathered pace.

Perhaps the most famous flower of the day was Mary Quant's daisy, which not only appeared on all her fashion products, but also sprang up throughout the decorative arts. In addition, Quant's simple motif—a white flower on a black background—provided a graphic contrast to the brilliant blooms of Pop Art, which featured overscaled flowers that were often stylized to the point of abstraction.

Fabric designs also became bigger and brighter during the sixties. Thanks to the advances in printing technology and the advent of permanent dyes, textile artists were able to group brilliant colors together to dazzling effect. Favored combinations included red and purple, orange and pink, and purple and orange, while the fashion for lime-green and peony-pink added another layer of vibrant color.

The trend for floral motifs and vivid colors continued well into the seventies—together with the fashion for hippie chic. Added to the glut of brilliant blooms was a pyschedelic reworking of the classic English paisley print, which saw the signature teardrop motif being blown up to huge proportions and distorted in order to incorporate the "lazy daisy"—a sixties favorite that remains popular to this day.

Considered by many as the decade that style forgot, the seventies witnessed an extraordinary number of aesthetic influences—from the tail end of pyschedelia to the razzle-dazzle of glam rock. Folk art was also popular, while the fashion for ethnic glitz—inspired by hippie trips to India—compounded the eclectic feel. As a result, seventies interiors featured a hodgepodge of designs, including modular furniture, shag-pile carpets, tinted mirrors, lurid lamp shades, and sequined floor cushions.

Toward the end of the decade, the fashion for psychedelia had given way to a softer, more neutral palette. Furnishings in mustard, avocado, and chocolate brown complemented the occasional splash of brilliant tangerine, while shades of purple—including mauve, violet, and lilac—reigned supreme.

LEFT Pretty floral bouquets floating on a washed-out background evoke the nostalgic appeal of days gone by.
OPPOSITE Childlike blooms in a variety of candy colors are combined with butterfly motifs to create a quirky botanical feel.

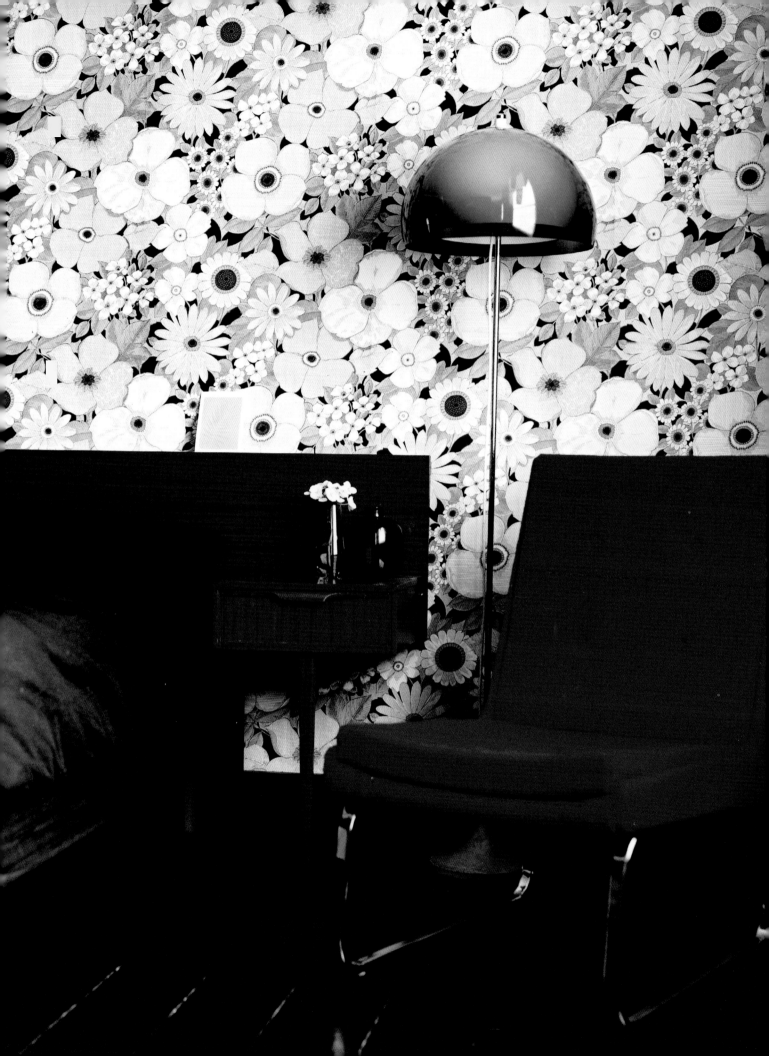

wall flowers

Bold floral wallpaper was a quintessential feature of sixties and seventies design schemes, its overscaled motifs and rich colors reflecting the ebullience of the Flower Power era. But while interiors in the sixties featured wallpaper on all four walls, seventies-style rooms favored a clash of different designs—including funky florals and jazzy geometrics.

Metallic wallpapers were also popular during the seventies. Inspired by the fashion for all things disco, typical designs included plant and leaf motifs set against gold and silver backdrops. Flock wallpaper enjoyed a similar renaissance, moving from the environs of seedy nightclubs into residential room schemes. Helping to compound the trend for textural contrasts, flock provided a nice juxtaposition to the smoother surfaces of metal and slate.

TIP: If the impact of retro wallpaper is too dramatic for your liking, why not dilute the effect with paper cutouts? Simply find a roll of floral wallpaper or piece of vintage fabric that you like, cut out the motifs that appeal the most, and paste them onto your walls. This way, you can control the decorative impact, while still achieving a period feel. For best results, opt for florals with clear outlines in Day-Glo colors such as sunny yellows, oranges, pinks, and acid green. Alternatively, decorate plain walls with borders featuring sixties flowers in a range of psychedelic shades.

OPPOSITE Seventies wallpaper designs in shades of chocolate brown are still available for purchase from specialist shops.
ABOVE RIGHT Floral motifs that have been cut out from retro papers and glued onto a plain background are a new spin on vintage wallcoverings, giving a more restrained approach than allover coverage.

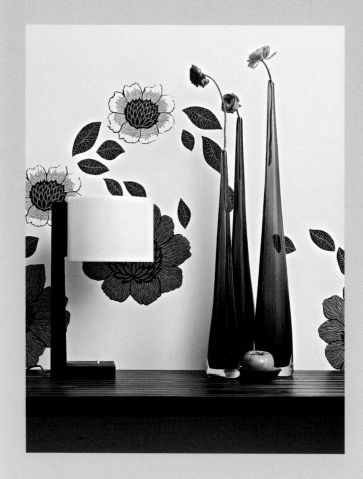

DECORATING WITH RETRO FLORALS

✳ Bold florals are a great way to correct a room's architectural defects as the directional stress of the pattern takes the eye beyond the flat surface of the wall, creating interest and depth.
✳ For a more sophisticated feel, contrast funky floral wallpaper with plain walls painted in complementary shades.
✳ To counter the rigid lines of modern interiors, select a softer, more fluid pattern.
✳ Use branching diagonal patterns in stairways and halls to lead the eye upward naturally.
✳ A large pattern need not necessarily dominate the proportions of the room. Instead, choose a pale color to reduce the impact of a dominant design.

✳ Using pattern successfully is all about scale and balance. If you love the texture of velvet, for example, but want to retain a light, modern feel, decorate one wall with a decorative flock, which will add a period feel without completely dominating the space.
✳ Use swatches of wallpaper to jazz up functional features such as headboards and screens.
✳ To create a funky patchwork effect, use a variety of ready-made wallpaper panels and fix them onto the wall in a medley of clashing designs.
✳ Mix horizontal and vertical panels across the room and combine them with painted areas of wall to produce linear and textural contrasts.

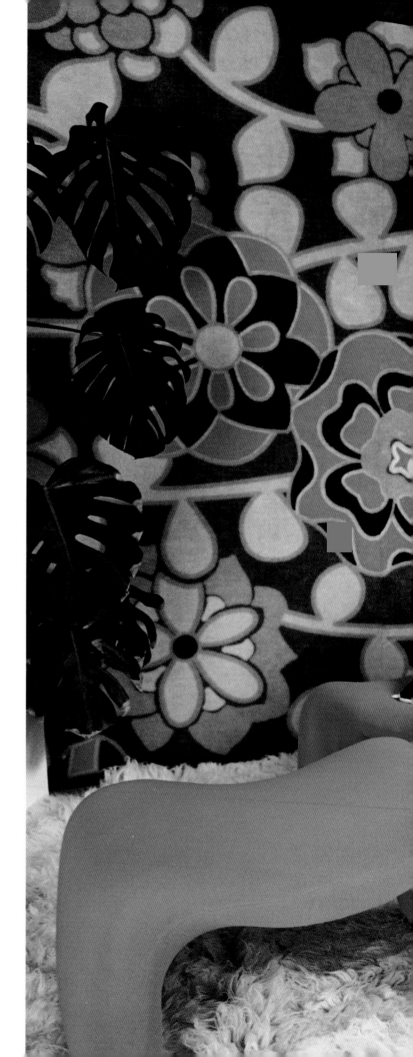

dens

Thanks to the availability of modernist furnishings, it's easy to recreate a retro feel in your interiors. Better still, the graphic immediacy of decorative items from the sixties and seventies enables homeowners to introduce a sense of nostalgia—either through the inclusion of authentic vintage furnishings or via a few key accessories.

Particularly well suited to smaller sitting areas such as dens, the retro look focuses its attention on laid-back lounging. Indeed, keeping your seating sleek and streamlined is a great way to conjure the ambience of those sixties "conversation pits," which comprised a recessed floor area surrounded by low-level seating.

Papering walls with a funky floral print is another way to evoke a vintage feel. Not for the fainthearted, sixties and seventies wallpaper designs can be used as allover coverage, or restricted to a single "feature" wall in order to create a striking focal point. Similarly, fabric featuring bold botanicals can either be used across a variety of soft furnishings or on a couple of cushions as a bold statement.

Modular furniture in brightly colored plastics is also key in retro interiors. A Panton S chair in scorching red will complement vibrant room schemes, while the same design in white will help to create a space-age feel. If you can't afford an original modernist piece, introduce newly produced stacking chairs, reminiscent of original plastic designs by the likes of Robin Day and Wendell Castle.

> **TIP:** Invariably associated with the hippie movement, burning incense is one of the easiest ways to recreate a chilled sixties vibe. For authentic aromas, opt for floral-scented incense such as jasmine, lavender, lotus flower, honeysuckle, and white lilac.

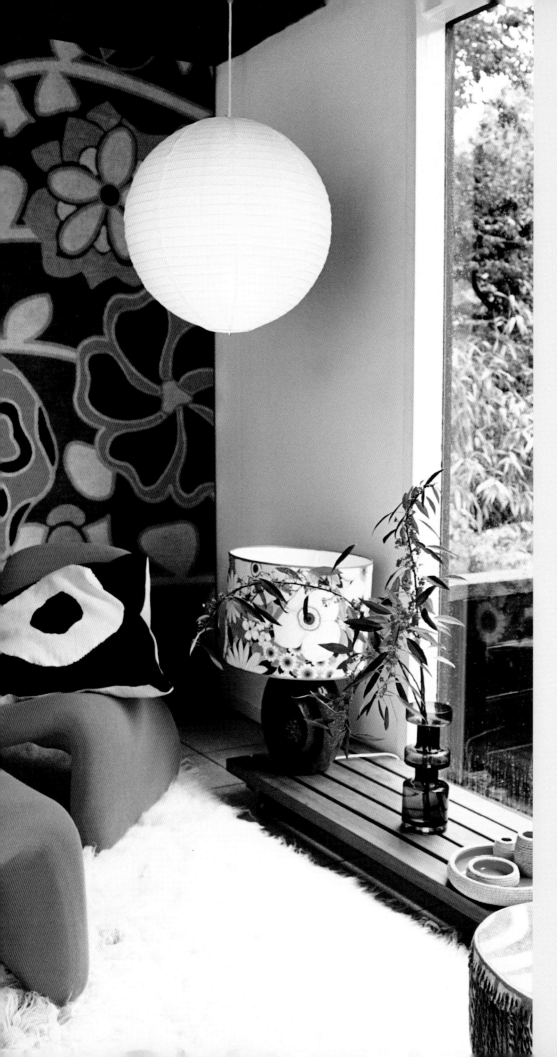

HIPPIE CHIC

Although graphic furnishings were a predominant feature in sixties and seventies interiors, the fashion for hippie chic also had a popular following. Offering a softer alternative to stark modernist lines, the look included walls painted in saturated shades of red, green, and orange, and furnishings draped with layers of ethnic fabrics. Low-level lounging was another feature of hippie interiors. Inspired by Morrocan and Turkish dining culture, the trend for kilim floor cushions evolved to include all sorts of floor cushions, including bolsters, poufs, and beanbags upholstered in floral fabrics.

These days, scattering your floor with a couple of cushions is one of the quickest and easiest ways to introduce a retro feel. If your interior has a modernist bent, large square pillows upholstered in a bold floral will soften the effect, while those with hippie leanings should opt for oversize cushions covered in Indian block prints or Indonesian batiks. Make sure that your cushions are of the super-soft feather-filled variety, as there's nothing remotely welcoming about stiff foam styles.

LEFT A single wall of graphic-print wallpaper, the organic forms of the modular seating, and a cream shag-pile rug give this den an authentic retro feel, while the globe light and orange-and-brown palette complete the look.

vintage florals

Timeless yet contemporary, the vintage look meshes decorative styles from the past and the present to create a cozily coherent whole. Fabulously versatile, its faded charm and sense of antiquity can be adapted to suit a variety of different dwelling places, allowing for interior schemes that look as individual as they do welcoming.

Floral fabrics, in particular, create feelings of lived-in domesticity; antique lace curtains, patchwork quilts, damask drapes, and embroidered tablecloths create a textural warmth that is the antithesis of stark minimalism, while furniture is imbued with the rosy resonance of days gone by. Though it is frequently associated with cluttered maximalist interiors, it is also possible to embrace vintage style through the inclusion of a few, carefully sourced pieces.

Whether you opt for a **MODERN ECLECTIC** look or a **CONTEMPORARY COUNTRY** one, you'll find that vintage style is attractive, informal, and easy to live with. As workable in country cottages as it is in urban lofts, modern nostalgia works best in **BEDROOMS**, **DRAWING ROOMS**, **KITCHENS**, and **LAUNDRY ROOMS**.

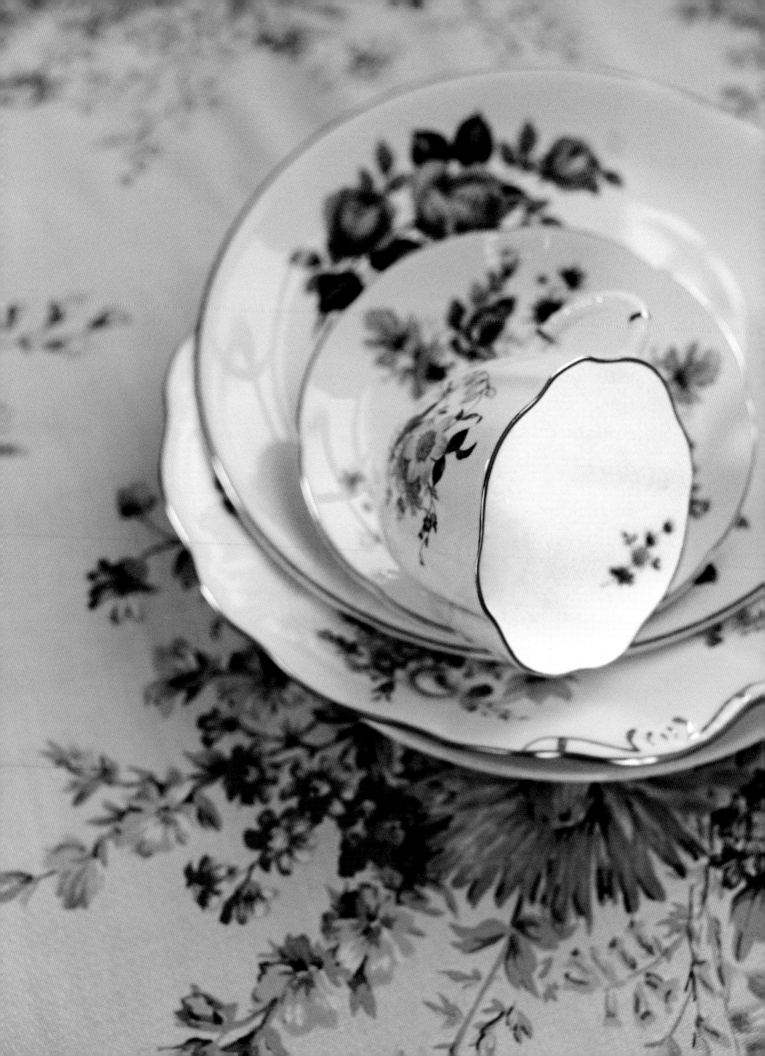

sourcing vintage florals

There can be few pursuits more rewarding than trawling for antique treasures. The frisson of excitement when you finally track down that elusive chintz teacup is unbeatable, while the expectation of stumbling across a truly original find makes the whole process doubly gratifying. Most cities and towns have salvage or junkyards, while other sources include antique markets, collectors' fairs, charity thrift shops, and trunk sales. Local auctions present further opportunities for picking up vintage pieces, while contacting dealers whose main business is tag or estate sales provides an excellent chance to buy job lots at reduced prices.

Another, more modern alternative is to use the Internet, where there are numerous sites run by antique dealers of all kinds. This is a particularly good idea if you are looking for something specific, as sourcing vintage pieces electronically is obviously much quicker than trekking around markets on foot. You also have access to dealers in other countries, so you could widen your search even further.

One of the reasons why decorating in vintage style is so rewarding is that the majority of items you introduce into your home are likely to be one of a kind. Handcrafted pieces, such as floral tapestries or toile candleholders, for example, are a million miles from the bland conformity of manufactured fixtures, while choosing sun-faded fabrics and quirky knick-knacks will enable you to create interiors that are imbued with memory and meaning.

OPPOSITE Displaying delicate floral china is a great way of introducing a vintage feel into your interiors. Providing the perfect excuse to throw an old-fashioned tea party, floral cups and saucers also make attractive display items. For best results, showcase pretty ceramics in glass-fronted cabinets; alternatively, arrange them on Welsh dressers, so that they become an integral feature of your design scheme.

MAKE THE MOST OF ANTIQUE MARKETS

❈ Make sure that you arrive as early as possible to beat the crowds and get a good look at everything being offered.

❈ Keep an open mind; it's impossible to plan purchases in advance, so relax and go with the flow.

❈ Take cash rather than debit cards or a check book, as some vendors will refuse to accept anything else. You'll also be in a better position to bargain if you're using cash.

❈ Don't forget that you can mix furniture, ornaments, and fabrics from different eras and cultures.

❈ Steer clear of pieces that are badly damaged, especially if you have neither the time nor the financial resources to fix them.

❈ Very few vendors deliver, so arrange transportation if you're planning to invest in some larger items.

❈ When you spot something you really like, don't let it become too obvious. Sellers immediately ask for more money if they see that you're keen on a particular item, while other buyers may catch your enthusiasm and beat you to it.

❈ It may take you more than one attempt to find the piece of your dreams, so persevere; it's impossible to predict what will come up for sale, and you never know when it will be your lucky day.

❈ Keep your eyes peeled for items such as cane headboards, leather or wooden trunks, faded rugs, and mottled mirrors.

❈ Using your imagination, examine vintage pieces for their untapped potential. For example, old window moldings can be used to frame pictures, while black wrought iron furniture can be transformed by a coat of white paint.

modern eclectic

Decorating your space with a selection of disparate furnishings is the best way to create an interior that is as individual as it is appealing. Best suited to bohemian types, who want to create an environment that looks like it has been casually thrown together, modern eclectic style pushes the mix-and-match effect to its maximum potential. Thus, florals are teamed with stripes, toile de Jouy is juxtaposed with gingham, and tiny buds feature alongside bold botanicals. Textural fabrics are also key in modern eclectic interiors—with old-fashioned fabrics including patchwork quilts, lace cloths, sweetly embroidered cushions, and velvet drapes. Furniture-wise, choose from four-poster beds, delicate side tables, and elegant chaises longues.

LEFT Overblown rose motifs evoke a sense of days gone by.
OPPOSITE A graphic floral brightens up the mullioned window in this contemporary living room, while a mix of modern and vintage cushions helps to compound the eclectic look.

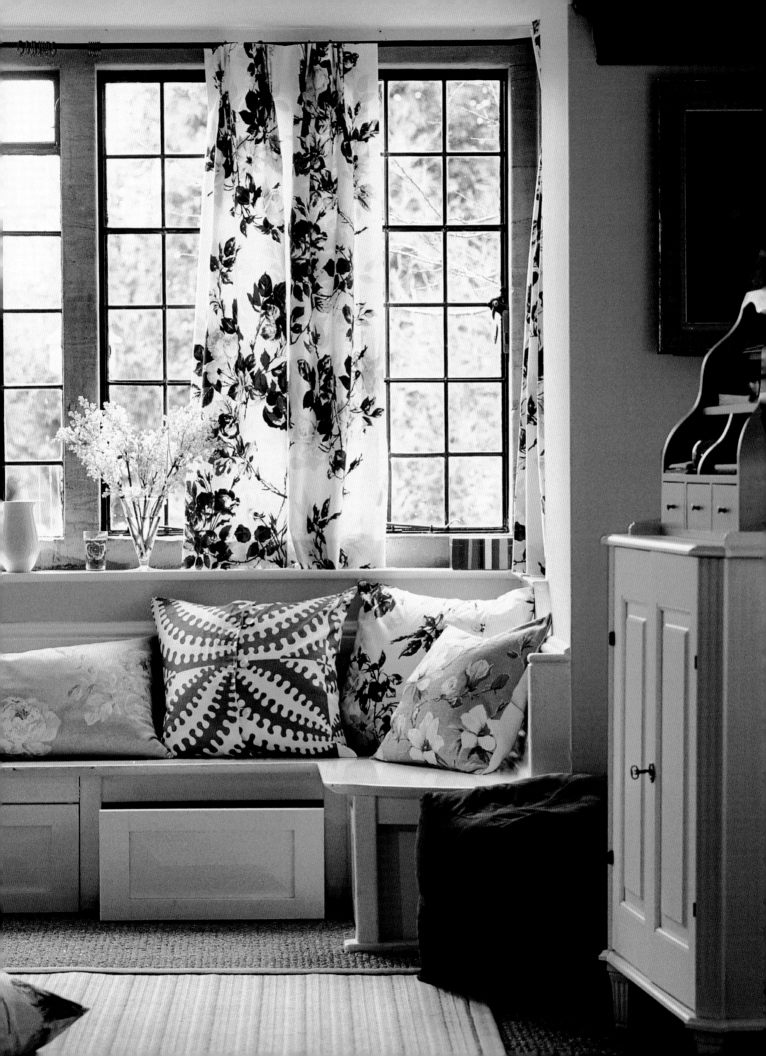

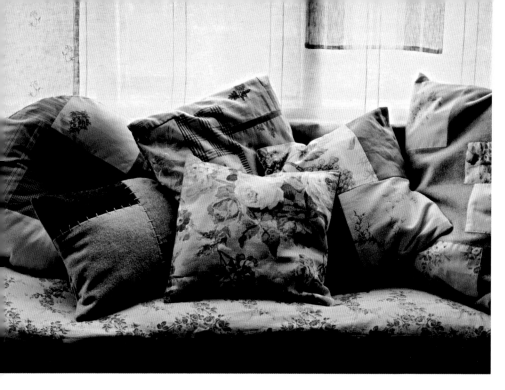

thrift florals

Recycling fabrics—either by making simple repairs or by cutting things up and making something else from them—is one of the principal pleasures of vintage style. After all, what could be more satisfying than giving a chair seat a stylish new makeover, or re-covering a lamp shade with material that has been recycled from a 1940s tea dress?

The antithesis of today's throwaway culture, thrift crafts such as quilting and rag-rug-making have been in evidence for hundreds of years. Indeed, the practice of cobbling together fabric scraps is witnessed around the world as generations of women continue to recycle old materials in order to make new ones.

Fashionably folksy, patchwork looks particularly inviting in eclectic drawing rooms, where its homespun appeal ushers in feelings of warmth and hospitality. Used to create a variety of soft furnishings, its most popular incarnation is in the form of quilting, an age-old practice that has become an art form in America.

Although many manufacturers produce ranges of fabric especially designed for making up patchwork (some of it reproduced from old prints), the fundamental ethos of stitching scraps of material together springs from the practical element of recycling and reusing. To create the most successful designs, choose textures, prints, and colors that complement each other. Florals are a perennial favorite, together with checks, stripes, dots, and spots. It is possible to create an all-floral quilt, just so long as you ensure that the essential element—variations on a pattern—remains the same. Additional fabric supplies can be sourced from dress material, damask napkins, scarves, bed linen, tea towels, tablecloths, and drapes.

Smaller pieces of velvet, brocade, and satin, along with fragments of embroidery, can also be pieced together to make patchwork, either in conventional hexagonal patterns or geometric blocks or, alternatively, in much more informal-looking shapes. Although patchwork quilts are usually thought of as a classic period bedcovering, they work equally well in vintage drawing rooms, where they can be draped over a sofa to create a colorful seat or suspended from a pole and displayed as a wall hanging.

TIP: Use fabric remnants to make pretty lavender cushions; vintage cotton florals look particularly attractive.

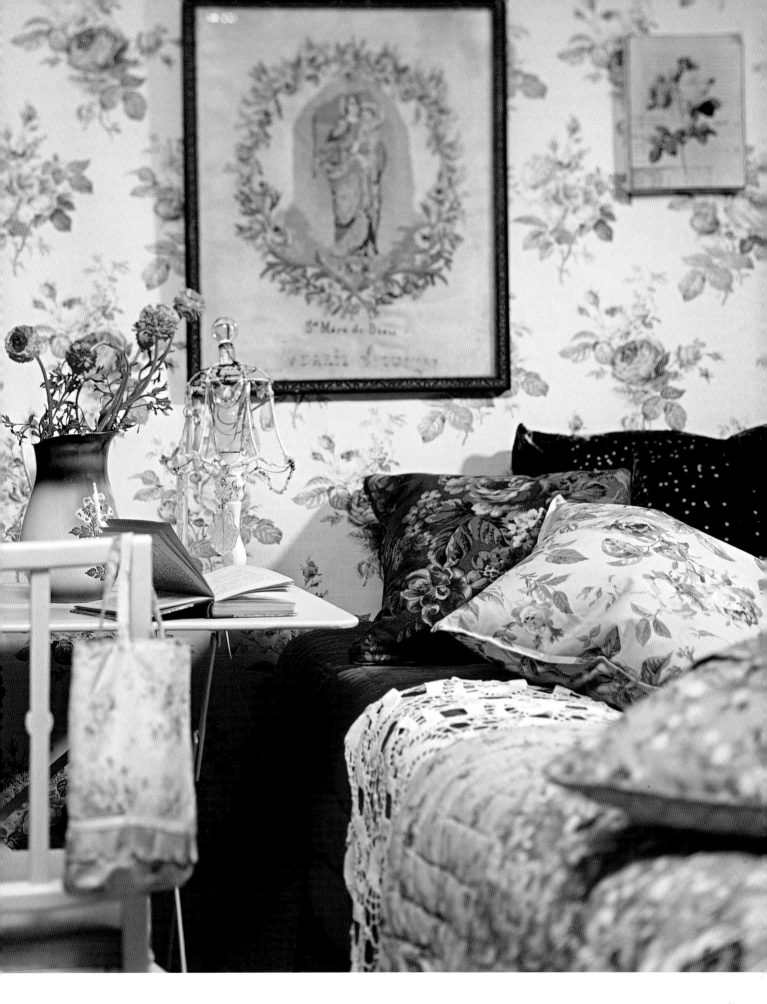

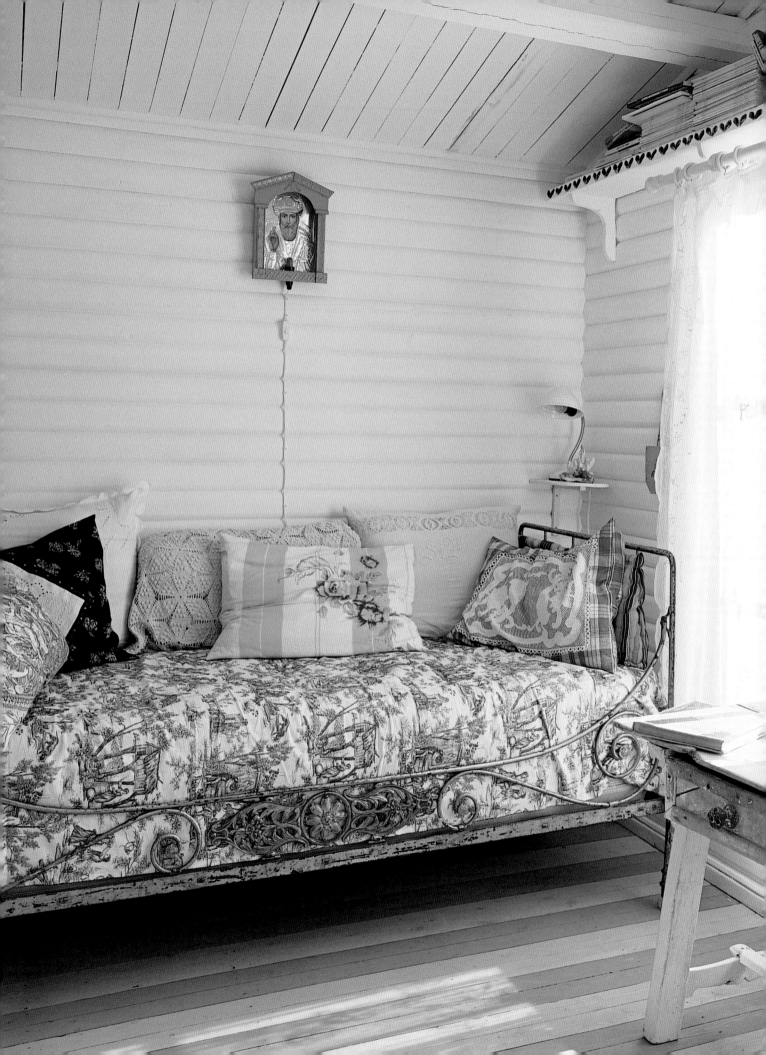

OPPOSITE Appliqué and lace cushions complement the wonderful toile de Jouy cover on this ornate metal bed.
RIGHT An embroidered lace and cutwork tablecloth offers the ultimate in floral vintage chic.

applied florals and lace

After years spent in chilly fashion Siberia, embroidery, appliqué, and knitted fabrics have now reentered the mainstream, thanks to the fashions on the catwalk filtering down into the home. Offering a decorative alternative to minimalist materials such as leather and suede, embellished textiles introduce an element of tactile glamor into modern interiors that has been absent for far too long.

Whether you choose to incorporate cushions embroidered with old-fashioned pansies or a knitted throw embellished with felt flowers into your home, the vintage drawing room is the perfect place to do it— particularly if its main focus is a bohemian mishmash of different colors, patterns, and textures. That said, decorative textiles work equally well in neutral settings, where there are fewer visual distractions. For example, a statement piece such as a single gorgeously decorated cushion is shown off to its best advantage when set on a plain divan, while larger expanses of pattern and color—a brilliantly appliquéd floral throw, for example—

look similarly striking on furniture that has been simply upholstered, set against a plain backdrop of neutrally colored walls.

A period fabric that also manages to look perennially fashionable, lace imbues vintage interiors with atmosphere and panache. Available in a wide variety of widths and patterns, ranging from the simplest of triangles to more ornate botanically based designs, it can be as fragile as a cobweb or more opaque, as cutwork or crocheted panels.

Best kept to shades of white or cream (pastels such as lavender and rose can look a bit too sugary sweet), lace fabrics make ideal cloths for occasional tables, and can also be used to provide coverage for the backs of sofas and chairs. Other options include lace curtains, which will softly dilute light, depending on the density of pattern, and lace wallpaper, which works best when it is contrasted with plain painted walls. If you don't want to go the whole nine yards, look for pieces of old cotton lace or lengths of white crochet edging and use these to trim your cushion covers or table throws.

timeworn treasures

Object displays are a significant part of vintage interiors, offering yet more opportunity to stamp rooms with a sense of your personal history. Predictably, there are few strict rules about what to include and what not, although the quirkier and more eclectic your collection, the better. It's also advisable to remember that eccentric objects work particularly well in vintage interiors simply because the general effect is greater than the sum of its parts.

One of the best ways to create an intriguing display is to ensure that you include only objects that speak to your heart—relics from your childhood, for example, or items that you have picked up while traveling abroad. By the same token, found objects such as shells, stones, leaves, and feathers will also strike an authentic note, thanks to their intrinsic beauty and their sense of organic naturalism.

Combining objects to create an attractive display tends to involve a good deal of trial and error; helpful pointers include grouping objects together from a similar period—even when they're made from very different materials— or opting for bizarre juxtapositions in which disparate groups of items are featured. For example, colored glassware, an antique figurine, silver snuff boxes, and a windup toy will all give vintage-style drawing rooms a sense of history and heart.

Objects that make you smile are a must. An old Snoopy mug filled with hydrangeas in bloom makes much more of a statement than a cut-glass vase filled with two dozen carnations, for instance, while a whimsical china animal or a souvenir wedding plate add a kitsch element that rarely goes amiss. It's also possible to lighten the appearance of heavyweight antiques with playful additions such as a string of floral fairy lights draped over a somber oil painting or a saucy postcard tucked inside a gilt frame.

When it comes to eclectic displays, the most important thing to remember is not to go overboard. Too many decorative pieces— however pleasing they may be individually— will cause visual mayhem if they're bunched together. Instead, restrict yourself to a few cleverly positioned vignettes, especially in rooms that sport the vintage minimalist look.

ABOVE LEFT A collection of painted and gilded antique glass containers conjures up a superb sense of nostalgia.
OPPOSITE Vintage trimmings spilling out of a rose-patterned box are reminiscent of an old-fashioned haberdasher.

"EVERYTHING'S COMING UP ROSES." Stephen Sondheim, songwriter

bedrooms

The modern eclectic interior borrows from a wide variety of sources to create a style that is as adventurous as it is colorful. Particularly well suited to lush bedrooms, where exquisite textiles in life-affirming colors can be displayed to their maximum potential, the focus is on a cross-fertilization between styles and traditions —as opposed to a glut of themed collections.

The best way to create a bohemian boudoir is to combine antique furniture styles with modern ones: a 70–30 mix works well, as long as you make sure that the majority of pieces are in the contemporary mold, as this will enable you to create a unique decorative scheme rather than a pastiche of a period interior. It's also possible to strike a balance between old and new by teaming nineteenth-century floral paintings with modern photographs, or by accessorizing a brand-new bedspread with a selection of charmingly threadbare cushions.

Vintage fabrics work particularly well in bedrooms, thanks to their old-fashioned allure and soft approach. In addition, there is an intriguing heritage of antique textiles available to us today, from Victorian chintzes to stylized 1960s blooms.

For best results, combine florals with contemporary furniture for a modern-country feel, or create a cottage-garden look by setting spriggy prints against a bright white background. Sensuous fabrics such as velvet, satin, chintz, lace, and organza evoke a sense of glamor and romance, while textiles that are embroidered, appliquéd or made from patchwork give a fashionable folksy feel.

RIGHT The clever use of luxuriant fabrics and rich colors creates an atmosphere that is stylishly eccentric rather than garish and overdone, while the modern-vintage mix compounds the uniquely glamorous feel.

"I HAVE NO RECIPE FOR HOW TO COMBINE THINGS. BUT YOU MUST BE SINCERE.

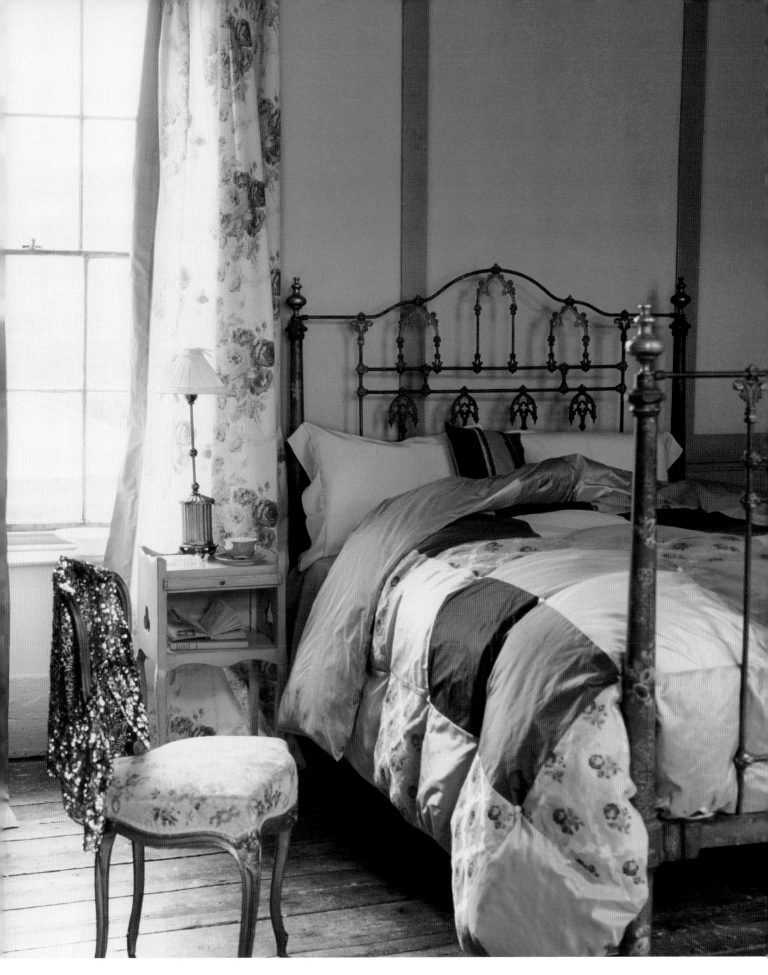

AND IF YOU ARE, STRANGELY, IT WILL SUCCEED." Andrée Putman, interior designer

mixing and matching

The bedroom is the most indulgent room in the home and it provides the perfect space for allowing your floral fantasies to run free. Indeed, there are few limits to how many prints you can include, so long as you focus your attention on a single area. Layers of floral prints look effective on beds, for example, offering a funkier, more flexible alternative to full sets of matching sheets and pillows, but remember, it's important to create a calming balance; after all, this is supposed to be a place of rest.

To mix and match bedclothes successfully, you need to ensure everything else in the room is kept neutral. By removing, editing, and simplifying the rest of your decor, the fabrics are able to reign supreme. A group of textiles need not share a common date or origin, provided the patterns have a resonance among themselves. Better still, not sticking to the same pattern throughout offers the chance to create exciting compositions full of dramatic changes in scale and outline; it also means that old and new can be combined to make a more individual statement about your design personality.

What goes well together is not an exact science, but similar colors and shades—as well as related motifs—are good starting points. To prevent confusion, choose a selection of designs that are alike in terms of color, mood, or type, but steer clear of similarity in size. One may be multicolored, another feature a dominant color from the first together with white, and a third display a duet of two-tone shades.

You can also mix and match designs from different eras, provided you keep a common color theme, as too many different shades can make a room appear overly busy. To avoid a cluttered Victorian look or a clashing pattern overload, ensure that you mix only prints and designs that fall within a similar color range, and that you keep the background—the floors and the walls—neutral where possible.

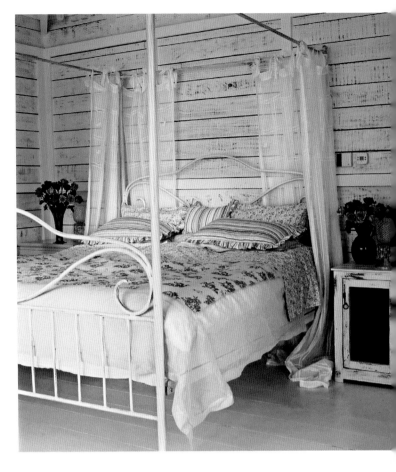

Although you can use any sort of floral patterns for your bohemian bed, the vintage look undoubtedly works best. Sun-faded fabrics that have seen some wear and tear go together much more comfortably than brand-new ones, for example, while the bright hues of funky florals can look garish and over-bright.

As far as cushion covers are concerned, why not put different designs on each side? A bold chintz combined with a striking plaid, for example, provides double the decorative choice, as well as an element of the unexpected.

> **TIP:** Do practice some restraint on the mix-and-match front, or your room may end up looking like it belongs to an old lady.

OPPOSITE Mix vintage fabrics from the same period to create a spontaneous sense of coherence.

ABOVE Juxtaposing floral fabrics with striped ones remains a popular decorating technique—with good reason.

drawing rooms

The key to creating a modern eclectic look is to ensure that your lounging area is as comfortable as it is stylish. There is absolutely no point in creating a showcase brimming with vintage finds and then discovering that it's too rarified to actually kick back and relax in. This is a particularly salient point with regard to vintage-style drawing rooms, which should aim to combine essential comfort and accessibility with flair and individuality.

Luckily, this sums up the essence of vintage style, which places its main focus on cozy, timeworn furnishings that are also easy on the eye. After all, what could be more conducive to relaxation than a huge comfy sofa, upholstered with a unique floral throw, or an alluring window seat scattered with a rag-tag of mismatched cushions?

Because they tend to be larger than other rooms in the house, drawing rooms provide an excellent domain for the modern eclectic look. Spacious enough to accommodate a hodgepodge of furniture, ornaments, and fabrics from different eras and cultures, their development should be should be viewed as something that slowly evolves over many years.

To create a truly successful vintage interior, patience is paramount. Although there are no hard-and-fast rules, it is vital to remember that the main criteria for choosing vintage pieces is that you really like them and will enjoy living with them. Understandably, accumulating such a collection of heartfelt treasures takes time, but the end result—a genuinely nostalgic room that reverberates with a sense of history—is surely well worth the wait.

RIGHT The charming appeal of this vintage drawing room is based on its eclectic furnishings, old-fashioned upholstery, and quirky decorative accessories, including a stepladder propped against a wall and a set of weighing scales.

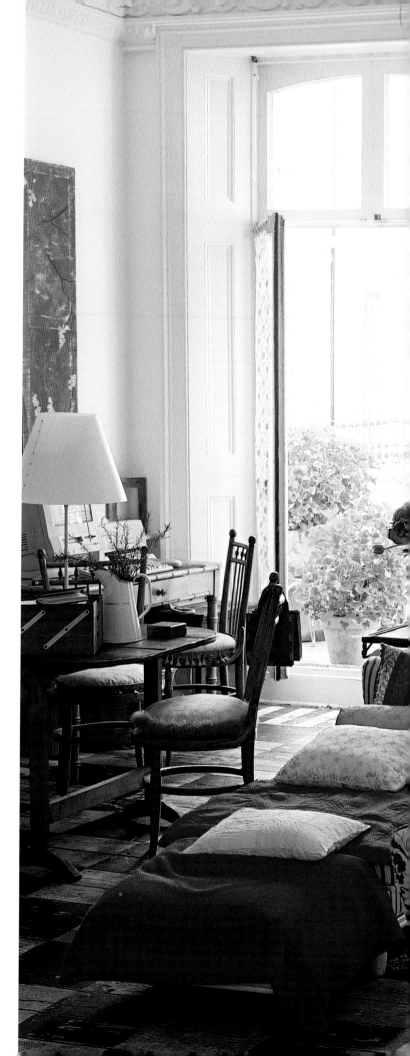

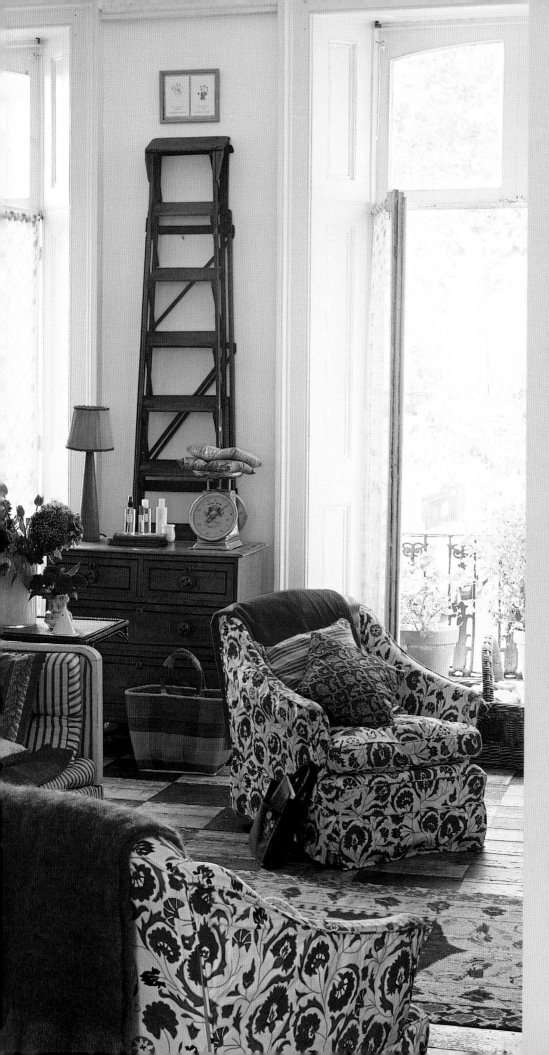

FURNISHING WITH OLD-FASHIONED FABRICS

Vintage fabrics play a key role in the decoration of eclectic drawing rooms, introducing a timeless quality that ushers in feelings of warmth and integrity. As a general rule, the most attractive fabrics are those that are already a little worn and faded; a splashy art nouveau pattern, for example, looks more appealing if the colors are slightly sunbleached, while a patched and darned chair cover adds an unbeatable feeling of immutability.

The sense of exclusivity wrought by antique textiles adds to their charm. Handwoven fabrics, in particular, are becoming increasingly hard to track down— as well as expensive. So it is important to remember that even the smallest scraps can be used to evoke a sense of nostalgia—as covers for precious books, for example, or as a lining for your jewelry box. Similarly, if you find a small piece of fabric you long to turn into a duvet cover, enlarge it with a border in a complementary fabric to make up the extra material.

Sometimes, it's impossible to find the exact pattern you're looking for, however hard you look. If this is the case, why not opt for a reproduction print? Available in a wide choice of patterns, modern materials decorated with vintage designs are almost as good as the real thing—particularly if the manufacturer has artificially aged the fabric by adjusting the dyes and chemical solutions.

contemporary country

Chic, simple, and uncomplicated, contemporary country style celebrates the homespun pleasures of bygone days in a thoroughly modern way. Providing a welcome escape from the techno-wizardry of twenty-first-century life, the look is fabulously rustic, while still retaining a good degree of comfort and decoration. As befits all vintage interiors, furnishings that have seen some action are a key feature; a pine dining table with a scrubbed top or a paint-chipped cabinet compound the sense of nostalgia, while a palette of pale colors provides the perfect backdrop for the floral media that bring the countryside into your home—from sprig-filled wallpaper to flowery ceramics.

LEFT Brightly colored florals set against a dazzling white background evoke a charming country cottage feel.

OPPOSITE The pale decor and paneled walls of this country kitchen are a perfect canvas for modern rustic additions such as painted chairs and an eclectic mix of fabrics.

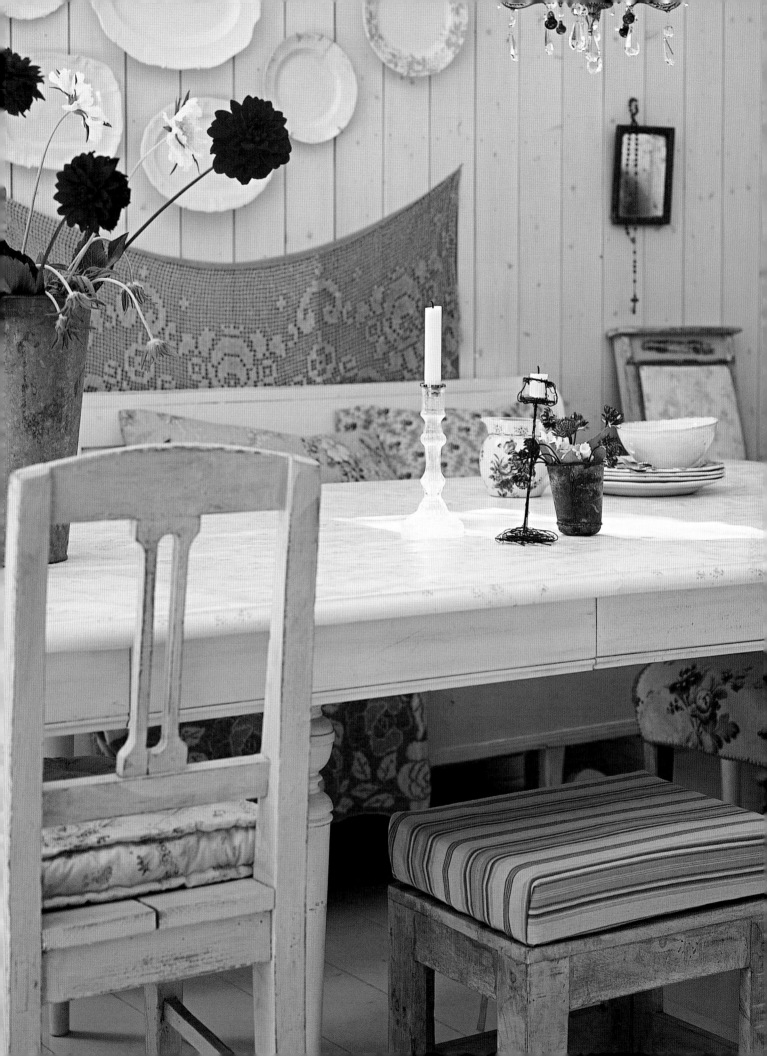

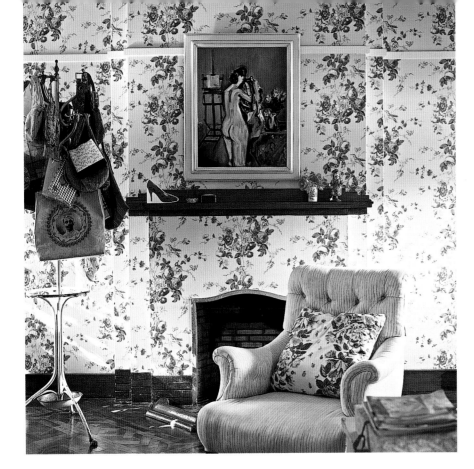

the rustic look

To create a rural-looking interior, it's important to ensure that your walls and floors are as natural looking as possible. Luckily, this is pretty straightforward, thanks to the wide variety of old-fashioned paint finishes that are available, which help to evoke a bucolic sense of space and calm. If you want your walls to have a rough-and-ready feel, try traditional distemper, which gives a pleasantly chalky finish; for surfaces that look elegantly flat, use whitewash. On the other hand, the natural pigments used in casein milk paint give a soft pastel hue.

Floral wallpaper is another staple in rustic interiors, providing the perfect cover-up for walls that are covered with lumps, bumps, and unsightly marks. Opt for old-fashioned prints to continue the vintage theme, or choose wipe-clean vinyl papers, which come in a range of colors and patterns and will give hardworking rooms such as kitchens and bathrooms a lighthearted, decorative feel.

For woodwork, try flat oil paint, which gives a very matte finish, or more durable oil eggshell, which has the advantage of marking less easily, but does have a slight sheen. But remember, if you're planning a rustic room from scratch, it is much simpler to pick a paint that goes with your chosen fabric (you can always get paint mixed to the exact shade you require), rather than to try to find a fabric that matches your choice of paint color.

Although contemporary country interiors tend to be calm and uncluttered, this does not mean you must restrict yourself to a bland palette of white and off-white. Instead, opt for colors that echo the natural world such as terracotta, brick, ocher, and green—earthy shades that complement rugged country furnishings and evoke a reassuring, lived-in feel. Alternatively, choose floral-inspired hues that are reminiscent of summer gardens; the delicate shades of lavender, clematis, and buddleia are all wonderfully subtle, and these tones work much better than stronger colors, which are just too overpowering for the majority of rustic room schemes.

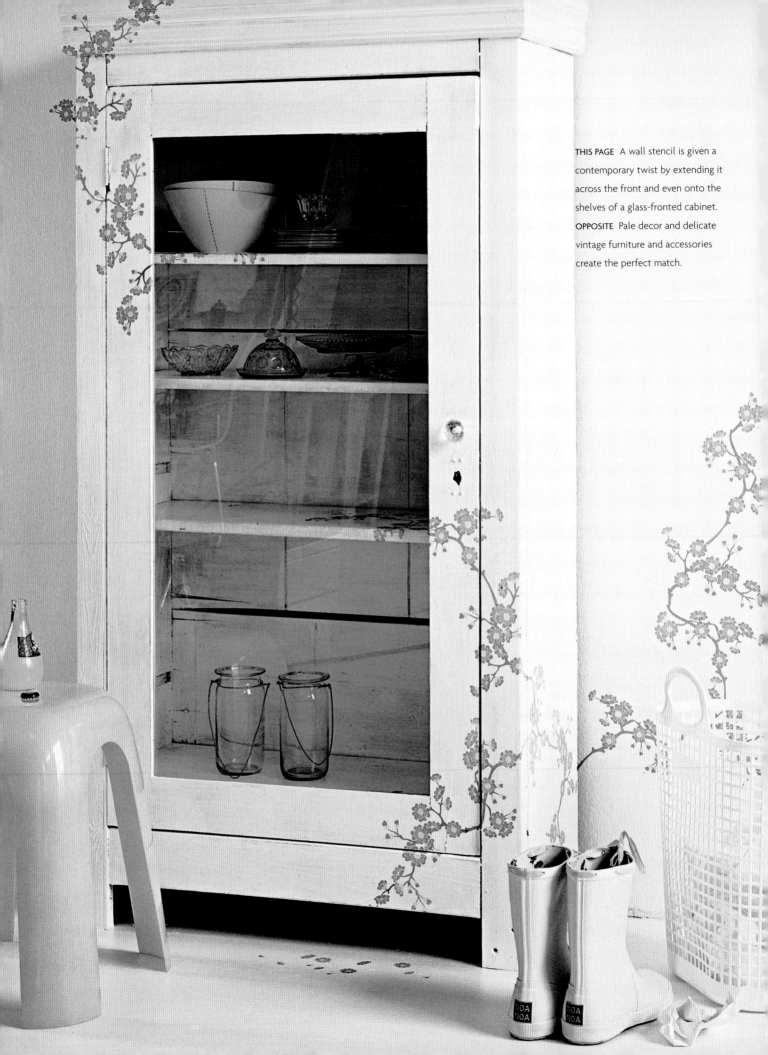

THIS PAGE A wall stencil is given a contemporary twist by extending it across the front and even onto the shelves of a glass-fronted cabinet. **OPPOSITE** Pale decor and delicate vintage furniture and accessories create the perfect match.

In keeping with the back-to-basics look, rustic-style floors are durable and down to earth. Choose neutral carpets or sisal matting if you want to ensure that your interiors remain cozy throughout the winter months, or cover brick, slate, or stone-flagged floors with floral rugs to introduce warmth, pattern, and color.

Stripped wooden floorboards also evoke the timeless appeal of country life, and can be employed in a number of ways to create different looks within the home. Use them on your floors, walls, and ceilings to create the intimacy of a cozy log cabin, or whitewash dark boards to open up small interiors and create a feeling of lightness and expansion. The continuous appearance of stripped boards also works brilliantly with wooden furniture carved from a different grain or hue, providing a pleasing textural contrast that is both spontaneous and natural.

Floral floor stencils are another option in rustic interiors, providing an arty feel that suits the pastoral profile. Easy to apply, as well as being inexpensive and fabulously low maintenance, stencils should be painted onto sanded floors and then covered with several coats of polyurethane to ensure that they withstand years of wear and tear.

Wood furniture is an integral part of country interiors, helping to promote feelings of warmth and longevity. Easily sourced from antique shops and flea markets, traditional wood furnishings are solid and practical (although not necessarily lacking in decoration), while the warm patina of old timber evokes a mellow ambience—and provides an attractive contrast to newer, sleeker styles.

It's also important to note that different woods summon different atmospheres. For example, if you want to create a calm feeling, opt for pale, light-reflecting timbers such as bleached driftwood or golden pine. A homely ambience is best achieved with richly colored woods such as cherry, which add warmth and security, while dark woods such as timeworn stained oak or gleaming ebony promote feelings of intimacy and seclusion.

Painted wood furniture is another option, imbuing interiors with a naïve, homely feel. Particularly suited to modern rustic rooms, it effectively masks any deficiencies in the wood, in addition to helping small dark rooms appear bigger and brighter. For best effects, opt for distressed pieces, where the original wood can be spotted beneath layers of peeling paint.

TIP: If you want to be sure a vintage fabric is the real thing, check for authentic signs of aging, such as fading along fold marks.

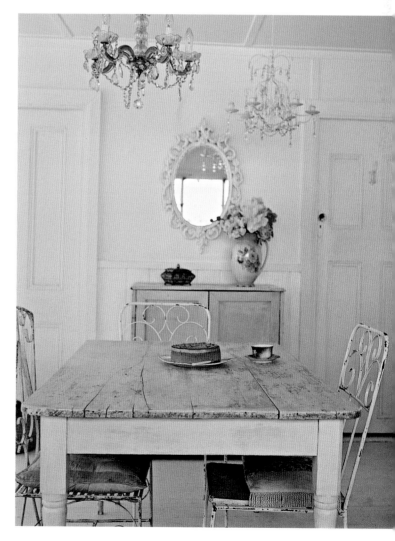

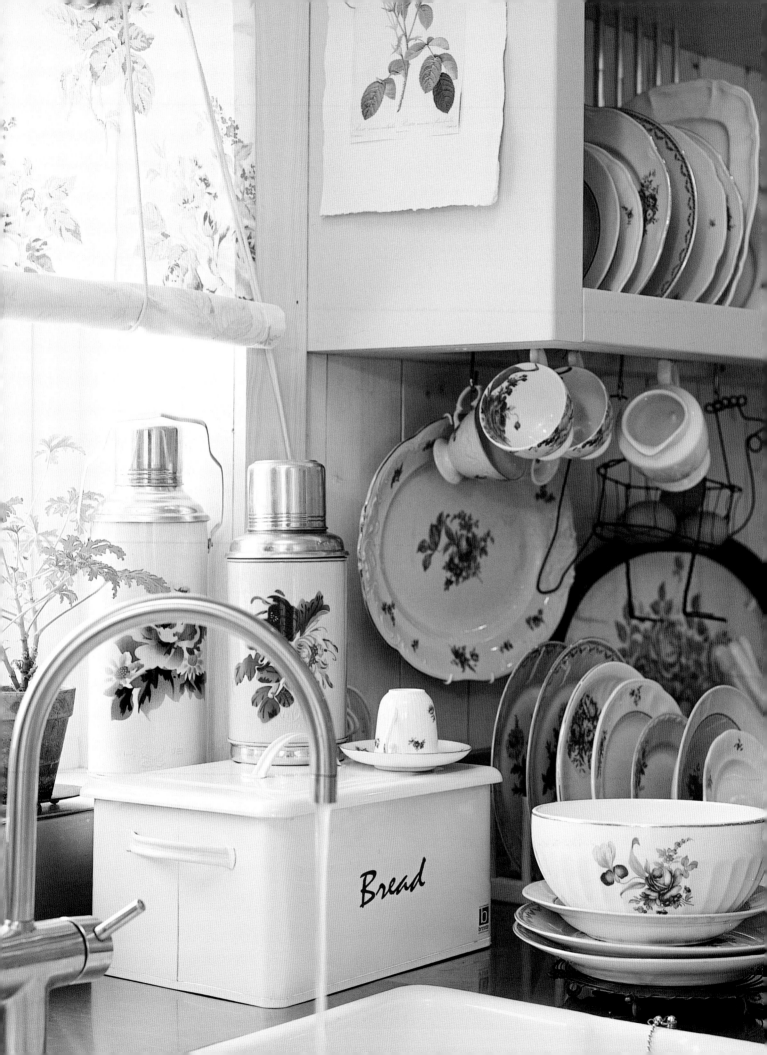

showcase florals

Pretty displays of floral china are one of the keynotes of modern country kitchens, instilling cooking areas with a sense of style and individuality. Even better, building up a collection of crockery—whether matching or unmatching—is an enjoyably slow process, which can take years to complete.

Another advantage of collecting china is the fact that it's still possible to buy tableware from markets and thrift shops at gratifyingly low prices. Single plates are particularly inexpensive purchases, as well as relatively easy to come by. If you're planning to build up a dinner service using secondhand ceramics, however, it's important that you scan potential purchases for chips and cracks, which will obviously render some pieces unusable.

Even if crockery appears to be in mint condition, keep your eyes peeled, as it may have been "invisibly" restored. (Repaired cracks are painted over with a matte white finish and can be very easy to miss unless you know what to look for.) Restored china cannot be used on a day-to-day basis, as repeated washing will cause the glue to dissolve. If you use these pieces for display purposes only, however, the odd crack or chip is sure to compound the vintage appeal.

In order to show off ceramics to their best advantage, choose glass-fronted cabinets and dressers, which have been especially designed for display purposes. Elegant armoires, with their doors left open to reveal stacks of pretty floral plates, provide an alternative to Welsh dressers, which are a staple feature in country kitchens, providing open and closed storage for tableware, cutlery, and linens.

If you don't have room for a full-size dresser, or even one of the smaller versions, customize your own display area with a rack or a set of open shelves fixed to the wall. These can be made from reclaimed floorboards or any piece of wood that looks suitably rough-hewn. If you're pushed for space, attach small hooks to the underside of shelves to hold mugs, jugs, and utensils such as cheese graters or sieves.

Mixing different styles of china on shelves and dressers is an integral part of vintage style; it reinforces the idea that although practicality is paramount, decor also has a part to play. White or off-white walls are the best backgrounds for displaying a collection of ceramics, while mismatched pieces introduce an informal feel.

For the most spontaneous-looking display (and therefore the most effective), simply select the individual pieces that you love and place them alongside other items that also speak to your soul. It's a good idea to mix old styles with newer ones, rather than sticking with pieces of the same vintage, while objects that create a stunning visual surprise—a plain purple jug among a clutch of primrose patterned plates, for example, will pump up the pace in an instant.

Contrasting textures is another display technique, and could include the arrangement of delicate chintz designs on rough, chunky shelving, for example, or display glossy art deco florals against roughly distempered walls. It's also advisable to try and balance larger pieces with smaller ones; this way, you will avoid the mind-numbing uniformity that's guaranteed to kill ceramic displays stone-cold.

If the haphazard look is too disorganized for your liking, the solution is to create a theme with different pieces to present a more unified look; a mass of different cream and white chinaware looks coolly coordinated, for instance.

TIP: Remove stains from vintage china by soaking it thoroughly in a bucket of cool diluted washing powder.

OPPOSITE Plates and dishes patterned with old-fashioned florals give this kitchen a unique sense of character.

kitchens

Warm, friendly, and inviting, kitchens are fast replacing dining rooms as the most convivial of places to eat and entertain. No longer viewed as an impersonal canteen, the modern kitchen has become a attractive meeting point—a hub where family and friends gather to pass the time of day. Particularly suited to country-style kitchens, this trend reflects the ancient farmhouse tradition in which the kitchen has always been the beating heart of the home.

As suited to urban spaces as it is to rural ones, the country-style kitchen is seen throughout the western world—with looks ranging from minimalist Scandinavian to elegant French farmhouse. The common denominator is the nostalgic ambience—a sense of warmth and inclusion, manifested as easily in a high-rise apartment as in a converted barn.

Decor-wise, simplicity is key in the modern rustic kitchen. To establish a traditional character, consider installing an old-fashioned enamel-fronted stove or Aga, which will keep your kitchen toasty throughout the year. Next, scour your local salvage yard for period fittings such as a deep ceramic Belfast sink, a butcher's block, reclaimed faucets, and single floorboards, which make excellent rustic-style shelves.

Lighting is another way to create a convivial atmosphere in kitchens that also serve as communal areas. For best results, look for styles that will efficiently illuminate working areas, and combine with ambient lighting for more relaxed spots. You should also incorporate lighting that is flexible enough to cope with a variety of dining situations—from raucous parties to cozy twosomes. If you choose pendant lights to illuminate your table, use tungsten bulbs, which emit a soft creamy glow.

The centerpiece of any country kitchen is the table. For the ultimate in rusticity, choose an old refectory style or an antique pine job with a battle-scarred top. Storage is similarly old-world. Eschew bland, fitted units in favor of freestanding pieces that have proved their worth; stripped pine cupboards and scrubbed wood dressers are so much more appealing than laminated counters and smooth-sliding drawers, while open shelves piled with floral crockery will compound the free-and-easy feel.

If your kitchen is on the small side, it's still possible to create a rustic look by incorporating concealed storage. This will keep the hum-drum items out of sight and allow room for a display of pastoral paraphernalia. A combination of built-in units with an old-fashioned plate rack strikes the right sort of note, for example, while a mélange of old-fashioned utensils hanging from ceiling hooks or pots of herbs on your windowsill continues the theme. It also helps to think laterally with regard to furnishing kitchens, whatever their size. Thus, a cozy armchair could be transferred from the sitting room to a niche by the stove, or a chest of drawers moved from the bedroom to serve as storage space for kitchen utensils.

Fabric is an effective way to soften the utilitarian lines of kitchen cabinets, as well as introducing a secondary color into your cooking area. For a truly vintage look, hang a floral curtain beneath the sink to hide ugly plumbing. Alternatively, employ floral "skirts" to disguise a number of modern monstrosities such as dishwashers, washing machines, and driers. Kitchens are full of steamy aromas, so make sure that soft furnishings such as drapes, blinds, or chair covers are washable. By the same token, kitchens are not ideal locations for valuable artworks; instead, decorate walls with inexpensive floral prints, tiles, and decorative plates.

OPPOSITE A faded tablecloth, some quirky decoration, and a mishmash of different furnishing styles create a homely feel in this charmingly cluttered kitchen.

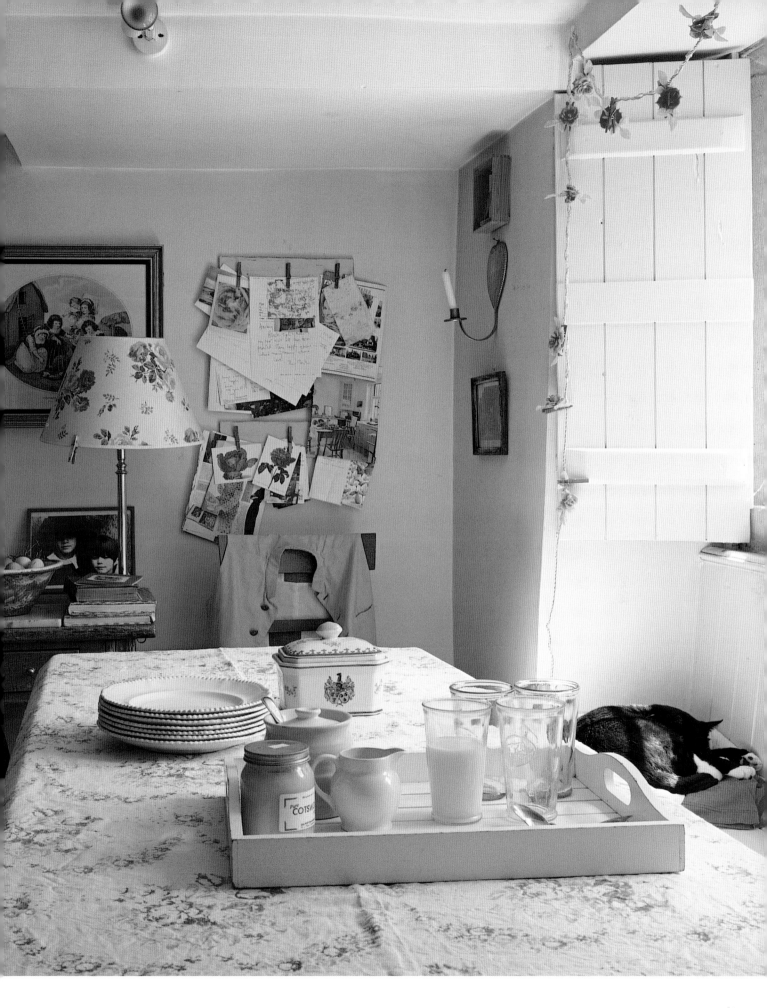

TEN WAYS TO ADD FLORALS TO KITCHENS

Although today's kitchens are full of gadgets, it's possible to counter the high-tech look with an assortment of floral details:

✻ Hang café curtains from a stretched wire to create a funky 1950s feel.

✻ Employ a similar technique to keep unattractive appliances such as your dishwasher, washing machine, or drier hidden from view.

✻ Enliven a drab corner with an arrangement of floral tiles, which are as practical as they are pretty.

✻ Reupholster stool seats with petal-patterned pads, and brighten up chairs with mix-and-match squab cushions tied onto the back struts (this is also an excellent way of using up smaller pieces of vintage fabrics).

✻ Make an assortment of napkins from vintage scraps, or use leftovers to trim plain placemats.

✻ Line the backs of cupboards, kitchen shelves, and cutlery drawers with floral wallpaper or thickly waxed floral giftwrap.

✻ Recycle a 1920s tea dress to make a kitchen apron.

✻ Rugs are a good way of introducing a floral theme, but make sure that they are made from material that can be easily cleaned, as spillages are bound to occur.

✻ Introduce florals via kitchen basics such as tea towels, oven mitts, trivets, and placemats.

✻ Decorate your windowsill with a heavenly scented hyacinth or a row of jaunty geraniums.

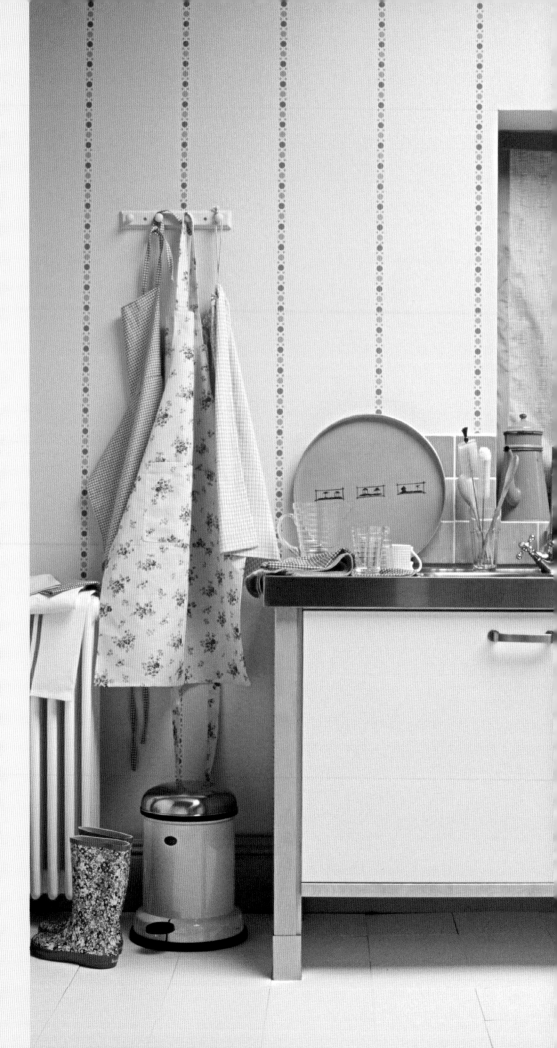

A far cry from the rigorous style of minimalist cooking zones, where everything is hidden behind brushed-steel units, vintage kitchens feature an exuberant mix of free-standing furniture, fabrics, and utensils. Abundance is the name of the game here, and the fruitful look is compounded by a celebration of nature. Thus, a bowl brimming with speckled eggs is proudly exhibited alongside a pot of basil, and a basket of apples placed next to a second basket brimming with wild flowers.

Although the inclusion of numerous different objects is a key feature of vintage kitchens, it should be noted that most of the decorative items in farmhouse kitchens have an intrinsic beauty that's born out of years of hard labor. As a result, a collection of old-fashioned ladles, whisks, and wooden spoons bunched together in a floral pot makes a spontaneous and interesting display, while gleaming copper saucepans suspended from the ceiling are as useful as they are aesthetic.

Although vintage kitchenware has been popular for quite some time now, there is still plenty of it around to buy. Best sourced from flea markets, antique shops, and trunk sales, where vendors often give gratifyingly good deals, many of the items are likely to show a degree of wear and tear. This should not present any real problems, however, as chips and scratches bear witness to a golden age when life seemed simpler and less hectic than it is today.

Old-fashioned gadgets are another way of giving rustic kitchens a retro feel. Early versions of coffee grinders, nutcrackers, cheese graters, whisks, and weighing scales provide an authentic look, while florally inspired antiques such as enamel flasks and decorated tin tea caddies combine with enamel colanders, storage jars with French labels, and old stone pestle and mortars to complete the vintage theme.

No modern rustic kitchen is complete without the addition of a few loosely informal flower arrangements. For best results, fill your space with typical country blooms such as

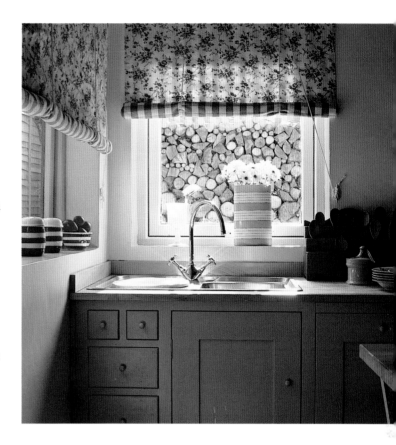

poppies, black-eyed Susans, sunflowers, and hollyhocks or hedgerow plants such as cow parsley. To complete the back-to-basics look, requisition kitchen containers as an alternative to conventional vases for displays of flowers and foliage. Items such as milk jugs, copper pots, storage jars, and tumblers are perfect for simple blooms, while cast-iron buckets and enamel coffee pots are suitable for bolder arrangements.

TIP: Old-fashioned French armoires with door panels faced in chicken wire provide a perfect frame for floral fabrics, which can be tacked onto battens set inside the door. If you have ordinary wooden cupboards, simply remove the center section of the front panel and replace it with wire mesh to create the same effect.

OPPOSITE A floral-print apron provides the perfect finishing touch in this wonderfully vintage green and pink kitchen.
ABOVE Floral blinds backed with a contrasting checked fabric soften harsh edges and introduce a relaxed feel.

laundry rooms

Thanks to their associations with age-softened sheets and embroidered lavender sachets, laundry rooms have an inherent vintage feel and provide the perfect forum for showing off your finest floral fabrics. After all, what could look more attractive than pretty piles of vintage eiderdowns, petal-patterned pillowcases, blooming curtains, and sprig-filled sheets?

Traditionally a female domain, laundry rooms emanate a sense of purity that inspires a decorative scheme that is light, bright, and pretty. If your space is on the small side, paper the walls with darling buds, which work better in more compact rooms; alternatively, line shelves with floral paper, or transform vintage fabrics into covers for ironing boards and coat hangers. You can also stitch together a variety of cloth bags from old-fashioned scraps and use them for storing clothespins and odd socks.

TIP: To scent linen naturally, add a solution of a clear essential oil, such as lavender, to the final rinse in the washing machine.

ABOVE A floral ironing board enlivens a utility room.
OPPOSITE Laundry bags provide a pretty alternative to dull linen baskets and are a decorative device in their own right.

STORING VINTAGE FABRICS

✽ Fabrics that are not in frequent use should be stored somewhere dark and dry. If you don't have a linen cupboard, a chest of drawers is a good substitute.
✽ Line shelves or drawers with paper so the fabric doesn't come into contact with the wood.
✽ Wrap delicate fabrics in acid-free tissue paper and gently roll them up to avoid straining the fibers.
✽ Do not use airing cupboards for storage. Instead, store vintage fabrics in cardboard boxes and make sure they are kept dry.
✽ Do not use plastic boxes for storage; the air cannot circulate, which might encourage mildew.
✽ To keep stored fabrics fresh, tie a handful of potpourri into an old floral handkerchief, and hang your makeshift bag inside the linen cupboard door.

IRONING-BOARD COVER

Take the drudgery out of ironing with floral ironing-board covers, which are simple and easy to make:
✽ To turn your ironing board into a decorative feature rather than a dreaded object, recycle an old floral fabric to use as your cover, bearing in mind that a heavyweight cotton will last longer.
✽ Make sure you use a fireproof lining and check that the fabric does not have any manmade content, which could be flammable.
✽ Trace the pattern from the old cover, and add a drawstring so it's easy to take off to wash.

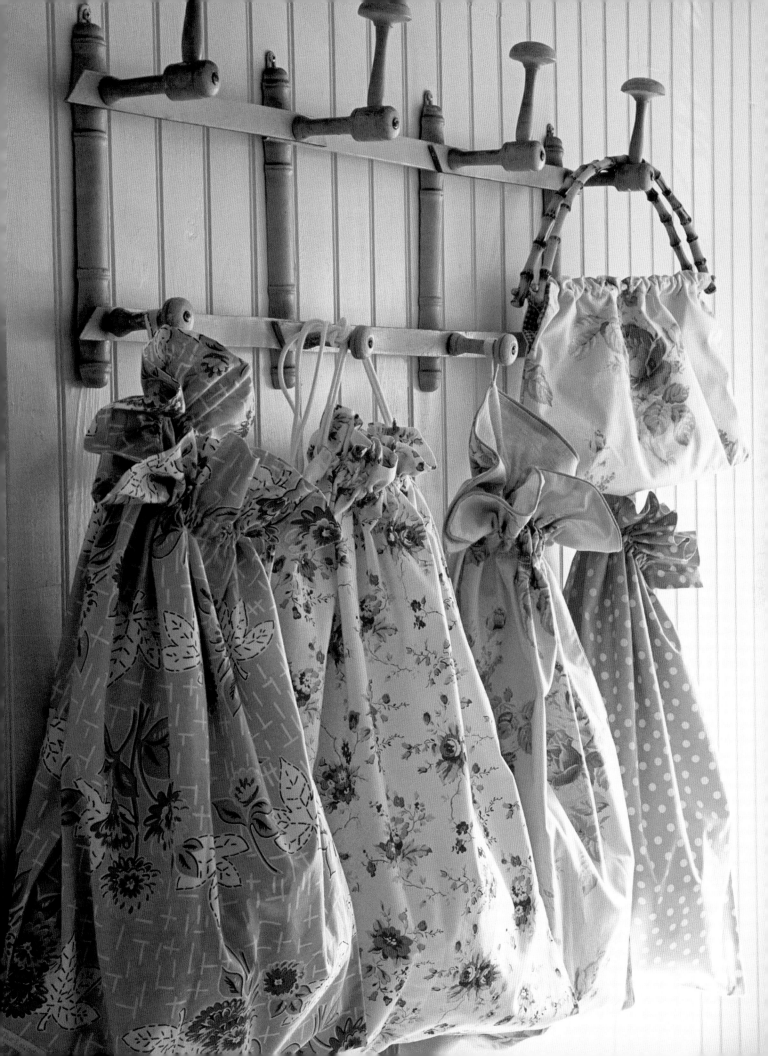

address book

ABC CARPET AND HOME
888 Broadway
New York, NY 10003
212-473-3000
www.abchome.com
Also locations in Florida and
New Jersey.
Antiques, furniture, accessories,
linens, lighting, rugs.

AMANDA ROSS
Studio 54
Clink Studios
1 Clink Street
London SE1 9DG
020 7234 0832
Hand-printed silk cushions and
decorative wall panels.

ANDREW MARTIN
222 E 59th Street
New York, NY 10022
212-688-4498
www.andrewmartin.co.uk
Fabrics, trimmings, wallpapers,
furniture, accessories.

ANNA FRENCH
343 Kings Road
London SW3 5ES
020 7351 1126
www.annafrench.co.uk
Fabric, lace, and wallpaper, plus
decorative accessories such as
rose-shaped fairy lights.

ANTHROPOLOGIE
www.anthropologie.com
Locations throughout the
United States.
Bedding, pillows, windows, furniture,
rugs, and other home accents.

BAER & INGRAM
Dragon Works
Leigh on Mendip
Radstock BA3 5QZ
01373-813800
www.baer-ingram.com
Mail order available.
Country-style furniture, patchwork
quilts, wallpaper, bed and bath ware.

BENNISON FABRICS
8264 Melrose Avenue
Los Angeles, CA 90046
323-653-7277
www.bennisonfabrics.com
Also locations in New York
and London.
King of tea stains and muted
eighteenth-century-style fabrics.

CABBAGES & ROSES
3 Langton Street
London SW10 OJL
020-7352-7333
www.cabbagesandroses.com
Mail order available
Faded floral linens, vintage
accessories.

CATH KIDSTON
201 Mulberry Street
New York, NY10012
212-343-0223
www.cathkidston.co.uk.
Painted furniture, fifties-inspired
vintage and modern fabrics,
wallpapers, and accessories.

COUNTRY SWEDISH
www.countryswedish.com
Showrooms in New York, Chicago,
Washington, and Florida.
Wide variety of furniture, rugs,
and wallpaper.

CRATE AND BARREL
www.crateandbarrel.com
Locations throughout the
United States.
Table lines, furniture, rugs, kitchen
and bath accessories.

THE CURTAIN EXCHANGE
129–31 Stephendale Road
London SW6 2PF
020 7731 8316
www.thecurtainexchange.co.uk
Bespoke and ready-made curtains and
blinds, plus second-hand curtains.

DESIGNERS GUILD
Osborne & Little Inc.
979 Third Avenue – Suite 520
New York, NY 10022
212 751 3333
www.designersguild.com
Modern furniture and fabrics,
including designs by Jasper Conran,
Emily Todhunter, and Ralph Lauren.

FINE ARTS BUILDING
232 East 59th Street
New York, NY 10022
212-223-0373
Aged and faded florals, many based
on archive French fabrics from the
eighteenth and nineteenth centuries.

HABITAT
196 Tottenham Court Road
London W1P 9LD
0845-601-0740
www.habitat.co.uk
Locations throughout Europe.
Modern furniture and furnishings.

JOHN LEWIS
Oxford Street
London W1A 1EX 5NN
020 7629 7711
www.johnlewis.com
25 locations throughout the United
Kingdom, mail order available.
Enormous range of fabrics,
homewares, and accessories.

THE LAUNDRY
PO Box 22007
London SW2 1WU
020-7274-3838
Mail order 1930s–1950s-inspired
patterned bed linen.

LAURA ASHLEY
Locations throughout USA
800-367-2000 for store location
closest to you
www.lauraashley.com
Fabrics, furniture, carpets, bedding,
curtains, and other home
accessories.

MARIMEKKO
1262 Third Avenue
New York, NY 10021
800-527-0624
www.kiitosmarimekko.com
Bold Finnish textiles, kitchenware,
and accessories.

MARVIC TEXTILES USA, LTD.
30–10 41st Avenue, 2nd Floor
Long Island City
New York, NY 11101
718-472-9715
Silks, toiles, and linens.

MISSONI HOME
Missoni Boutique New York
1009 Madison Avenue
New York, NY 10021
212 5179339
www.missonihome.com
Brightly colored homewares.

NEISHA CROSLAND
8 Elystan Street, London SW3 3NS
020 7584 7988
www.neishacrosland.com
Inspirational print-based furnishings and fabrics.

ORNAMENTA
Stark Wallcovering
979 3rd Avenue
New York, NY 10022
212 752 9000
www.ornamenta.co.uk
Hand-printed wallpaper and site-specific designs by Jane Gordon Clark.

OSBORNE & LITTLE, INC.
90 Commerce Road
Stamford, CT 06902
www.osborneandlittle.com
Leading designer of English country house fabric and wallpapers.

PIER 1
www.pier1.com
Locations throughout the
United States.
Bed and bath, kitchens, windows, and other home accessories.

PIERRE FREY INC.
12 East 33rd Street, 8th Floor
New York, NY 10016
212-213-3099
Known for printed cottons based on its archive of eighteenth and nineteenth century French Fabrics.

RACHEL KELLY
71 Goldman Close
London E2 6EF
020 729 3552
www.interactivewallpaper.co.uk
Interactive wallpaper; customers can tailor-make their own designs.

RALPH LAUREN HOME
381 West Broadway
New York, NY 10012
212-625-1660
www.polo.com
Also locations throughout
the world.
Designer homeware including a wide range of bed linens.

ROMO
Lowmoor Road
Kirkby in Ashfield
Nottinghamshire NG17 7DE
01623 756699
For export call: +44 (0)1623 755881
www.romofabrics.com
Modern floral fabrics in sumptuous silk, satin, linen, and cotton.

THE RUG COMPANY
88 Wooster Street
New York, NY 10012
212-274-0444
www.therugcompany.org
Designer rugs by Paul Smith, Matthew Williamson, and Diane von Furstenberg.

SERA OF LONDON
020 7286 5923
www.seraoflondon.com
Interior design service, plus luxury homeware.

SHABBY CHIC
www.shabbychic.com
Retail stores in New York and
Los Angeles.
Furniture, bedding, fabric, and accessories.

SUSAN SARGENT DESIGNS INC.
4783 Main Street
Manchester, VT 05255
802-366-4955
www.susansargent.com
Rugs, bedding, furniture, fabric, wall coverings, and decorative accessories.

SVENSKT TENN
Strandvägen 5, Box 5478
SE-11484 Stockholm
Sweden
+46 8 670 16 00
www.svenskttenn.se
Swedish design company selling textiles, furniture, and lamps.

TAPETTITALO
Fleminginkatu 4
00530 Helsinki
Finland
+358 9 76 76 58
www.tapettitalo.fi
Finnish purveyors of over 200 Scandinavian wallpapers.

TIMOROUS BEASTIES
Holland and Sherry
979 Third Ave 14th Floor
D&D Building New York
212 355 6241
www.timorousbeasties.com
Funky fabrics, roller blinds, wallpapers, and accessories.

TORD BOONTJE
The Bake House
Basing Court
16a Peckham High Street
London SE15 5DT
020 7732 6460
www.tordboontje.com
Modern furnishings including lighting, embroidered chairs, paper screens, and digital-print fabrics.

VV ROULEAUX
6 Marylebone High Street
London W1M 3PB
020 7224 5179
www.vvrouleaux.com
Ribbons, trimmings, braid, and couture flowers.

index

Figures in italics refer to captions.

acknowledgments

The publisher would like to thank the following photographers, agencies and companies for their kind permission to reproduce the following photographs in this book:

2 Bill Kingston/Elle Decoration; 5 Courtesy of Romo Fabrics; 6 Mark Williams/Elle Decoration; 9 Courtesy of Osborne & Little; 10–11 Courtesy of Cath Kidston Ltd; 12 Lars Ranek; 14 above Courtesy of Cath Kidston Ltd; 14 below Courtesy of The Curtain Exchange; 15 Courtesy of Designers Guild; 16 Mel Yates/Elle Decoration; 16–17 Tom Leighton/Homes & Gardens/IPC Syndication; 18 Caroline Arber/Homes & Gardens/IPC Syndication; 19 Annika Vannerus; 20 Tom Leighton/Homes & Gardens/IPC Syndication; 21 Courtesy of Romo Fabrics; 22 Alex Sarginson; 23 Gaelle le Boulicaut; 24 Simon Brown/Red Cover; 25 Mikkel Vang; 26 Lina Ikse Bergman/Elle Decoration; 27 Polly Wreford/Living Etc/IPC Syndication; 28 Gaelle le Boulicaut; 29 Minh + Wass (Designer: Betsey Johnson); 30 left Jan Baldwin/Narratives; 30–1 Pia Tryde/Courtesy of Cath Kidston Ltd; 32 Kim Sayer/Homes & Gardens/IPC Syndication; 33 Deborah Jaffe; 34 above Courtesy of Cath Kidston Ltd; 34 below Courtesy of Cabbages and Roses; 35 Dennis Brandsma/VT Wonen/Sanoma Syndication; 36 Dana Gallagher/Achard & Associates; 37 Gaelle le Boulicaut; 38 Dana Gallagher/Achard & Associates; 39 Margaret de Lange; 40 Christopher Drake/Red Cover; 41 Polly Wreford/Narratives; 42–3 Sally Chance/House and Leisure; 44 Marianne Luning/VT Wonen/Sanoma Syndication; 45 Polly Wreford/Narratives; 46 Solvi Dos Santos; 47 Tom Leighton/Elizabeth Whiting & Associates; 48–9 Jan Baldwin/Conran Octopus; 50 Di Lewis/Elizabeth Whiting & Associates; 51 James Merrell/Living Etc/IPC Syndication; 52 Courtesy of Sera of London; 52 above Courtesy of Amanda Ross; 53 Alex Sarginson; 54 Anson Smart; 55 Mark Williams/Living Etc/IPC Syndication; 56 Ray Main/Mainstream; 57 Martyn Thompson/Marie Claire Maison (Stylist: Marie Kalt); 58 Mel Yates (Designer: Sera of London); 59 Courtesy of Romo Fabrics; 60 Mel Yates/Elle Decoration; 61 Henry Bourne; 62 James Merrell/Living Etc/IPC Syndication; 63 Philippe Garcia/Marie Claire Maison (Stylist: Marion Bayle); 65 Tom Leighton/Living Etc/IPC Syndication; 66 above Courtesy of Osborne & Little; 66 below Courtesy of Neisha Crosland; 67 Edina Van Der Wyck/Homes & Gardens/IPC Syndication; 68 Mee, Bath (Artist: Kate Milson Hawkins); 68–9 Jacques Dirand/The Interior Archive (Designer: Carolyn Quartermaine); 70 Jake Curtis/Homes & Garden/IPC Syndication; 71 Tom Leighton/Living Etc/IPC Syndication; 72–5 Alexis Armanet/Marie Claire Maison (Stylist: Marion Bayle); 76–7 Courtesy of Timorous Beasties; 78 Adrian Briscoe (Lamp Designs by Plumo); 79 Bill Kingston/Elle Decoration; 80 above Courtesy of Neisha Crosland; 80 below Courtesy of Cath Kidston Ltd; 81 Graham Atkins-Hughes/Elle Decoration; 82 Bill Kingston/Elle Decoration; 83 David Hiscock/Homes & Gardens/IPC Syndication; 84 above Graham Atkins-Hughes/Elle Decoration; 84–5 Lina Ikse Bergman/Elle Decoration; 86 Graham Atkins-Hughes/Elle Decoration; 87 Mathew Shave/Elle Decoration; 88 Mel Yates/Elle Decoration; 89 Bill Kingston/Elle Decoration; 90 Chris Tubbs/Elle Decoration; 91 Mel Yates/Elle Decoration; 92 Jake Fitzjones/Living Etc/IPC Syndication; 93 Mel Yates/Elle Decoration; 94 above Courtesy of Osborne & Little; 94 below Courtesy of Rachel Kelly; 95 Chris Tubbs; 96 Paul Massey/Living Etc/IPC Syndication; 97 above Courtesy of Missoni Home; 97 below Mai-Linh/Marie Claire Maison; 98 Courtesy of The Rug Company (Design by Lulu Guinness); 99 Courtesy of The Rug Company (Design by Diane von Furstenberg); 100 Adrian Briscoe/Elle Decoration; 101 Courtesy of Habitat UK; 102–3 Craig Knowles/Elle Decoration; 104–5 Courtesy of Svenskt Tenn; 106 Thomas Stewart/Elle Decoration; 107 Mel Yates/Elle Decoration; 108 above Courtesy of Tapettitalo; 108 below Courtesy of Osborne & Little; 109 Jan Baldwin/Narratives; 110 Annika Vannerus; 111–12 Jan Baldwin/Narratives; 113 Pia Tyler/Living Etc/IPC Syndication; 114 Dennis Brandsma/VT Wonen/Sanoma Syndication; 115 Chris Tubbs/Conran Octopus; 116 below Courtesy of Tapettitalo; 117 Wilfried Overwater/Taverne Agency (Stylist: Rosa Lisa); 118 Simon Brown/Red Cover; 119 Ulrike Schade/Elle Decoration; 120 Graham Atkins-Hughes; 121 Mel Yates/Elle Decoration; 122–3 David Woolley; 124–5 Courtesy of Cabbages and Roses; 126 Torsten Oelscher/Elle Decoration; 128 above Courtesy of Cabbages and Roses; 128 below Courtesy of Anna French; 129 Polly Wreford/Homes & Gardens/IPC Syndication; 130 Craig Fordham/Homes & Gardens/IPC Syndication; 131 Margaret de Lange; 132 Stuart McIntyre (Stylist: Lene Utzon); 133 Alexander Van Berge/Taverne Agency/Elle Eten; 134 Lisa Cohen/Vogue Living; 135 Tim Beddow/The Interior Archive (Designer: VV Rouleaux); 136–7 James Merrell/Homes & Gardens/IPC Syndication; 138 Yutaka Yamamoto/Marie Claire Maison; 139 Sally Chance/House and Leisure; 140–1 Andrew Wood/The Interior Archive; 142 Courtesy of Cath Kidston Ltd; 143 Margaret de Lange; 144 Jan Baldwin/Narratives; 145 Niels Harving/Lykke Foged; 146 Studio Dreyer Hensley (Stylist: Paul Lowe); 147 Gaelle le Boulicaut; 148 Margaret de Lange; 150–1 Edina Van der Wyck/The Interior Archive; 152 Pia Tryde/Homes & Gardens/IPC Syndication; 153 Edina van der Wyck/The Interior Archive; 154 Edina van der Wyck/Courtesy of Cabbages and Roses; 155 Mark Broussard/Homes & Gardens/IPC Syndication

Every effort has been made to trace the copyright holders. We apologize in advance for unintentional omissions and would be pleased to insert the appropriate acknowledgment in any subsequent publication.

FABRIC AND WALLPAPER SWATCHES

10 Cath Kidston Petals; 14t Cath Kidston Bleached Rose Paisley (blue); 14b Curtain Exchange; 34t Cath Kidston Rose Stripe; 34b Cabbages & Roses Cerise Hatley; 48 De Gournay wallpaper; 52t Amanda Ross; 52b Sera of London Aroused Rose wallpaper (copper & gold rose on black); 59 Romo fabrics Japonica; 66t Osborne & Little Papilio wallpaper; 66b Neisha Crosland Merlin Plough Green; 76 Timorous Beasties McGegan Rose; 80t Neisha Crosland Tudor Plum Rose; 80b Cath Kidston Ottoman Rose (blue); 94t Osborne & Little Sakura collection Asuka design; 94b Rachel Kelly; 97t Missoni Home Ester; 97b Cacharel; 104 Svenskt Tenn Milles Fleurs (designed by Josef Frank); 108t Tapettitalo; 108b Osborne & Little Adelphi collection Tamara design; 116t Liberty; 116b Tapettitalo; 124 Cabbages & Roses Bees; 128t Cabbages & Roses Blue Podge; 128b Anna French Bird in the Bush; 142t Cath Kidston Bleached Summer Blossom; 142b Cath Kidston Antique Rose.